ART AND HISTORY
OF
GREECE

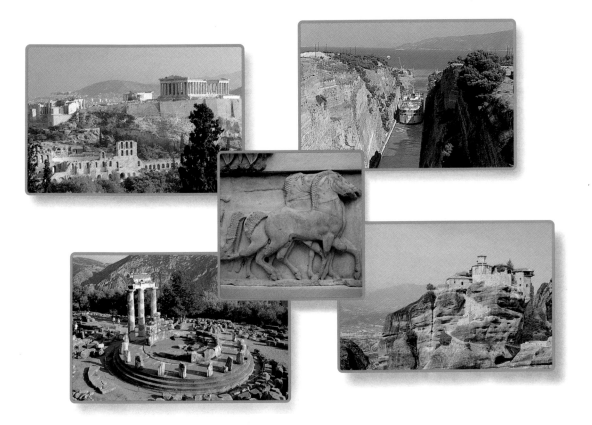

AND MOUNT ATHOS

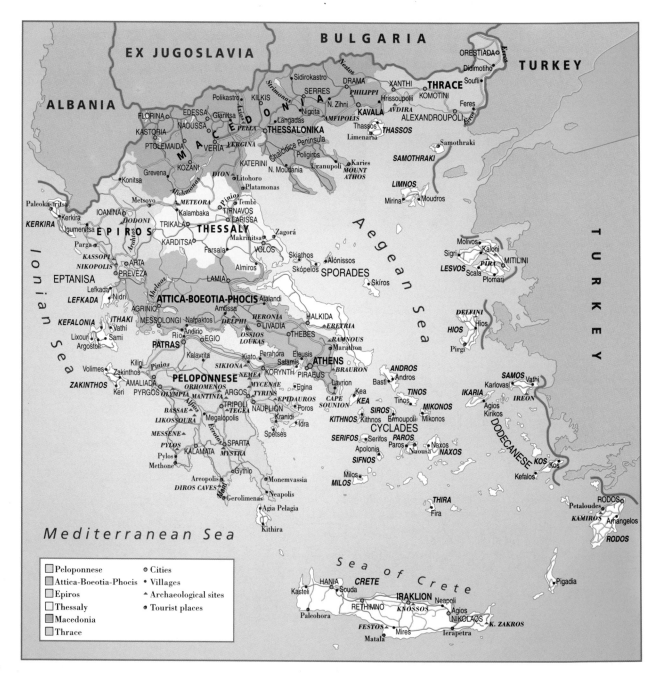

ART AND HISTORY OF GREECE

Publication created and designed by *Casa Editrice Bonechi*
Photographic research and documentation: *Giovanna Magi*
Graphics and layout: *Serena de Leonardis*
Videographics: *Laura Settesoldi*
Text by: *Mario Iozzo, Federica Borghesi* and *Adalberto Magnelli*
Translation: *Paula Boomsliter - Traduco Snc, Florence*
Editing: *Simonetta Giorgi*

Drawings by *Stephen Sweet* page 8 and *Stefano Benini* page 52
Maps by *Panajota Kolokotroni* and *Studio Grafico Daniela Mariani, Pistoia*

The photographs are property of the Bonechi archives and were taken by:
Smara Ayacatsica, Marco Bonechi, Luigi Di Giovine, Paolo Giambone.
Photos by *Gianni Dagli Orti:* cover and pages 9 below, 10 above, 12, 13, 14, 15, 16, 18, 19 above, 21 below, 24, 25, 26, 27, 28, 29, 30, 31, 32, 50, 62, 63, 65 above, 67, 68 above, 69 below left, 70 left, 71, 78, 79, 80, 81, 87, 90 above 98, 103 below right, 104, 105, 146 above right, 148, 149, 171, 175, 180,
Photos by *George Poupis:* pages 181, 182, 183, 184.

ISBN 88-8029-435-0

* * *

INTRODUCTION

Loving a country and its people means first of all becoming acquainted with their history, their distinctive features and the social and cultural components of their society, appreciating their environment and their forms of expression. In few regions of the world is it possible to grasp the profound essence of a people as it is in Greece: the Greeks are on the whole a good-natured people, in all about ten million in the two great cities of Athens, the capital (with about five million inhabitants, if we include the suburbs and Piraeus), and Thessalonika (about one million), who generally welcome foreign visitors warmly and courteously. They are a people who live among the vestiges of a grandiose past, in the knowledge that they are heirs to a profound cultural legacy but also with the modesty deriving from awareness of the true worth of that heritage; while standing almost in awe before such greatness, they would show off Greece's treasures to the world that others might also enjoy them - but at the same time they are actively committed to protecting, valorizing and safeguarding the historical wealth of which they are the trustees.

The visitor thus experiences full immersion in ancient art, that art which, with its splendid harmony, illuminated by the golden overtones of the Pentelic marble or the luminous white of that from the islands (the major quarries were on the islands of Páros and Náxos), was decreed even by the great writers of ancient times (Plato, Xenocrates, Pliny, Cicero, Quintilian) to be "classical"; that is, a point of reference for posterity and for all artistic expression to come, a "condition" which was respected in Roman art and transmitted to the Middle Ages, given a new value during the Renaissance and down through neo-Classicism, and breached only by contemporary and modern art.

The studied proportions of the architecture, fruit of long and carefully re-evaluated experience, the organic unity and the naturalism that inspired the portrayals of the human body (ancient Greek art was the most naturalistic in the entire Mediterranean area, and was the direct inspiration for the later Roman art) and rational city planning, a technique which evolved slowly but precociously, harmonize the ones with the others in a fascinating landscape that from the harsh mountains of the Peloponnese shades into the wooded slopes of northern Greece and the blinding luminosity of the innumerable islands, which as tradition has it formed a path of stepping stones across the Aegean Sea to Crete and Cyprus to the south and to the east to that other vast region which was for centuries dominated both culturally and politically by Greece, the Anatolian coast, today's Turkey.

The marked diversities among the landscapes that characterize the different regions of Greece, each with its individual qualities and particularities, have a common denominator in the irregularity of the stupendous coastlines, bathed by seas of intense hues, teeming with fish, that offered the ancient Greeks an infinite series of sheltered harbors and bays, the starting points for the initiatives, cultural and otherwise, of one of the most active and intelligent peoples of the ancient world, who possessed - then as now - one of the most powerful fleets sailing in and controlling the Mediterranean basin.

And in an environment so intimately pervaded by the forces of nature, one that offered so many opportunities to man's genius in the enchanted light reflecting off the sea and contrasting with the green expanses of the olive groves, in the heat of a constant and at times pitiless sun, there could not but have developed a parallel reflection on Being and the Divine, concepts which even in ancient times aroused the interest of the Greek intellectual class, whose speculations were reflected in the birth of philosophy and the creation of that great mythological heritage by which the Greeks explained and justified every phenomenon, every concept, every action - and even the names of the flowers, of the animals, etc.: those philosophical theories and that corpus of myths that in practice are foundations upon which the culture of the modern West is based.

It is in this spirit that we suggest the visitor observe the monuments that he will encounter as he travels in Greece, from the great urban acropolis' to the temples dotting the tops of the hills or standing out against unforgettable marine panoramas; from the sanctuaries, immersed in the silent green of the countryside and disturbed only by the faint tinkling of the streams and springs once held to be sacred or healing to the crowded museums that are today home to unequalled masterpieces.

Athens alone, with its monuments cloaked in the majesty of the ages, would be ample recompense for a trip to Greece - but so would be the Delphi Sanctuary, pervaded by a sense of the sacred inspired by the cult of Apollo, the god of purity; or the infinite monasteries and isolated small churches of the Byzantine world that was able to preserve that inheritance of profound religiosity proper to the Greek people and to fuse it with the strictest of Christian teachings - and to give birth to a great art which, if in its architecture was still influenced by the Roman style, in painting was already projected toward the new trends that were emerging in medieval Europe.

But the visitor will soon become aware of how intimately the cultural and spiritual elements bequeathed by a great past, the vestiges of which are scattered uniformly throughout the country, still pervade modern Greek life - almost as a constant reminder that it was in this soil that the roots of our modern society took hold.

GLOSSARY

Abacus	Upper portion of a capital.
Acroterion	Decorative motif, at the top and corners of the pediment.
Agora	The main square, where public meetings and the market were held.
Anta	Angular pillar used as reinforcement for a wall.
Aphendikó	Appellation of the Virgin Mary as "Lady".
Architrave	Lower portion of the entablature.
Caryatid	Female statue used in place of a column.
Dipteral	Of a monument surrounded by a double row of columns.
Echinus	Lower portion of the capital linking the abacus and the shaft of the column.
Entablature	Architectural structure set on columns and composed of an architrave, a frieze and a cornice.
Faience	Terracotta glazing technique.
Gigantomachy	Battle of the Giants and the Gods.
Heraion	Temple dedicated to the goddess Hera.
Iconostasis	Divisional structure found primarily in the ancient Byzantine churches, between the presbytery and the nave, on which sculpted or painted sacred images were hung.
Khiasmos	Crossing of two lines to form an "X"; ornamental motif used primarily in Greek sculpture of the Archaic period.
Kore	Female statue.
Kouros	Male statue, standing with arms along sides and left foot slightly forward.
Krepidos	Supporting steps of a temple.
Lesche	Public building used by the ancient Greeks as a place for meeting and discussion.
Metope	Sculpted or painted panels which alternated with triglyphs to decorate the frieze of the entablature.
Naós	Sacred area of a temple within the peristyle, including the cella, the prónaos and the opisthódomos.
Narthex	Porticoed atrium of a church.
Odigítria	Of the Madonna depicted holding, on her left arm, the infant Christ blessing the faithful, while with her right indicating Him to the assembly.
Omphalos	Literally "navel", the hub of the world, symbolized in Delphi as a decorated conical stone.
Opisthódomos	Rear portico of a Greek temple.
Panagía	Appellation of the Virgin Mary as "Most Holy".
Pandánassa	Appellation of the Virgin Mary as "Queen of the Universe" or "of All Things".
Peripteral	Of a building encircled by a single row of columns.
Peristyle	The columns encircling the cella.
Stoa	Portico composed of a front colonnade and a rear wall.
Témenos	Area consacrated to a god, distinct from the surrounding land.
Theotókos	Appellation of the Virgin Mary as "Mother of God".
Thesaurós	Treasury; small, circular, domed building, used as a tomb; later, in the Classical period, a votive chapel within the precinct of a sanctuary, used for conservation of offerings.
Thólos	Circular temple or tomb.
Triglyph	Rectangular slab with vertical grooves, which alternated with metopes to make up the frieze of the entablature.

ATTICA-BOEOTIA-PHOCIS

ATHENS - PIRAEUS - MARATHON - RAMNOUS
BRAURON - CAPE SOUNION - ELEUSIS - THEBES - KESSARIANÍ
DAPHNE - OSSIOS LOUKAS - ARAHOVA - DELPHI

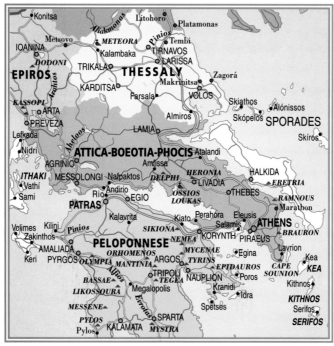

The territory of the ancient city of Athens extends along a harsh, mountainous peninsula, poor in water resources, the profile of which, with its suggestive irregular coastline, offers shelter in an infinite number of inlets, bays and coves; adding the outlying islands of Aegina and Salamis brings the total land area to 2650 square kilometers. Cultivated since ancient times in wheat and other grains, the landscape is dominated by the plantations of olive trees, which the Greeks considered a gift of the goddess Athena to her city, and of grapevines, a more recent gift of Dionysos. Agriculture has always been accompanied by sheep-rearing and exploitation of mineral resources, which in certain periods of history represented the true wealth of the region and above all of Athens: examples include the silver of Cape Laurion that armed the Athenian fleet and so determined its victory over the Persian armies, and the marble from Mount Pentelikon, with its warm golden overtones, used in building all the principal monuments of the Classical period and still quarried today at a prevalently local level. The primary resource of Attica, however, is represented by its maritime activities, which have determined the creation of a powerful fleet and the development of industry in the golden triangle Athens-Piraeus-Eleusis, in which are located refineries and mechanical industries, iron and steel works, chemical, textile and manufacturing industries, besides the many mills and factories producing foodstuffs, the inevitable oil-mills and the soap-works. All these activities are carried on under the shadow of an enormous tourist influx and the consequently well-developed hotel trade: Greece is the only country in the world to host a number of visitors more than twice that of its population; what is more, almost all of these visitors stop in Athens for at least a few days, dedicating their time to archaeology and the museums, creating an economic, cultural and social impact not without repercussions for Attica, which today is without doubt the region of Greece with the most to offer in terms of accommodations and facilities but also that which has as a consequence most prematurely lost those of its characteristics which are most exquisitely "Greek".

Attica, delimited to the south by the Aegean Sea, into which projects one of the pearls of the region, Cape Sounion, crowned by the Temple of Poseidon silhouetted against the intense blue of a peculiarly luminous sky, borders to the north on the rich flatlands of Boeotia. Set between the Gulf of Corinth and the Euripos Channel that separates it from the island of Euboia, Boeotia closes off Attica to the north; it was for this reason that Athens, during all of its development in historical times, kept the Boeotian territory under tight control, either directly or through indirect influences. The territory was gradually permeated by the culture of the nearby great city of Athens, made capital by Theseus, to such a point that it became imitative of and dependent on it: and still today, in the entire West, the term "Boeotian" brings to mind a guileless simpleton. As is the erritory of Boeotia, so is that of the nearby Phocis distinguished by massive highlands alternating with vast fertile plains cultivated in grains and olives despite the dry climate: the "bread basket" of Athens and indeed of Attica as a whole. Horse-breeding also once flourished around Thebes, although the activity has now been abandoned. The introduction of modern irrigation systems and the re-opening of the textile industries, as well as a certain stimulus to crafts activities, have been the distinguishing characteristics of the recent development of certain areas in the interior, as for example that of Livadiá, situated in the basin of the ancient Lake Copaïs, the subterranean waters of which irrigate two yearly harvests. And if the name of Boeotia is still today linked to the great plains areas, once the theatres of epoch-making battles (Leuktra, Chaeronea, Plataia), that of Phocis is synonymous with the great panhellenic sanctuary of Apollo at Delphi, on the slopes of Mount Parnassus, the non-stop flow of tourists to which represents a decisive contribution to the economy of this small region.

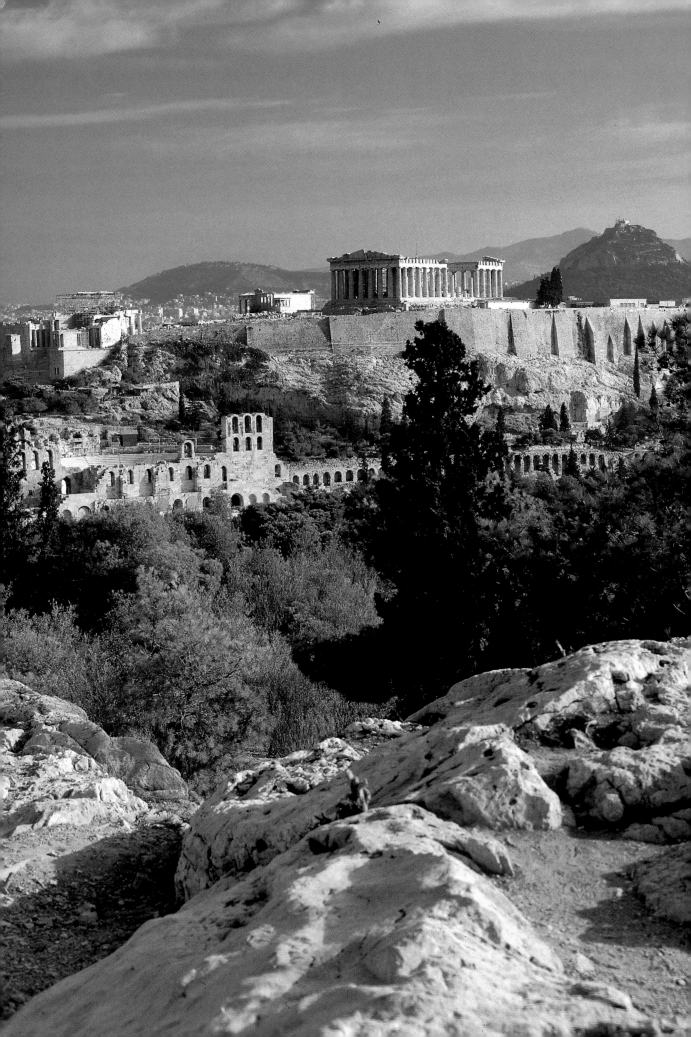

ATHENS
AN INTRODUCTION TO THE HISTORY OF THE CITY

The capital of Greece, one of the world's most glorious cities and the cradle of Western culture, Athens' origins date to the Neolithic period (ca. 3000 BC), when a primitive village arose at the center of a basin delimited by hills: the Licabettos (Wolves' Hill), the Pnyx, the Philopappos, the Areopagos and above all the Acropolis. The white monuments of the latter still dominate the landscape of the immense modern city, which extends as far as the eye can see down to the two ports of Piraeus and Phaleron.

It was around the Acropolis that Athens, defined by the historian Herodotus as a *pólis trochoeidés* ("city in the form of a wheel") developed, similarly to a great wheel of which the Acropolis was the hub. Already an important center of culture in the 15th century BC, Athens' importance was confirmed when the city resisted, the bulwark of the peoples of Ionic culture, against the invasions of those of Doric language and culture from the north of Greece. Upon its emergence from the long period of settling-in that followed, of which we know very little due to the dearth of archaeological finds and monuments from the time, Athens was governed by a monarchy, the importance of which is reflected in the Homeric poems and in the country's vast mythological heritage.

At the beginning of the 7th century BC the monarchy was replaced by a government of aristocrats, formed by nine archons (magistrates) who were officially elected each year. Dominion by only a limited number of families led to ferocious struggles which induced Draco to issue laws that were so repressive and intransigent that it was said they were written in blood and not in ink. The rise to power of the wise and moderate Solon (593 BC) brought timocratic government; his reforms, based on the wealth of citizens, are famous for having mediated the differences between the aristocrats and the lower classes until the tyrant Peisistratos took power. Peisistratos nevertheless respected the Solonian reforms, and with his sons Hippias and Hipparchos enriched Athens on both the economic and the cultural levels, making of the city a center of primary importance that exerted a direct influence on all the peoples of the Mediterranean. Following the fall of the dynasty of the Peisistratids, Athens, the cradle of the concept of democracy, received its first true democratic constitution in 510 BC thanks to Kleisthenes, who also stipulated the treaty that was to check the arrogant advance of the Persians into the Aegean. But war was nevertheless imminent: in 490 BC at Marathon and again in 480 BC in the Strait of Salamis, the Athenians succeed, practically single-handedly, in repelling the Persian attacks. The prestige of the city, which had taken on the role of savior of the entire Greek population, grew to the point that Athens became stronger than even its rival Sparta and the supreme power in the Mediterranean.

Athen's Golden Age, to which the monuments of the Acropolis bear the most eloquent testimony, began in 461 BC with the election of Pericles, and ended with the disastrous Peloponnesian War against Sparta and the ensuing plague of 429 BC (of which Pericles himself was a victim). Athens defeated Sparta in the Battle of Mantineia (362 BC), but was nevertheless forced to bow to the dominion of the Macedonians and was spared destruction only thanks to its importance.

Sacked by Sulla in 86 BC, Athens was the jewel of emperors such as Hadrian until it was destroyed by the Erulians in 267 BC. By 529 AD, when the Emperor Justinian closed even the University, Athens was only a poor village. Snatched from the Byzantines by the Normans in 1040, the city passed to the Burgundians, the Franks and the Catalans in turn, and was ruled by the kings of Aragon until its liberation in 1387 by the Florentine Accaiuoli.

In 1456, Athens was captured by the Turks (during whose rule the Parthenon was transformed into a mosque and the Erechtheion into a harem), to be liberated only in 1828; in 1834 it became the capital of the unified state of Greece, first the seat of the reigning dynasty, then of the government of the Colonels during the period of dictatorship, and finally of the republican government in 1977. Today, about two-thirds of the entire Greek population resides in Athens.

View of the Acropolis from the Pnyx.

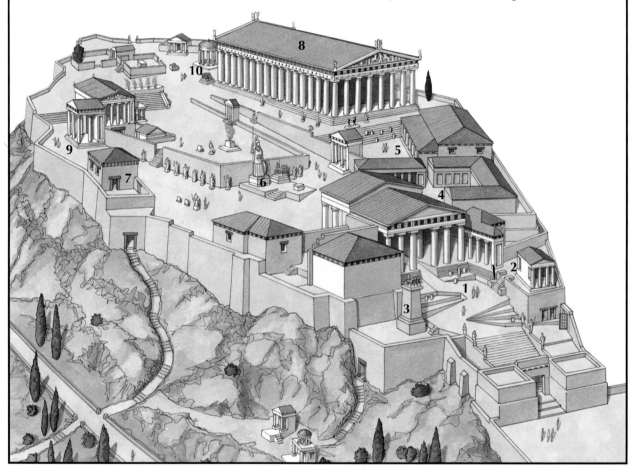

Reconstruction of the Acropolis in Roman times.

View of the Acropolis from the Areopagos.

View of the Acropolis. In the foreground the monument to Agrippa, which supported a quadriga.

THE ACROPOLIS

Symbol of the profound religious spirit of the Greeks and, with its monuments, a cornerstone of Classical art, the Acropolis is an imposing natural fortress composed of a rock platform rising to 156 meters above sea level. Initially the site of the royal palace and a shelter for the population in case of danger, as were all the citadels that arose during the Mycenaean period (Argos, Mycenae, Tiryns, Glá), it was fortified during the 15th century BC with a bulwark of **Cyclopean walls** in which there opened, to the west, a protected entrance on that same down-slope today occupied by the monumental gates to the Acropolis, the **Propylaia**.

In historical times, when its importance as a stronghold declined, the Acropolis became the principal sanctuary of the city, dedicated to its first king, Cecrops, to his successor, the snake-god Erechtheos, son of Athena, to Zeus Polieos ("of the city") and above all to the Athenian's patroness and protectress, Athena, goddess of wisdom and of war, born fully armed with her shield, lance and helmet from the head Zeus. The Acropolis continued in its role of sanctuary even after the city was sacked by the Persians in 480 BC and until the Byzantine era, when the Parthenon was transformed into a Christian church. With the Turkish occupation, the temple became a mosque, and a minaret was added. Today the Acropolis is the highest testimony to the grandeur of Classical Greek art in the 5th century BC.

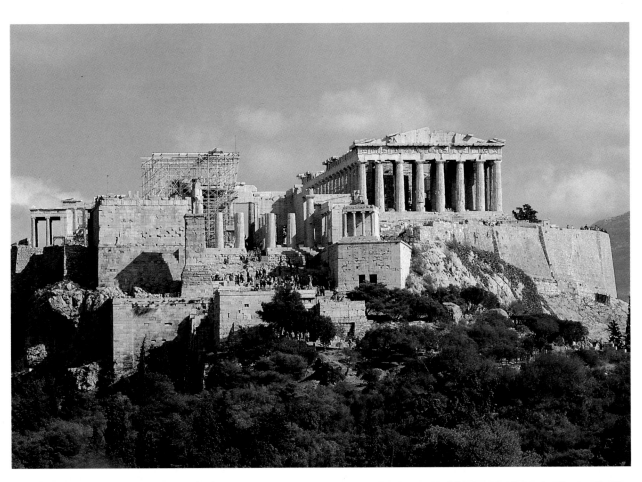

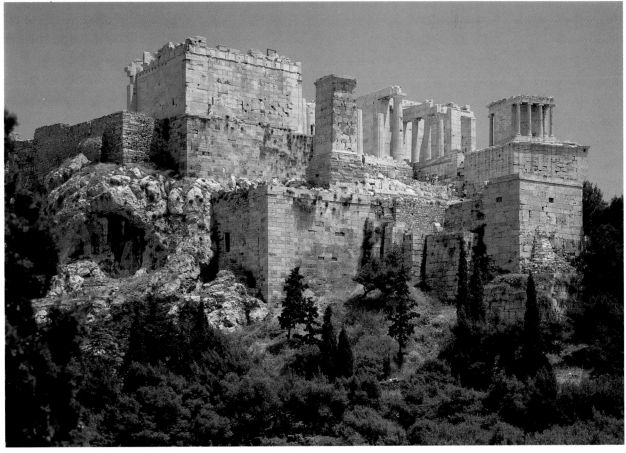

TEMPLE OF ATHENA NIKE

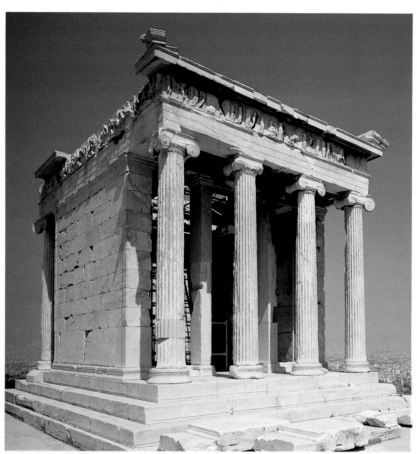

Ascending toward the Acropolis through the **Beulé Gate** that protected the entrance during the Middle Ages, our eye is caught by the great fan of the **Propylaia**, the monumental gates, work of the architect Mnesikles (437-433 BC), consisting in a monumental portico flanked on the left by the **Pinakothéke** and on the right by a symmetrical architectural element which was not fully developed in order to leave room for that small jewel of ancient architecture that is the **Temple of Athena Nike** (430-420 BC). Erected by Kallikrates on the site of the building destroyed by the Persians, it is an Ionic temple with four columns on the ends; a frieze in high relief, depicting the battles between the Greeks and the Persians, ran above the architrave and was encircled by a balustrade of marble slabs, sculpted by Kallimachos, showing scenes of sacrifices to Athena.

Temple of Athena Nike.

The Erechtheion and the Porch of the Caryatids.

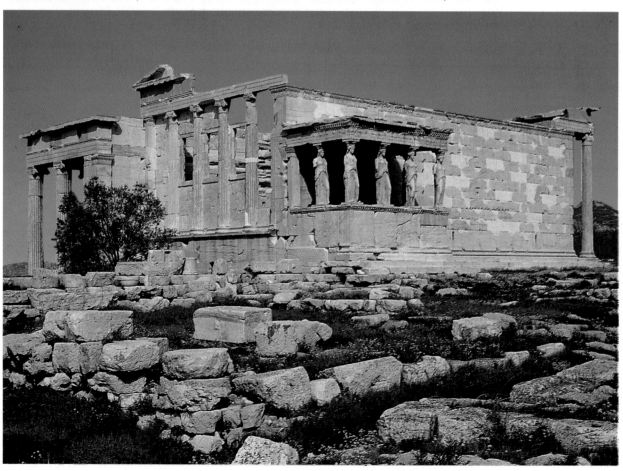

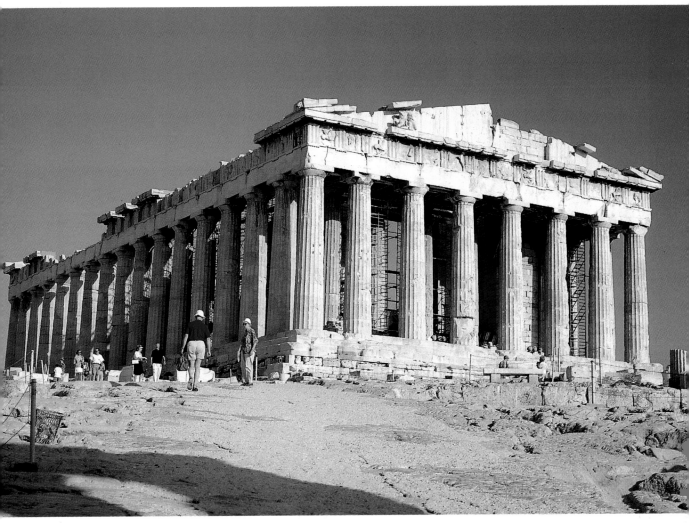

The Parthenon. View from the west.

PARTHENON

After passing through the Propylaia and leaving on the right the few remains of the **Sanctuary of Artemis** and of the **Gallery of Casts** (which housed the bronze statues), we reach the Parthenon, which takes its name from the opisthódomos in which four virgins (*parthénoi*) wove the sacred peplum of the goddess, who was known as *Athena Parthénos*. This imposing edifice is a Doric peripteral temple built of Pentelic marble, with 8 columns on the ends and 17 down each side. The sumptuous decoration, sculpted in part by the great Pheidias, is composed of 92 metopes (Gigantomachy, the Battle between the Greeks and the Amazons, the Battle between the Lapiths and the Centaurs and other Athenian myths) and the pediments, portraying the Birth of Athena to the east and the Quarrel between Athena and Poseidon for possession of Attica to the west; a frieze showing the great procession of the sacred festival of Athena, the Panathenaia, ran above the architrave. Erected by order of Pericles on the site of the temple destroyed by the Persians, the Parthenon was not a true temple (worship was held at the great left altar of the circular temple of Rome and Augustus) but rather a precious container for the gold-and-ivory statue of Athena, by Pheidias, that was the sacred image and at the same time the treasure of the city.

ERECHTHEION

On the opposite side is the other masterwork of Ionic architecture, the Erechtheion, designed by Philoklés, which rose around the olive tree sacred to Athena; it is known world-over for its complex design and above all for the precious **Porch of the Caryatids** which rises on the foundations of the first Temple of Athena (420 BC).

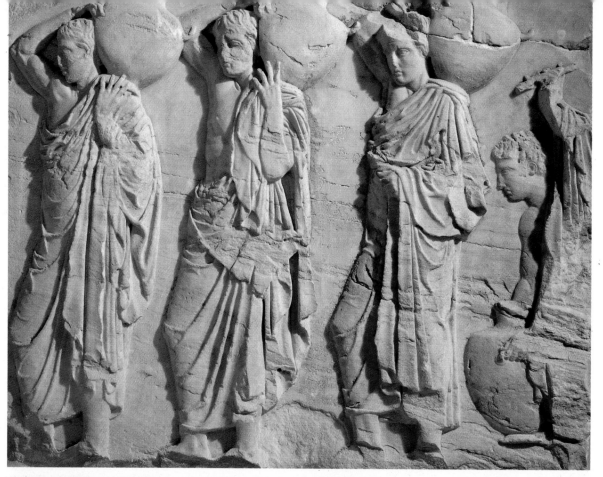

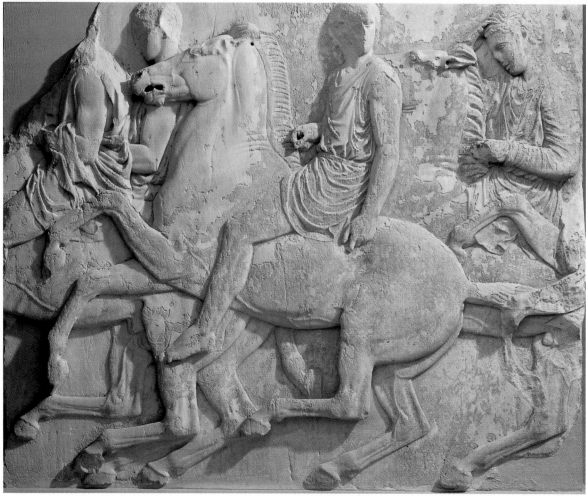

THE ACROPOLIS MUSEUM

Located at the southeastern spur of the Acropolis, the Museum contains the objects found during excavation of the hill, above all those from the *Persian Embankment*, an enormous "land-fill" containing what remained after the devastation wreaked by the Persians in 480 BC. The Athenians buried the damaged votive offerings and the debris of the sacred buildings that had been violated in an embankment that served the secondary purpose of enlarging the Acropolis to make room for the new Parthenon.

In the **entrance hall**, among statue bases carved in relief, stands a colossal marble owl, the symbol of Athena. In **Rooms 1 and 2** are the remains of the *poros* (local sandstone) pediments (6th century BC) of the Archaic temples dedicated to the goddess that preceded the Periclean Parthenon, among which we note the lioness felling a calf, scenes from the life of Herakles (*The Hydra of Lerna, Deification on Mount Olympus, Struggle with The Three-Bodied Triton*), and the *Olive-Tree Pediment* showing Achille's ambush of Priam's youngest son, Troilus, without whose sacrifice the Greeks would have been unable to win the Trojan War. At the center is the celebrated *Moschophoros*, a *kouros* carrying a calf, the oldest marble statue dedicated on the Acropolis (votive offering by Rhombos, 560 BC).

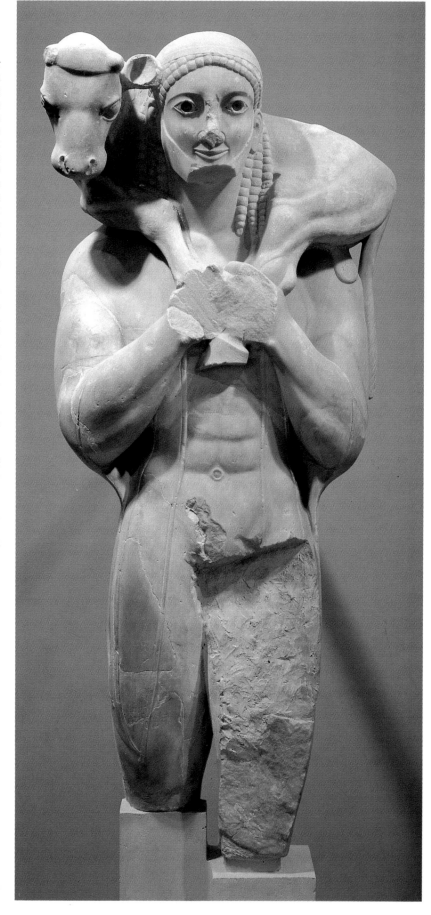

North frieze of the Parthenon: the procession of the water-bearers carrying hydrias, and young men on horseback.

The Moschophoros dedicated by Rhombos.

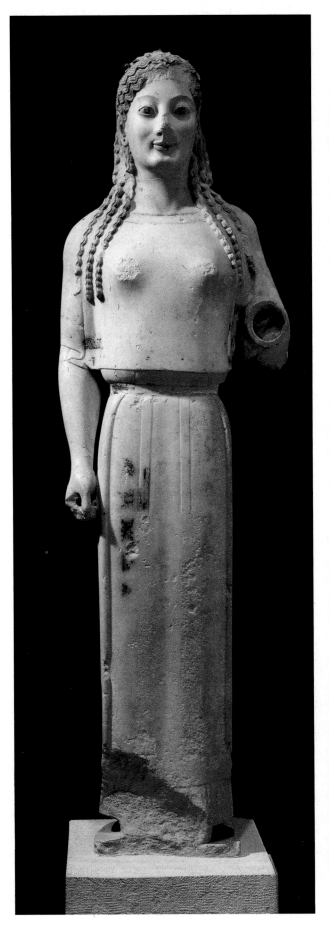
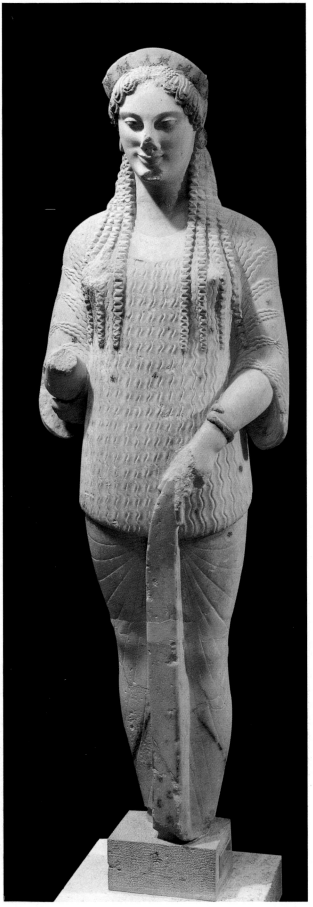

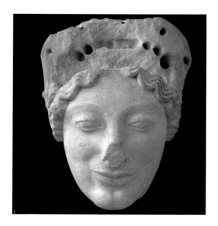

Kore of the Peplos.

Kore no. 670.

Head of kore no. 643.

Kore no. 674.

Kore no. 682.

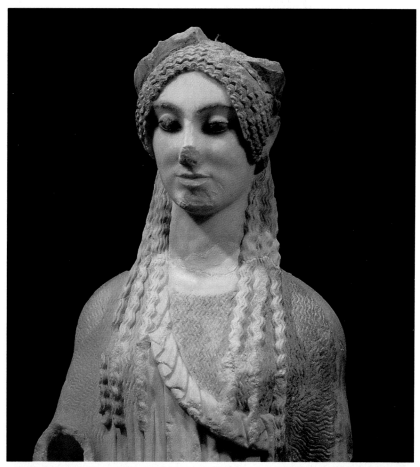

The *Kore of the Pomegranate* is the oldest of a series of statues of young women dedicated to the goddess Athena, perhaps images of priestesses or worshippers. There follows a bull being attacked by two lions, perhaps the pediment of the first Parthenon, and two seated statues of Athena, one of which is by Endoios (510 BC). In **Room 4**, after the relief of Athena being honored by a family of worshippers, the masterworks of ancient Greek sculpture: the *Kore of the Peplos,* so named after its severe attire, work of the same sculptor to whom is also attributed the statue of the *Rampin Horseman,* on the right (original torso with cast of the head once in the Rampin collection and today in the Louvre); the *korai* nos. 674 and 682 and the head no. 643, sculpted with sensibility and delicate plane shifts, all with refined headdresses and precious garments (*chitons*) draped by cloaks (*himations*).

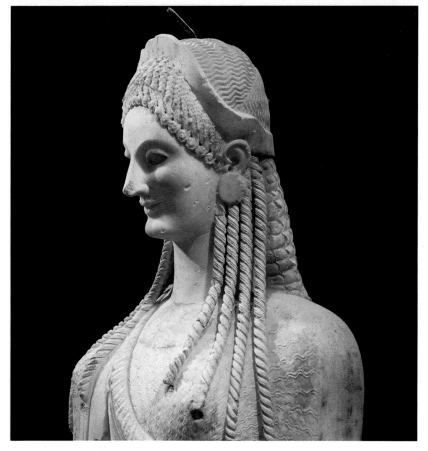

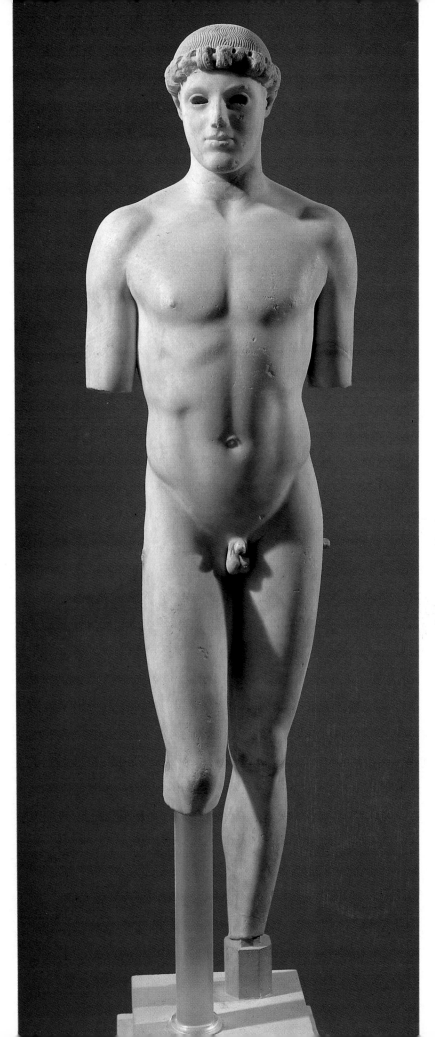

In **Room V**, besides the *Kore by
Antenore*, the sculptor of the ped-
iments of the Temple of Apollo
in Delphi, we find the *Battle
between Athena and the Giants*
from the pediment of the Temple
of Athena destroyed by the
Persians and on the foundations
of which rests the Porch of the
Caryatids. **Room VI** marks the
transition from Archaic art to the
Severe style, prelude to the
Classical forms, with the *Kritian
Boy*, the relief of the *Mourning
Athena* and the head of the *Blond
Boy*, all masterworks of propor-
tion and psychological expres-
sion. In the rooms that follow is
displayed the Classical art of the
metopes, the friezes and the pedi-
ments of **Pheidias' Parthenon**,
on which powerful figures,
cloaked in Olympic calm, stand
in counterpoint to the grace of the
draping of the women's clothing
and the rapt expressions of the
worshippers in the procession.
Echoes of Pheidias' art are also
evident in the *Erechtheion frieze*
and in the *Caryatids* (original:
those outside are casts) that fol-
low. At the exit stands *Prokne*
about to kill his infant son Itys, a
work by Alkamenes, the great
pupil of Pheidias (440 BC).

Kritian Boy.

*View of the Agora with
the Temple of Hephaistos
(today called the Theseion).*

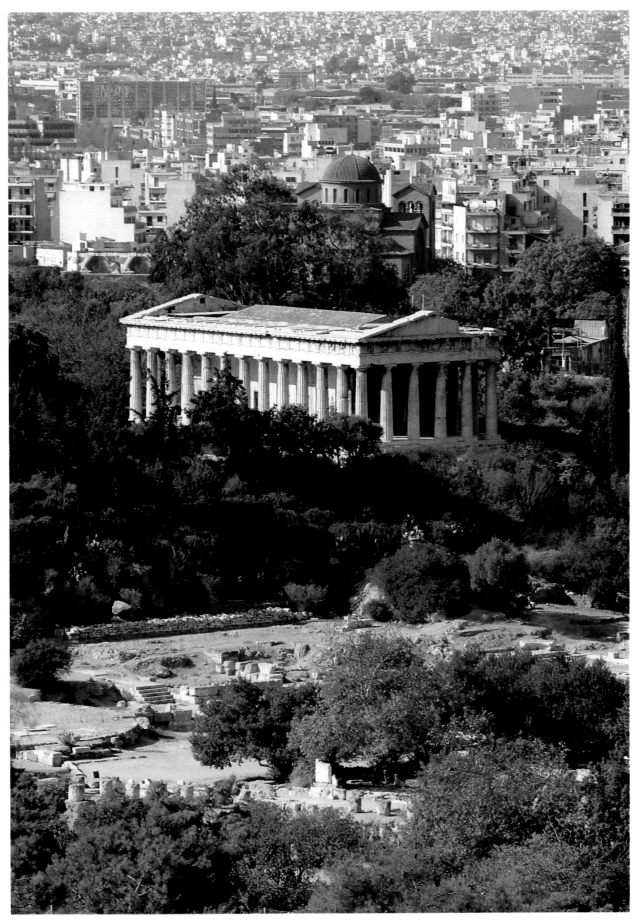

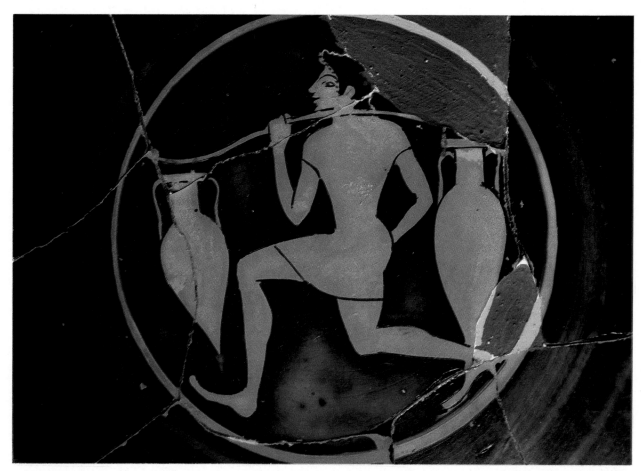

Agora Museum: interior of a red-figured cup, depicting the carrying of the amphoras (510 BC).

Odeion of Herod Atticus.

Theatre of Dionysos Eleutherios.

AGORA

The ancient main square of Athens, the hub of public and administrative life, covered a vast area at the foot of the Acropolis, divided by the **Panathenaic Way**, where the solemn festivities in honor of Athena, depicted in the Parthenon frieze, were celebrated. Originally closed in by **porticoes** such as that of **Attalos II**, king of Pergamon, rebuilt by the American Archaeological School (1953-1956), the *Agora* in antiquity was gradually filled with monuments to the point that during the Roman era it became necessary to build a second *forum*.

The center of the *Agora*, which is dotted with temples, altars and sanctuaries, is occupied by that complex which includes the ruins of the *Odeion*, a small building with a 1000-spectator capacity, in which concerts were held. Semicircular in form and enclosed by a two-story portico, it was built in 15 BC by M.V. Agrippa, Augustus' son-in-law, and decorated in the 2nd century AD with the addition of four statues of Triton and the Giants, still in place. After its destruction by fire, it provided the foundations for a *gymnasium* erected in 400 AD.

The *Agora* is dominated by one of the best-con-

served buildings of ancient Greece, the **Temple of Hephaistos** (improperly called the Temple of Theseus or Theseion) dating to the Periclean era, with 6 columns at each end and 13 down each side and adorned with metopes and friezes depicting the exploits of Theseus. The **Museum**, located in the spacious reconstruction of the *Stoa of Attalos*, houses the finds from the excavations in the area; besides a number of curiosities and masterworks of sculpture and ceramic art, the collection is of note for the rigorously chronological ordering of the exhibits.

THEATRE AND ODEION

On the south slope of the Acropolis is the precious *Odeion*, in which performances are still held, donated to Athens by the rich Herod Atticus in 161 BC in memory of his wife Annia Regilla; it is connected by a portico to the imposing **Theatre of Dionysos Eleutherios** (15,000 seats) erected in 534 BC in honor of the god Dionysos, whose cult was imported from *Eleutherai* and in whose honor the *Great Dionysiac Festivals* were held.

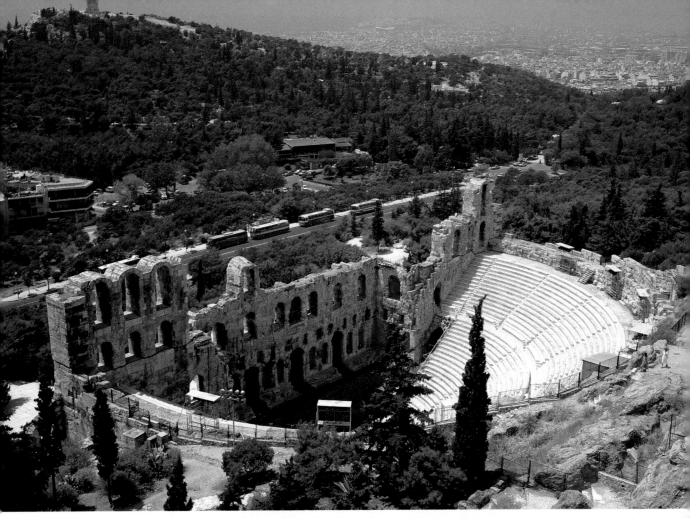

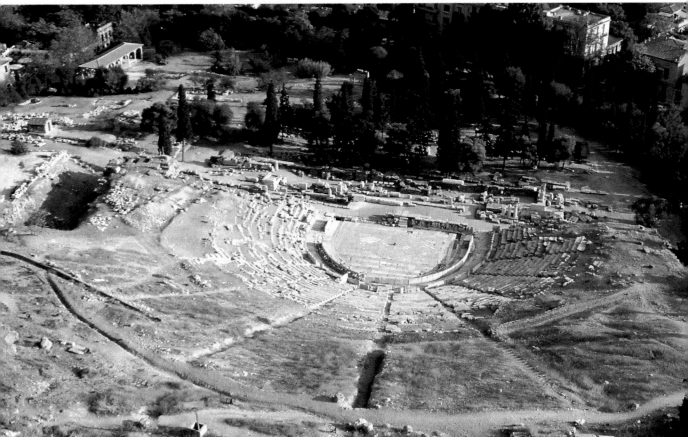

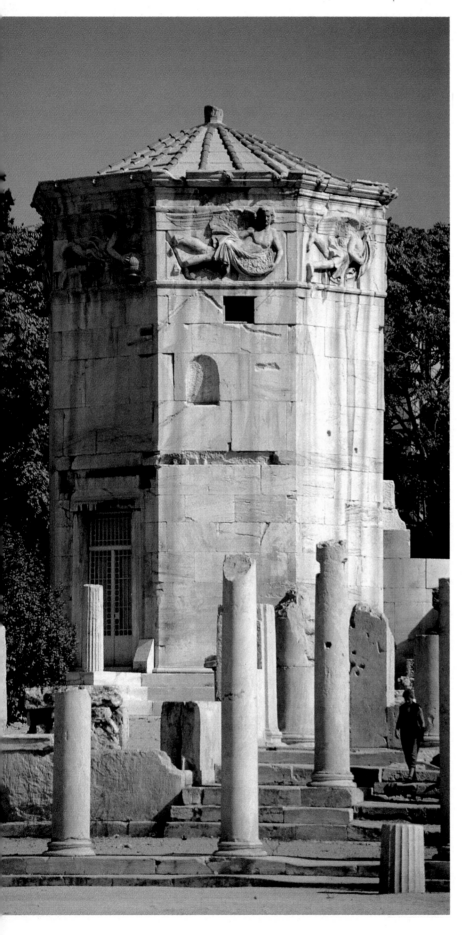

ROMAN FORUM

A second *agora* was built during Roman times at the foot of the north slope of the Acropolis, since the Greek square had become unusable due the number of monuments that had been erected there. The rectangular space, surrounded by columned porticoes with shops, had two **entrances**. The west entrance is a monumental Doric gate, erected between 12 BC and 2 AD (on the rear of the pediment is engraved one of Hadrian's laws regarding the oil reserved for the State). On the north side, which looks toward the immense library donated to the city by Hadrian, there rises the **Tower of the Winds**, the name given by tradition to the tower housing the great hydraulic clock built by Andronikos of Kirrhos in the first century BC.

TOWER OF THE WINDS

A harmonious octagonal building in Pentelic marble, with a lowered pyramidal roof, the **Tower of the Winds** takes its name from the reliefs sculpted at the top of each face portraying the personifications of the eight principal winds, identified by inscriptions. Inside, a hemispherical cupola on columns, the ashlared walls, the corbels and the numerous cuts in the stone blocks testify to the complicated system of wooden gears which drove the public hydraulic clock.

Roman Forum: Tower of the Winds.

PNYX

The Pnyx hill was used, between the 6th and 4th centuries BC, as a site for popular assemblies. Its present-day appearance dates to the restoration work under Lycurgus, with a semicircular terrace supported by a Cyclopean wall; the remains of an *altar to Zeus Agoraios*, protector of the Assembly, as well as those of two *porticoes* and the foundations of the astronomer Methon's *sun dial*, the oldest public clock in Athens (433 BC), are also visible.

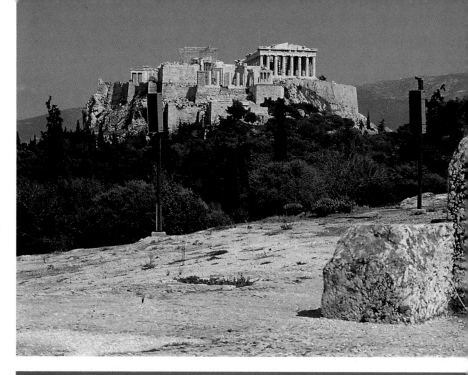

HILL OF THE MUSES

The Hill of the Muses, also known as the *Mouseion* or Philopappos Hill, which offers one of the most enchanting views of Athens all the way down to the sea, was originally dedicated to the cult of the Muses; one of the highest of the hills surrounding the Acropolis, it was fortified by Demetrios Poliorcete in 294 BC.
Today, besides the scarce remains of the fortress and a dwelling cut into the rock, called **Socrates' prison**, there stand on the hill the remains of the monument erected between 114 and 116 AD in memory of the Roman consul **C. Julius Antiochus Philopappus**, prince of the Syrian Commagen dynasty and benefactor of Athens. Of the monument there remains a portion of the semicircular elevation in Pentelic marble, the base of which is decorated with a frieze depicting Philopappus on the consular chariot; in the upper niche at the center is a seated statue of the naked Philopappus in a heroic pose.

Acropolis: View of the Pnyx.

Monument to C. Julius Antiochus Philopappus.

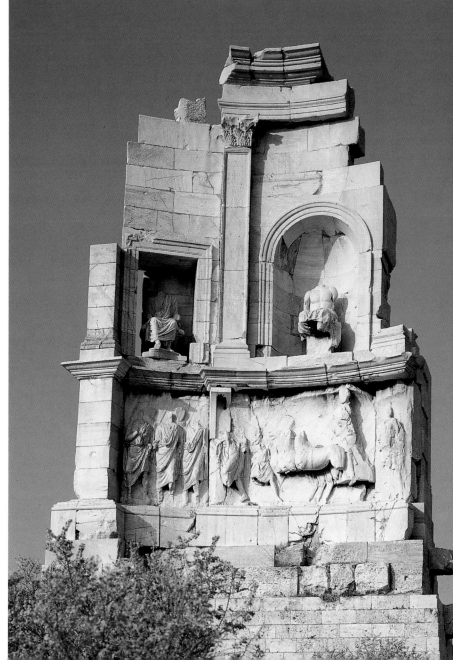

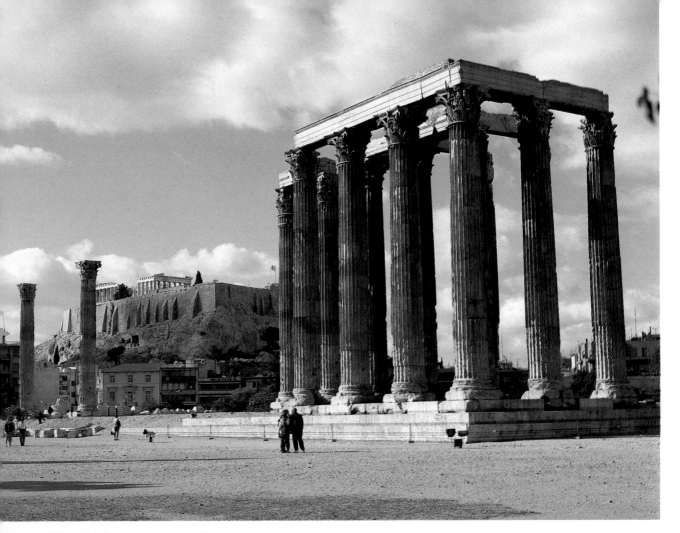

The Olympieion and Hadrian's Gate.

OLYMPIEION

Not far away rise the ruins of antiquity's largest temple, the *Olympieion*, in Corinthian style with two rows of 20 columns each on the sides and three rows of 8 columns each on the ends; begun under the Peisistratids, work on the temple dedicated to Olympian Zeus was abandoned after the fall of the tyrants and taken up again only in 174 BC by the king of Syria Antioch IV, who entrusted construction to the architect Cossutius; at the king's death (163 BC), the temple was again abandoned, and Sulla, after the sack of 86 BC, took some of its columns to Rome for the temple of the Capitoline Jupiter. Work was resumed under Hadrian, who in 129 AD consacrated the yet unfinished temple.

HADRIAN'S GATE

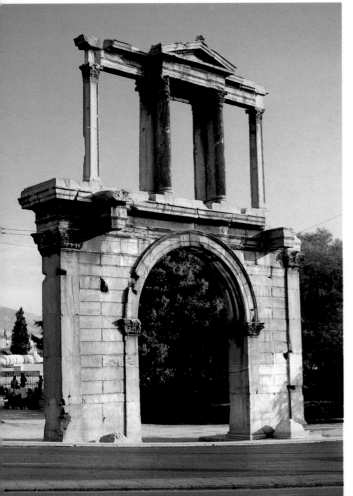

Between 125 and 138 AD, the Emperor Hadrian enlarged the city and marked the boundary between the old and the new parts with an arch, the vault of which carries an explanatory **inscription**: on the side facing the Acropolis, *"This is Athens, the ancient city of Theseus"*, and on the other, *"This is the city of Hadrian, not of Theseus"*. The monument is built of Pentelic marble; the supporting arch is surmounted by three aediculas and Corinthian decorative elements.

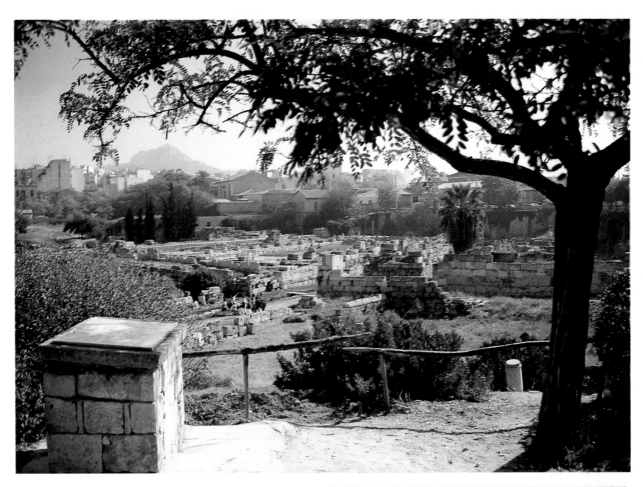

View of the Kerameikos.

Choregic monument of Lysicrates.

KERAMEIKOS

The Kerameikos, the vast area embracing the ancient **necropolis of Athens**, scattered with tombs and sumptuous private and public funerary monuments, the sculptures from which are displayed in the National Ceramics Museum, takes its name from the many potters' workshops installed there due to the presence of watercourses, needed for their activity, and from the custom of using vases as grave goods. The area, which was naturally located outside the city center, is near the *Dipylon*, the double city gate built by Themistocles in 479 BC.

LYSICRATES' MONUMENT

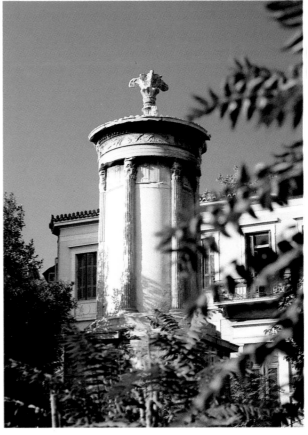

At the foot of the Acropolis, in the **Pláka**, near the Church of Saint Catherine, there rises the *Monument* erected by Lysicrates in 334 BC in memory of the victory of the authors he had sponsored in a theatrical contest. A high square base supports a circular aedicula with 6 Corinthian columns and a roof consisting of a single marble slab with a Corinthian capital which supported the tripod, the victory prize. Above, a frieze of tripods and Dionysos punishing the pirates who had attacked him.

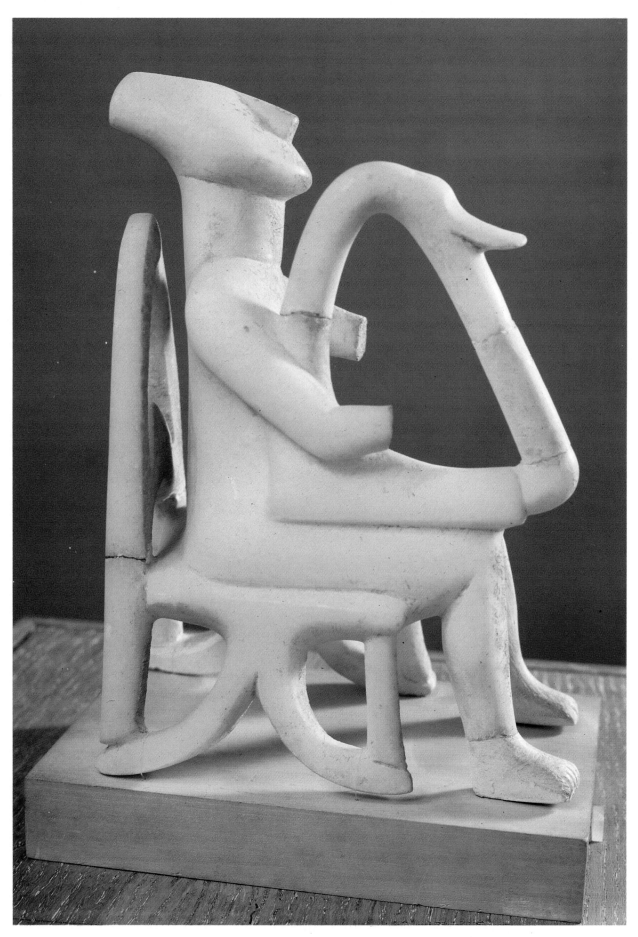

NATIONAL ARCHAEOLOGICAL MUSEUM

The most extensive collection of evidence of the civilization of ancient Greece opens with a vast section dedicated to prehistorical times: the first room in the museum is in fact the imposing **Room of the Mycenaean Excavations**, rich in treasures and true masterworks recovered since 1876 from the royal tombs discovered in Mycenae by E. Schliemann and from other sites from the same period. We are struck by the finely-chiselled ivories and the gem-struck swords showing hunting scenes, but above all by the gleam of the gold of the funerary masks, of the *Vapheio Cups*, of the women's jewelry and ornaments; but no less attractive are the ceramic vases with their rich floral decoration, the sculptures and the containers in various semi-precious stones. It would be impossible to list each single object, since the visitor will discover in each showcase a curiosity or a jewel worthy of his attention. To the left of the central hall is found the **Helladic Section** (4th through 1st millennium BC), home to the collection of *archaeological finds from Sésklo and*

Cycladic figure of a harpist, from Keros.

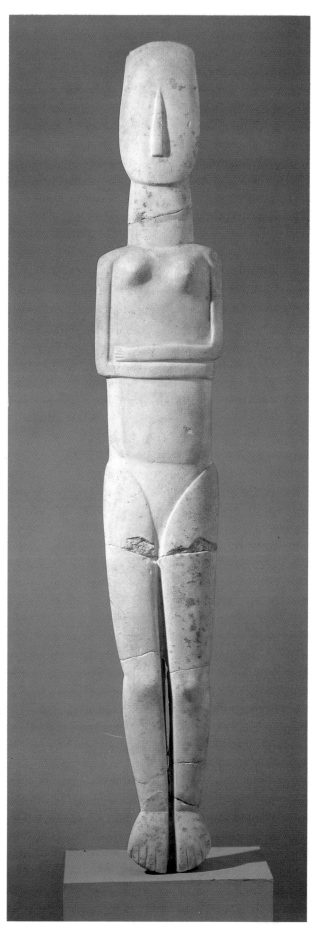

Female Cycladic figure, from Amorgós.

Cycladic "violin" figure.

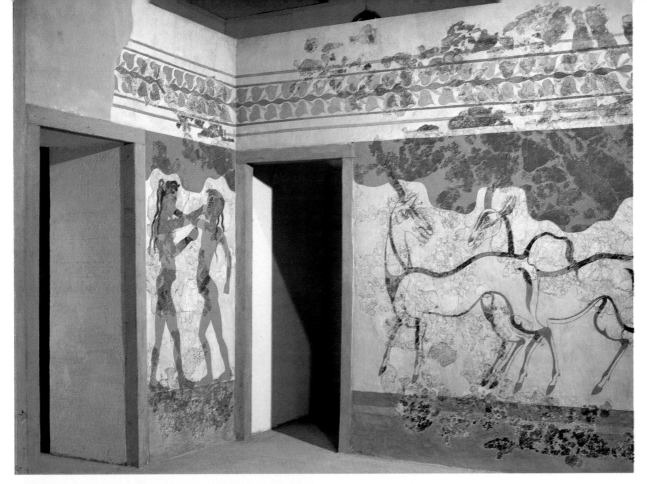

Minoan frescoes from Thera (Santorini): reconstruction of the room with boxing youths (on the right, antelopes); below, "The Fisherman".

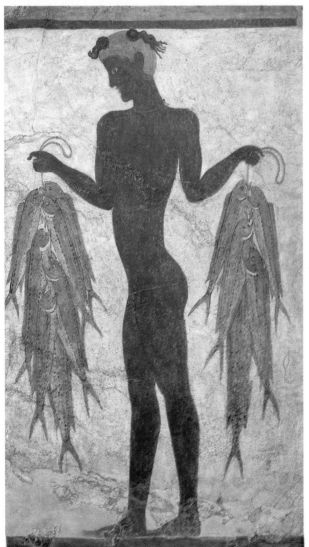

Dimíni, sites which have given us the first painted ceramics in the Mediterranean area. On the opposite side, the Cycladic section dedicated to the pre-history of the islands, abounding in idols, vases and sculptures in marble. Next are the **Rooms of Archaic Sculpture**, dominated by the great *kouroi*, funerary and votive statues of youths in the flower of their lives found in all the principal sanctuaries of Greece. True masterworks of an art that evolved only near the end of the 7th century BC, that of the great statues, these finds document the activities of the different schools: from the rigor of the Attic style, with the *Head and Kouros of Sounion* (compare the body structure with the figures painted on the great funerary amphora in Room 7), to the gentility of that of the islands and eastern Greece (*Kouros of Melos, Kore of Nikandre*) to the provincial character of that of Boeotia (*steles of Dermis and Kitilos* embracing, from Tanágra). Among the sculptures of mature Archaic art (late 6th century), of note are the *Kouros of Volomandra*, the painted stele of the hoplite Aristion, by Aristokles (510 BC), the *kouroi* from the sanctuary of Ptoon in Boeotia, the funerary statues of *Kroisos* (Croesus, the great sovereign of Lydia) and of *Aristodikos*, and the statue base with scenes of physical exercises, later incorporated in Themistocles' wall. A large portion of the museum is dedicated to the **sculpture of the Classical period** (5th-4th centuries BC), a collec-

Painted stucco head (Sphynx), from Mycenae.

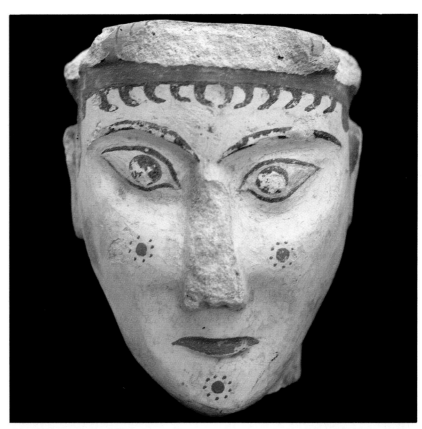

Krater of the Warriors, from Mycenae (late 13th century BC).

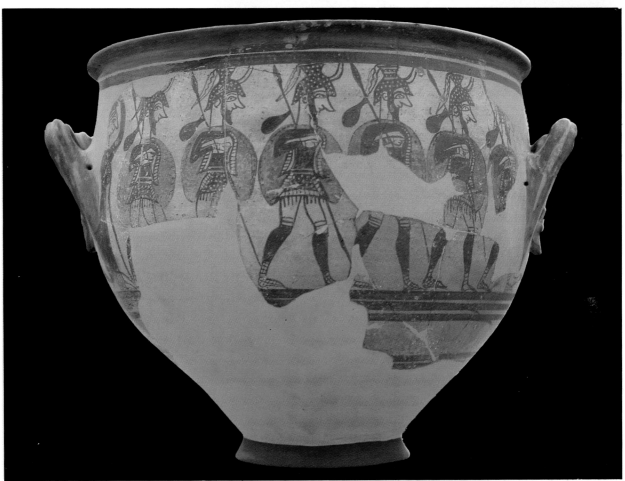

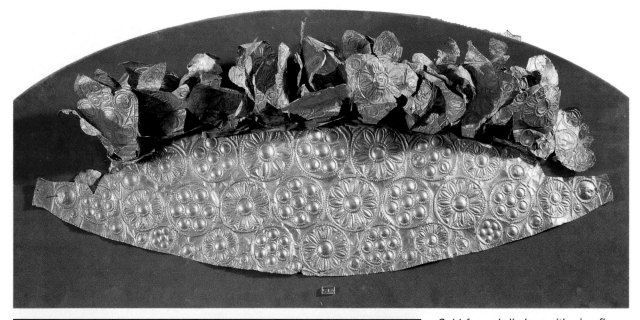

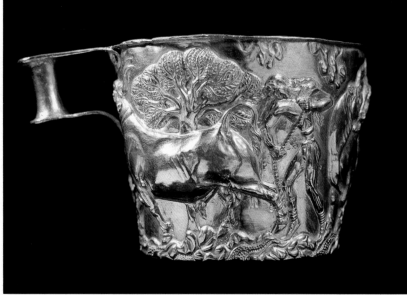

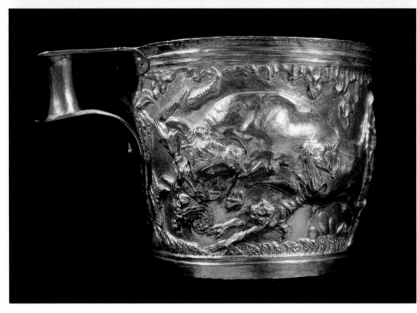

Gold funeral diadem with nine flower calyxes, from Mycenae.

Gold cup with the capture of the bulls, from the tomb at Vapheio in Lakonia (ca. 1500 BC).

Kouros from Sounion (600 BC).

Statue of Kroisos from Anavyssos (530 BC).

tion of true Greek masterpieces and Roman copies of the lost originals. Of note are the *Apollo of the Omphalos*, a copy of a bronze original attributed to Kalamides (460 BC), exemplary for the interior harmony it expresses; the great *Eleusinian Relief*, from Pheidias' studio, showing Demeter and Kore (Persephone) presenting the sheaves to the young Triptolemos that he may teach humanity the art of cultivating wheat; the large statue of *Poseidon* throwing his trident, an original bronze by Kalamides (or perhaps by Onatos of Aegina), recovered from the waters off Cape Artemision in Euboia. Among the many funerary monuments, steles and marble *lekythoi*, that of *Hegeso*, from 420-410 BC, with its intense portrayal of the deceased woman and a slave girl handing her for the last time her jewel casket.

In the **central room**, adjoining the Mycenaean room, the celebrated *Jockey of Artemision*, a Hellenistic bronze of considerable realism, seated on the *horse* that was recovered from the sea together with the boy but which may not be his.

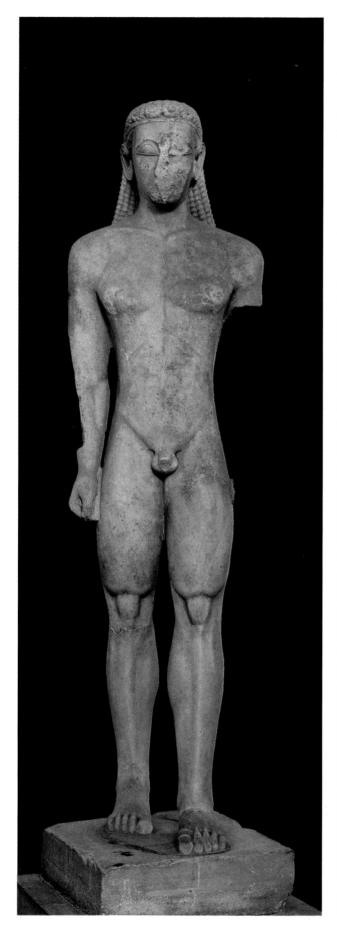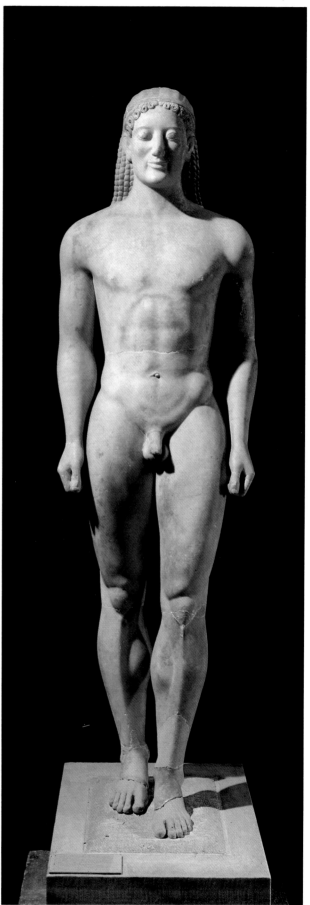

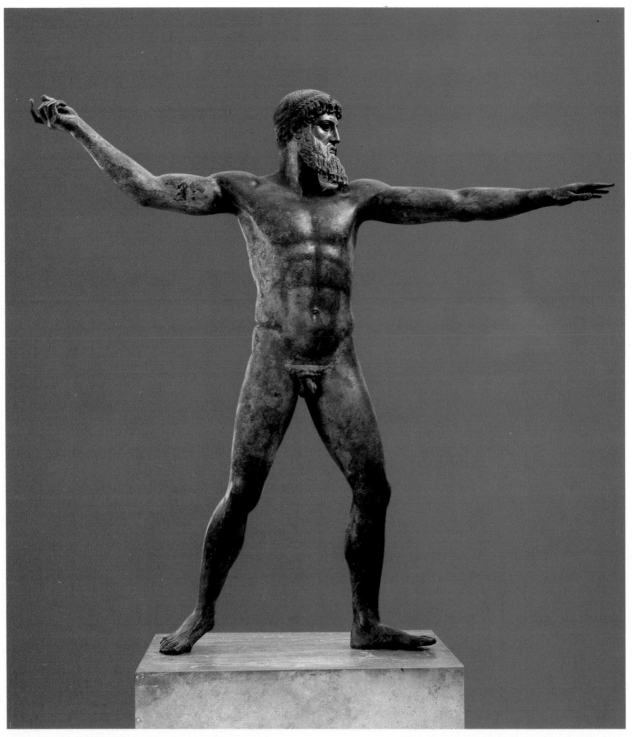

The "Artemision Poseidon", Greek original, ca. 460 BC.

Horse with young rider, from Cape Artemision (ca. 150 BC).

"Ephebe of Antikythera", bronze original (340 BC).

Votive relief from the Sounion, with a young athlete crowning himself (460 BC).

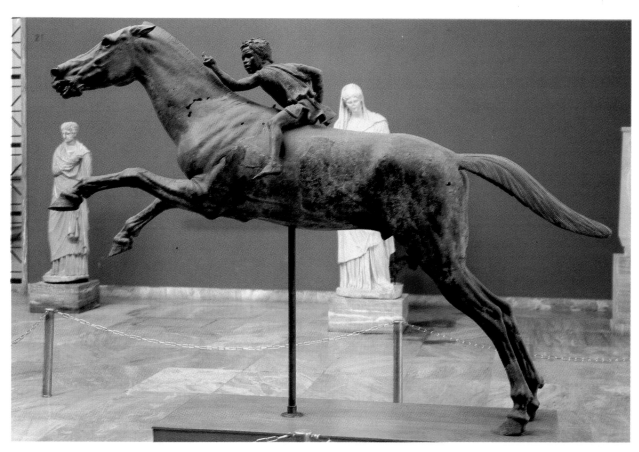

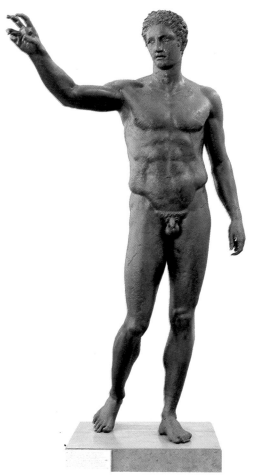

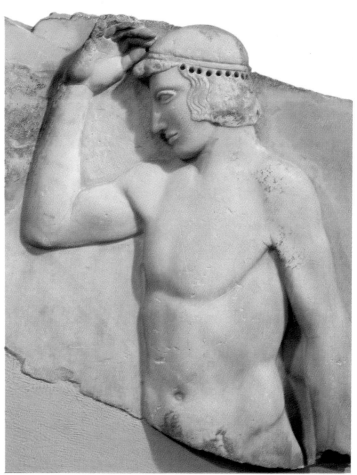

In the same room is the *Diadumenos*, a Roman copy of a famous statue by the great Polykleitos, and the Roman copies of two female statues by Lysippos known as the *Large* and *Small Herculanese Women* after the examples recovered at Herculaneum. The sculpture of the 6th century BC continues with the rooms dedicated to the funerary reliefs of the age and to the decorations sculpted for the temples of *Athena Alea* in Tegéa and of *Asklepios* in Epidauros, works by Scopas and Timotheus. The large bronze statue known as the *Ephebe of Antikythera*, recovered from the sea off that small island at the southern extremity of the Peloponnese, is an important original sculpted by Euphranore, dating to 340 BC. The position of the arm and the hand suggests it may be representative of Paris giving the golden apple of his judgement to Venus. Among the **Hellenistic sculptures**, of note are the statue of *Themis*, goddess of law and of order, sculpted by Chairéstratos in 280 BC for the Ramnous sanctuary; the reliefs on a *statue base from Mantineia*, showing Apollo, Leto and Artemis, of the school of Praxiteles; and the colossal *Poseidon of Melos*, dating to 150-100 BC.

An important **selection of bronze statues** is found in the room housing the *Carapanos Collection*; following are the rooms containing Roman art and the jewels of the *Stathátos Collection*. On the **upper level**, the exceptional *frescoes of Thera*, including the lively scene of the fist-fight between two youths, the harmonious pair of antelopes and the young man showing off the fish he has caught, all in brilliant color; and the section illustrating the development of **Greek ceramics** from ca. 1000 through 300 BC, from the austerity of Geometric decoration through the realism of the black-figure and the red-figure techniques to the exclusively funerary, white-background vases.

White-background lekythos (funerary ampulla) showing the tomb of a warrior, his ghost and a woman visitor.

BYZANTINE MUSEUM

The Byzantine Museum, in an Italian-style villa built for the Duchess of Piacenza, houses one of the world's most important collections of **painted icons**, thanks to which we can appreciate the development of the cultured and refined art that flourished in Constantinople under the Palaiologos dynasty (13th-15th centuries) and spread rapidly to Greece and the nearby kingdoms of Serbia, Bulgaria and Russia, reaching as far as Italy and France, where it influenced Gothic painting. On the ground floor are reconstructions of the interiors of *paleo-Christian* (5th-6th centuries AD), *Byzantine* (10th century) and *post-Byzantine* churches, each with its decorations, among which are worth note the precious *episcopal pulpit* of the paleo-Christian sanctuary, pieced together from carved marbles, the bas-reliefs of the Byzantine reconstruction and the sumptuous post-Byzantine *iconostasis*. On the first floor, the imposing display of icons, including true masterworks from the 12th through the 15th centuries, and the rooms containing frescoes and illuminated manuscripts.

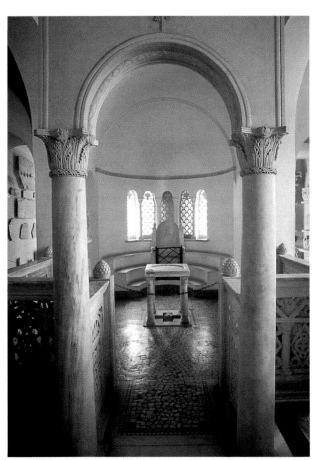

Byzantine Museum: reconstruction of a paleo-Christian church.

Saint George and scenes from his life.

Crucifix.

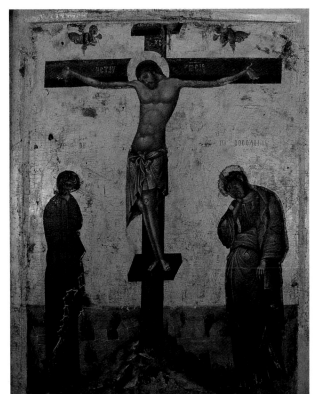

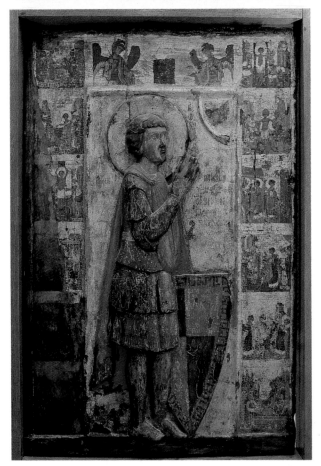

THE MODERN CITY

The modern capital is an immense agglomerate of cement buildings, more often than not lacking exterior stucco, which create a seemingly endless "suburb" around the Acropolis, enlivened by chaotic traffic. A few **neo-Classical buildings** which survived the uncontrolled post-war reconstruction (dating above all to the period following military dictatorship) stand out in this panorama, as do certain areas of today's suburban neighborhoods with their luxurious private homes surrounded by gardens (*Kifissiá*).

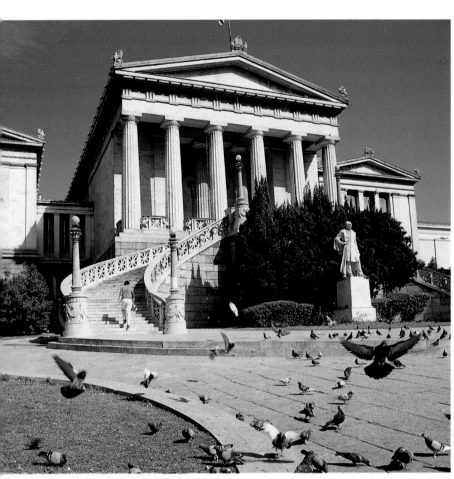

The changing of the guard at the Monument to the Unknown Soldier.

The Zappeion Hall.

Athens. Neo-classical building.

Cathedral (Megalí Mitrópolis).

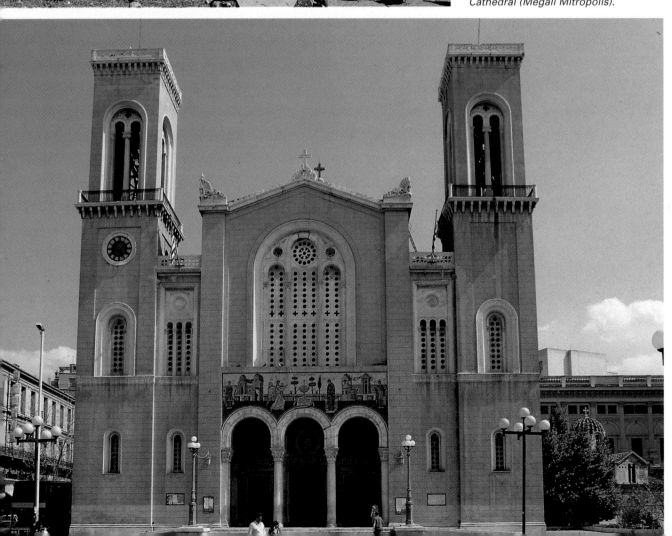

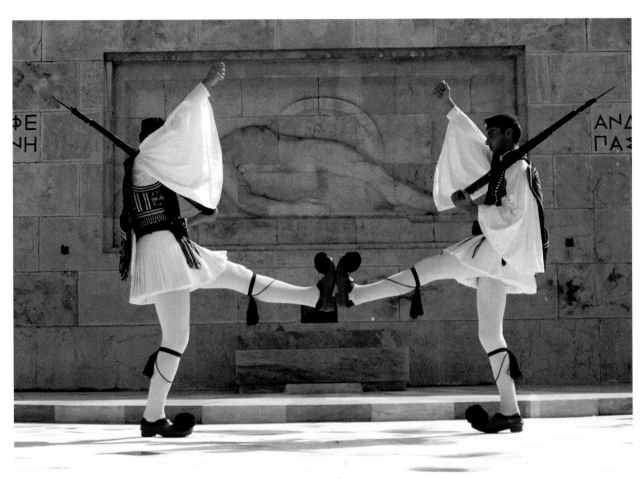

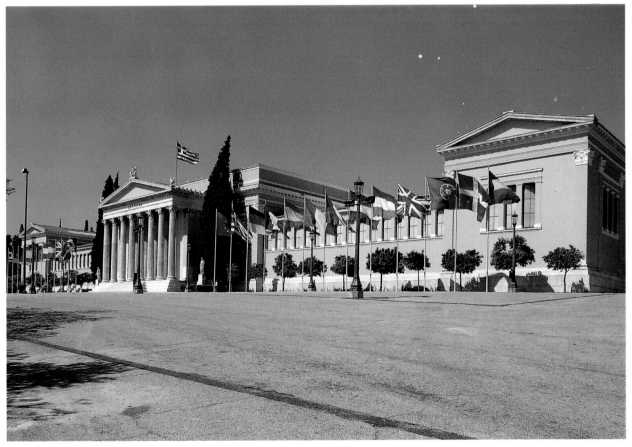

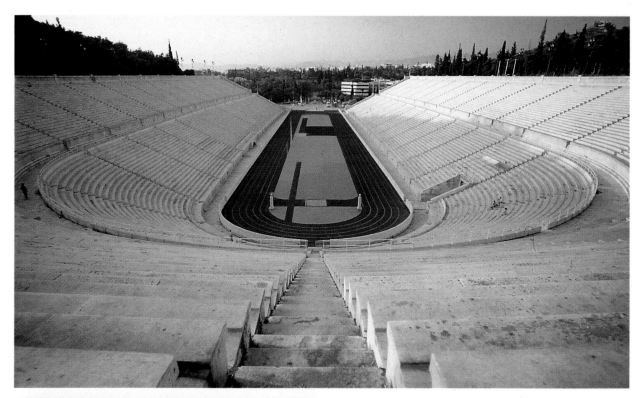

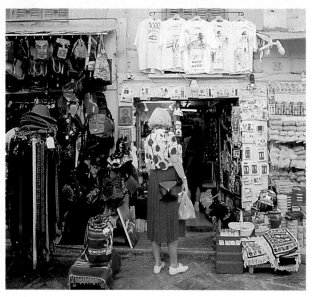

Today's Olympic Stadium, re-built on the site of the
ancient stadium.

Typical, picturesques scenes in the Plaka.

The most significant examples of modern architec-
ture are to be found around the central **Síndagma
Square**, overshadowed by the House of Parliament,
in front of which are stationed the famous *Evzoni*
("beautiful sash") soldiers, whose rhythmical, almost
acrobatic changing of the guard at the *Monument to
the Unknown Soldier* is quite spectacular. Little
remains of Turkish domination, most testimony to
which was comprehensibly erased, with the excep-
tion of the **Pláka**, the characteristic popular neigh-
borhood with its lively markets, tavernas and tourist
shops, in which the ancient layout of narrow wind-
ing streets has not changed. On the edge of the
Pláka, the minuscule Old Metropolitan cathedral
(*Mikrí Mitrópolis*), an example of 11th-century
Byzantine architecture wearing precious vestments
in the form of reliefs and fragments of ancient
works; next door, the New Metropolitan cathedral
(*Megáli Mitrópolis*), a grandiose building in neo-
Byzantine style dating to between 1840 and 1855.
The vast **Zappeion Park**, named after the Záppas
brothers who donated the land to the city together
with the large neo-classical building that rises at its
center, used for expositions and exhibits, is one of
the few green areas in modern Athens. Nearby, the
Olimpiakos stadium, rebuilt on its original plan by
de Coubertin in 1896 for the first modern Olympics
on the exact site of the ancient stadium begun by
Lycurgus in 330 BC and completed by Herod
Atticus in 140 AD.

PIRAEUS

By the 5th century BC, Piraeus, with its three natural harbors (*Kantharos*, *Zéa* and *Mounychia*), had become the principal port of Athens (replacing the old Phaleron) and one of the most important and active on the entire Mediterranean. Piraeus was strengthened by Themistocles during the Persian Wars and fortified by Cimon and Pericles, who built the Long Walls (an enclosed, fortified passage connecting Athens with her port). The city also became famous for the rational planning scheme implemented by the architect Hippodamos of Miletos, who in the mid-5th century BC subdivided the city into blocks of equal size with parallel cross-streets, a model which immediately spread through the entire Mediterranean world. Suffocated by the power of Sparta, winner of the Peloponnesian War and well aware that Piraeus' wealth depended on Athens, the port languished until Konon defeated the Spartans at Knidos in 394 BC and re-built the *Long Walls* and the *arsenals*.

Between 346 and 329 BC, Lycurgus completed the work of reconstruction and expansion with the *long portico* for equipment, built by the architect Filon along the port of Zéa. Seat of the Macedonian contingent that installed itself in the Mounychia fortress and then sacked by Sulla in 86 BC, Piraeus remained a village of no importance until the second half of the last century, when industry and the shipyards began to develop. Although the archaeological remains are few (lengths of the Long Walls and a sanctuary near Ipodamias Square), it is worthwhile visiting the **Archaeological Museum** near the **Hellenistic theatre** of Zéa (2nd century BC). Among the many works displayed in the museum are the important *bronze sculptures* buried by collapsing buildings before they could be shipped to Rome, among which the *Apollo* and the *Piraeus Artemis*, as well as the series of *marble slabs*, recovered from the sea, that repeat the scenes sculpted by Pheidias on the shield of Athena Parthénos.

View of Piraeus with its three ports.

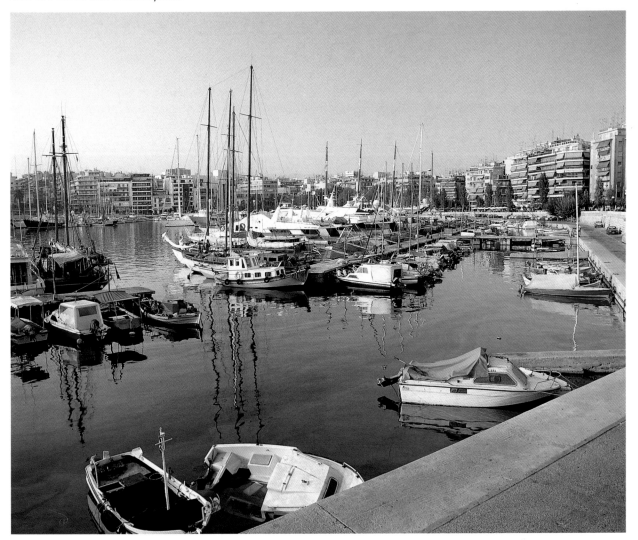

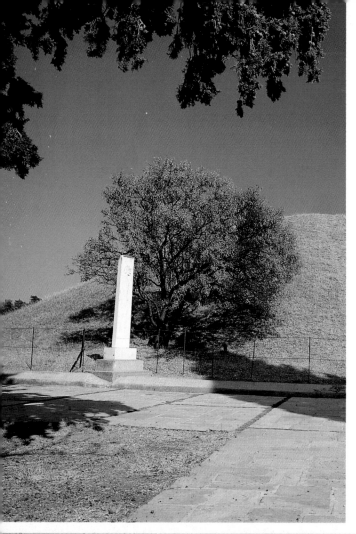

MARATHON

In 490 BC, on a deserted, swampy plain, Darius' Persian and the Athenian armies engaged in battle. The Athenians, although inferior in number, succeeded in repulsing the attack. Tradition has it that to announce the victory an Athenian soldier ran the 40-plus kilometers to Athens, thus making the name of *Marathon* forever synonymous with long-distance foot-racing. The *Marathon barrow (Timvos Marathóna),* raised over the Athenians who fell in the battle, is still standing. Nearby, next to the Barrow of the Plataians, Athens' allies, is a small **Museum**.

RAMNOUS

On a spur of the Attic coast, across from the island of Euboia, the Athenians erected a **sanctuary dedicated to Nemesis** (goddess of Divine Retribution) and a **fortress**, the imposing remains of which still stand on the sea, dominating the *Euripos* channel. In the sanctuary, on a stone peribolos, is the small *temple of Themis* (goddess of Justice), with two columns on the front (late 6th century BC); and the *temple of Nemesis* (436-432 BC), with 6 columns on the ends and 12 along the sides, which was never finished (the columns are not grooved) due to the outbreak of the Peloponnesian War.

Marathon: Barrow of the Greeks who fell
in the battle of 490 BC.

Ramnous: Temple of Nemesis.

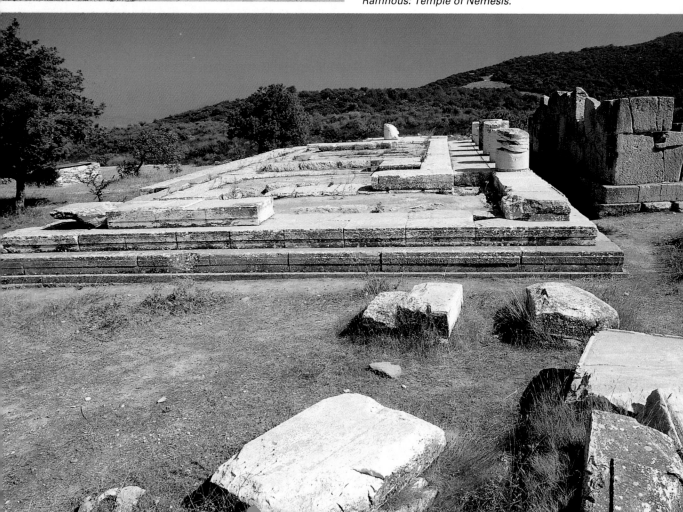

BRAURON

The Brauron sanctuary, one of the most relaxing and peaceful of the archaeological areas of Attica, immersed in the green landscape not far from the coast, was one of the most renowned places of worship of Artemis as the goddess of parturients. Founded to expiate the killing of a bear, an animal sacred to the goddess, the sanctuary took in young girls, some of whom blind, who became priest-esses and took the name of *Arktoi* ("little bears"). In the sanctuary, which would have been the place of refuge of Iphigenia, saved by Artemis from the sacrifice for which her father Agamemnon had destined her, a rare **bridge** of the Classical era leads to the wide **Doric portico** with its rooms for the Arktoi and the pilgrims; on the rocky rise where today there stands **Saint George's Chapel** (15th century, remains of frescoes) are the founda-tions of the temple erected in the 5th century BC after the ancient temple was destroyed by the Persians, who carried the cult statue off to Susa. Near the temple, in a cleft in the rock, are the remains of other holy places, including, as tradi-tion has it, the tomb of Iphigenia. Nearby, the **Museum**.

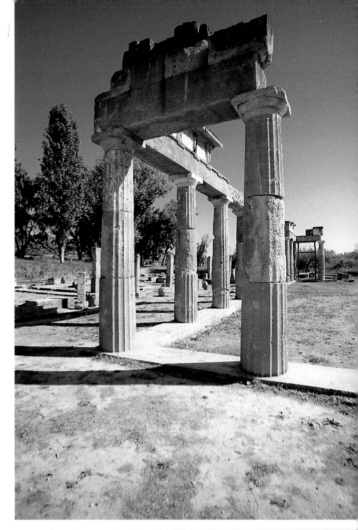

Brauron: view of the Doric portico.

Cape Sounion: Temple of Poseidon.

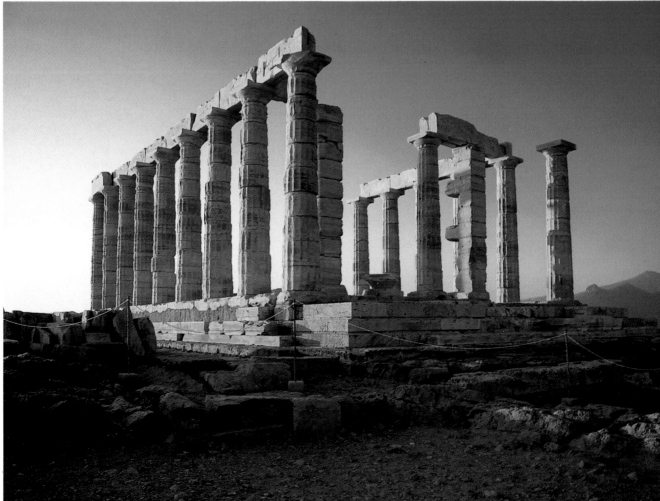

CAPE SOUNION

Following the road south from Athens along the enchanting Attic coastline with its jagged inlets, we reach Cape Sounion, at the tip of which rises the most famous monument in Greece after the Parthenon: the **Temple of Poseidon**. Besides the remains of the walls fortified in 409 BC for the Peloponnesian War and of the small propylaia leading into the sanctuary, there still stand the 16 tall, graceful columns of the temple that at sunset take on the romantic colors admired even by Lord Byron, who cut his name into the north pillar of the naós. Built in 444-440 BC by the same architect responsible for the Temple of Hephaistos of the Athenian *Agora* and the temple of Nemesis at Ramnous, it had 6 columns on the ends and 13 on the sides, each with 16 grooves instead of the usual 20 to provide better resistance to erosion by the sea elements, and a frieze sculpted on the architrave showing exploits of Theseus, the Gigantomachy, and Centaurs and Lapiths in battle. On the facing hill, the remains of the **Sanctuary of Athena Sounios**.

ELEUSIS

The place most sacred to Demeter, who had been the guest of King Keleos there during her pilgrimage in search of her daughter Kore (Persephone or Prosperine), abducted by Hades, Eleusis became the most-celebrated **mysteric sanctuary** of the ancient world and one to which access by non-initiates was punishable by death.

The large and complex archaeological area, surrounded by mighty walls, opens with a paved square delimited by *porticoes*, with the *Temple of Artemis and Poseidon* at its center. The **Great Propylaia** built by Antoninius Pius (138-161 BC), imitations of those of the Athens Acropolis, lead to the sanctuary and the great *Telesterion*, the colonnaded hall of initiation and mysteric worship of the goddesses Demeter and Persephone who, in gratitude to King Keleos, had taught his young son Triptolemos the principles of fertility and through him presented the sheaves of wheat to mankind. The **Museum** adjacent to the excavations merits a visit.

Eleusis: the Great Propylaia leading into the sanctuary of Demeter.

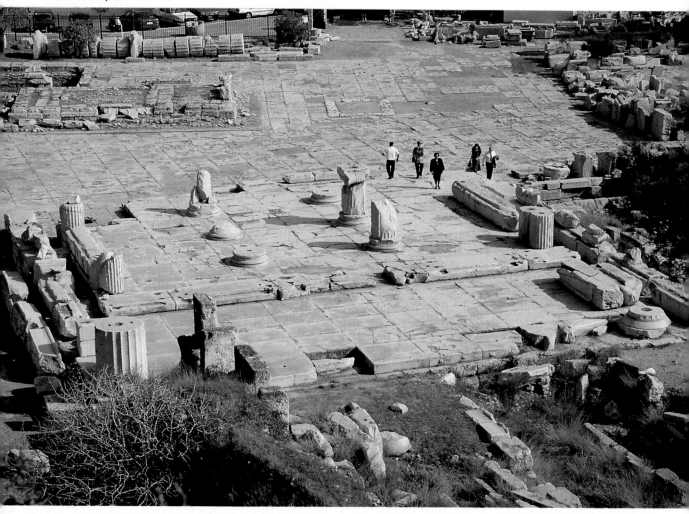

KESSARIANÍ

In a shady valley, among pines and cypresses, on the slopes of Mount Hymettos, alongside a spring of curative waters mentioned by Ovid in the *Art of Love* (of which the mouth, in the form of a ram's head, remains), is found the Kessarianí Monastery with its suggestive **Church of the Annunciation** of the Virgin, a small building erected in the 11th century on Greek cross foundations and with a central cupola and 16th-century frescoes (*Christ Pantocrator* in the cupola, the *Tree of Gethsemane* and *Apostles* on the north wall, and scenes from the life of Christ between the apse and the transept). The bell-tower, the side chapels to the right of the church, and the narthex, decorated with frescoes in 1682, are 17th-century additions.

In a valley at about 10.5 kilometers distance, to the left of the road, is another small religious complex immersed in the silence of the green woods: the **Asteri Monastery**, with its church dating to the 11th century and *frescoes* from the 16th century.

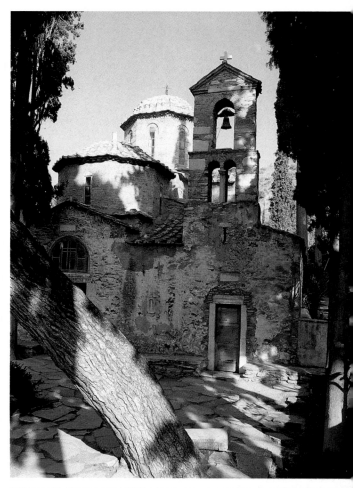

Monastery of Kessarianí: Church of the Annunciation of the Virgin.

Portico of the monastery.

Kessarianí: fresco of Christ Pantocrator, in the cupola.

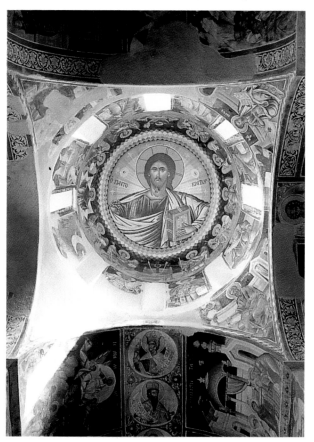

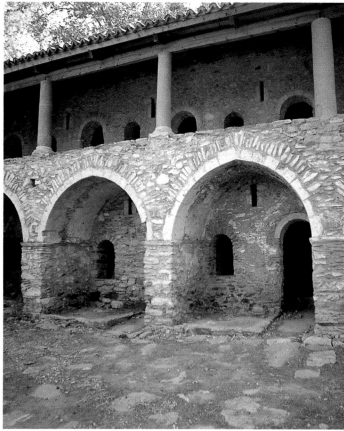

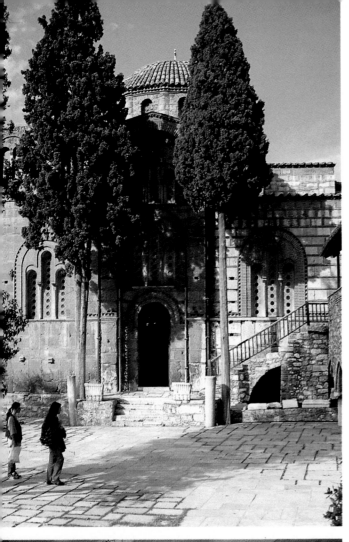

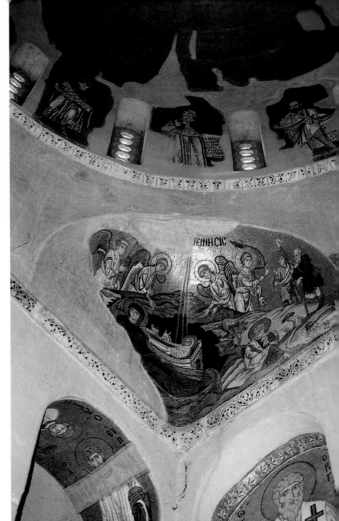

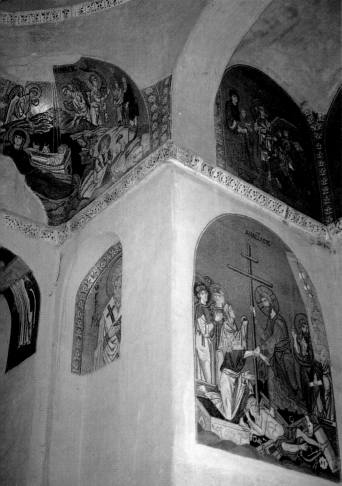

Daphne: View of the church.

Daphne: Mosaics on the right pendentive
of the cupola (Nativity).

Daphne: Mosaic of the Resurrection of Lazarus,
in the chancel entrance.

Daphne: Mosaic in the cupola, with Christ Pantocrator.

DAPHNE

Along the Holy Way which led from Athens to the
Eleusis sanctuary, facing the remains of an **area
sacred to Aphrodite** with votive niches cut into the
rock, is the Daphne **monastery**, consecrated to the
Dormition of the Virgin, which takes its name from the
laurel trees (*dáfni*) that grew there and were sacred to
Apollo, whose temple, on the same site, was destroyed
in 395 BC. Enclosed by a wall and towers (late 5th to
early 6th century AD), the monastery buildings, origi-
nally Cistercian and then Orthodox, include the often-
reworked *church*, preceded by the 11th-century
narthex (restored in the 13th century) and, on the right,
the small Cistercian *cloister* with its low Gothic arches
(re-built). The interior, on the Greek-cross plan and
with a central cupola on pendentives, is decorated with
beautiful polychrome **mosaics** on a gilded background
in full-blown Byzantine style (late 11th century) domi-
nated by the imposing figure of the *Pantocrator* in the
cupola. In the narthex, scenes from the *Life of the
Virgin* and her *"Dormition"*, prelude to the Ascension.

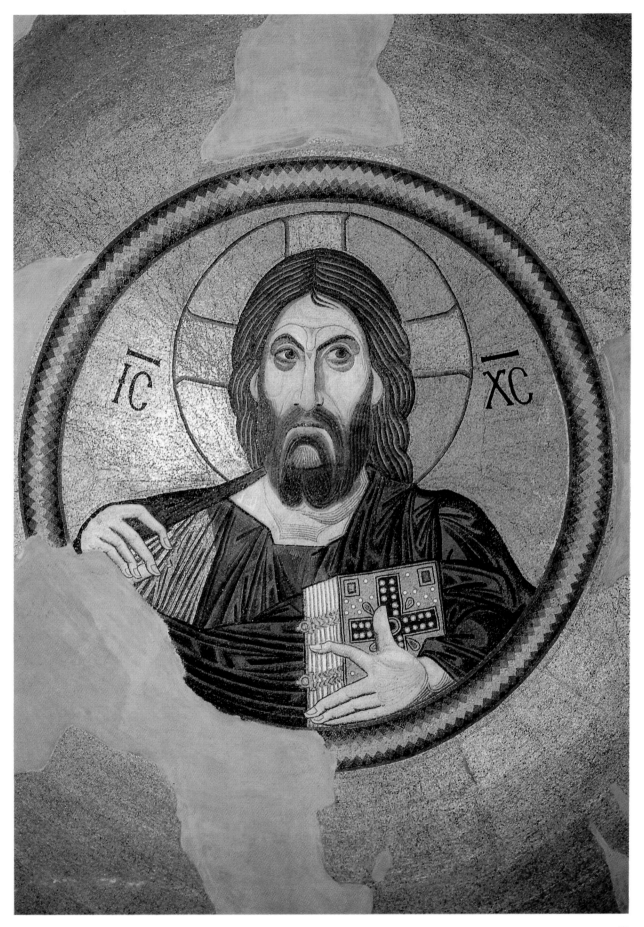

43

THEBES

Very little remains of the once-great Thebes, capital of Boeotia, cradle of the Muses, home to the Sphinx and theatre of the great mythical events involving Oedipus, Electra and Orestes that inspired the most famous of the Greek tragic poets, including Aeschylus, Sophocles and Euripides. The city, today an isolated provincial center, conserves but a few elements of Medieval architecture and limited remains of its great past. Tradition has it that on the **acropolis** (called the *Cadmea*) once stood the palace of King Cadmos, husband to Harmonia. At the very highest point of the city (*Pindar Street*) there has been brought to light a *hall* with smaller adjoining rooms, dating to 1450-1350 BC and destroyed by a fire in about 1200 BC.

Dirkis Street leads to the valley of the ancient Ismenos River, in which are located, on the left, the remains of **Electra's Gate** flanked by two circular towers (the foundations of one are visible); a little

Medieval tower of the Museum.

Mycenaean vases from the "Palace of Cadmos".

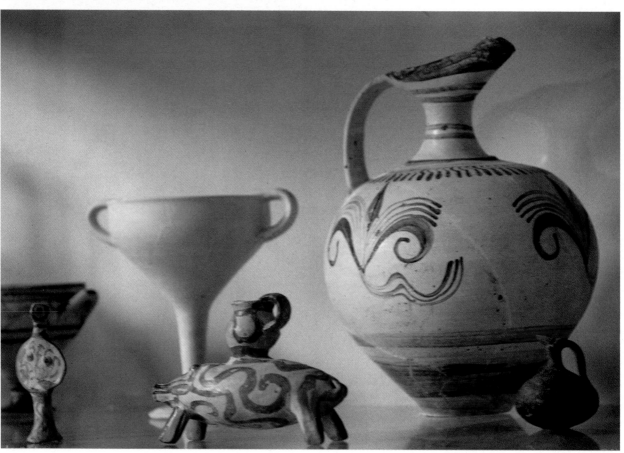

44

further on, what little remains of the famous **sanctuary of Apollo Ismenios**, whose oracle is mentioned even by the historian Herodotus.

Of greater interest is the **Archaeological Museum** near the 13th-century *Frankish tower*. Among the collections, besides the **Mycenaean** section with vases, numerous *larnakes* (funerary urns) in painted terra-cotta, and jewels, of special note is the collection of *Archaic sculptures* documenting the existence of a flourishing local school, strongly influenced by the style of nearby Attica, which produced mainly statues to be dedicated at the sanctuary of Apollo on *Mount Ptoon*. In the **second room**, a group of 42 cylindrical *seals* in lapislazuli and *faience*, of Oriental origin, that testify to the intensity of the political and cultural exchanges between Thebes and the Near East in the Mycenaean period. Of particular merit, in the **third room**, another example of local production: the collection of *funerary steles* of warriors, in black stone with finely carved figures and *engraved names*, that more closely resemble painting than sculpture.

Kouros in Boeotian marble from the sanctuary of Apollo on Mount Ptoon.

Larnax (cinerary urn) in terra-cotta, from the Mycenaean period.

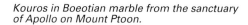

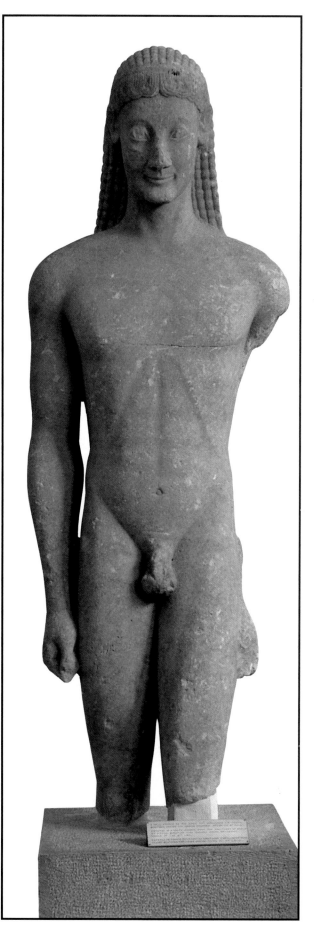

OSSIOS LOUKÁS

The monastery of Ossios Loukás (Holy Luke) on the slopes of *Mount Helicon*, immersed in the silent landscape of the olive groves, is a fundamental monument of Greek Byzantine architecture and art. It was erected in the first half of the 11th century over the tomb of the hermit Luke the Styriot, deceased in 946 or 949. At the center of a complex of buildings, which offers suggestive glimpses of stairways and arched passages, are the *three churches* surrounded by the peripheral buildings with their *cells*, the *bell-tower* and the *refectory*. The most ancient of the churches, founded by Luke himself, soon became a place of pilgrimage: it was the small **Church of Saint Barbara**, today the crypt of the main church, decorated with 11th-century frescoes and containing five tombs including that of the hermit saint and founder, recently restored in marble. In chronological order, the second holy building is the small **Church of the *Theotókos*** ("Mother of God"): built in 950 on a foundation in the form of a Greek cross, with a dome supported by columns and with an octagonal lantern and three apses, the church is elegantly proportioned, with refined sculptures and ceramic decoration as well as many frescoes, some of which date back to its construction.

The main church, or **Katholikon**, dated 1011 (perhaps 1042), is a perfect example of the Greek cross-in-square floor plan, with a great central cupola preceded by the narthex. With its elegant external stonework resting on a course of bricks, the church is known for its rich interior décor in the form of splendid *mosaics* on a gold background with the names of God, the Saints and the Apostles written in the typically Byzantine abbreviated forms alongside each of the figures. Certain of the original mosaics were destroyed by an earthquake in 1593 and replaced with frescoes, like those of the central cupola with Jesus *Pantocrator* ("Ruler of All") in the tondo, accompanied by the *Virgin Mary* and *Saint John* and surrounded by the *Empireus* of the four Archangels and the sixteen Prophets. Among the mosaics, the most noteworthy are found in the *narthex* and in par-

Katholikon: view of the central nave with the apse.

Katholikon: central cupola with Jesus Pantocrator.

Katholikon: view of the narthex.

Church of the Theotókos: mosaics in the exo-narthex.

Monastery of Ossios Loukás, view from the south.

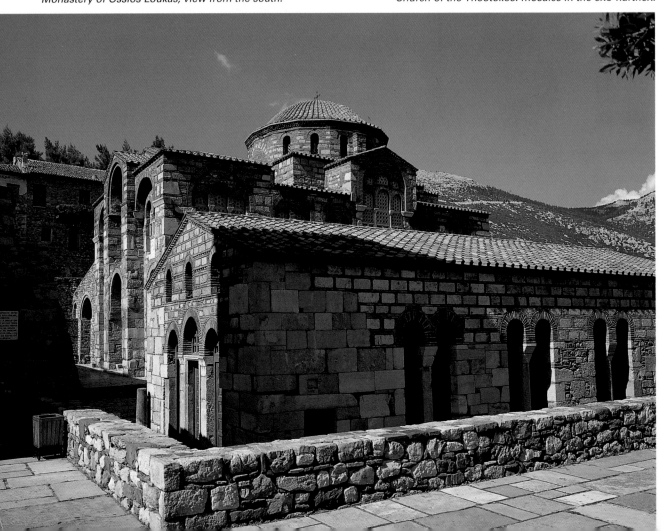

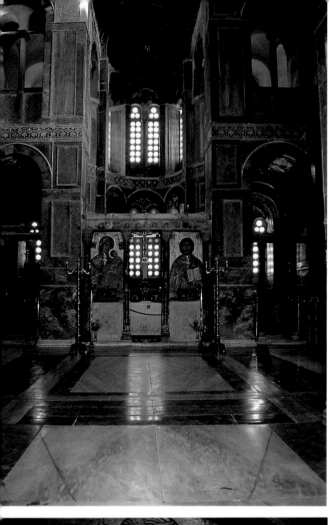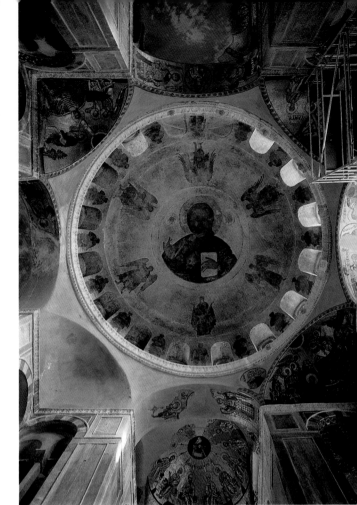

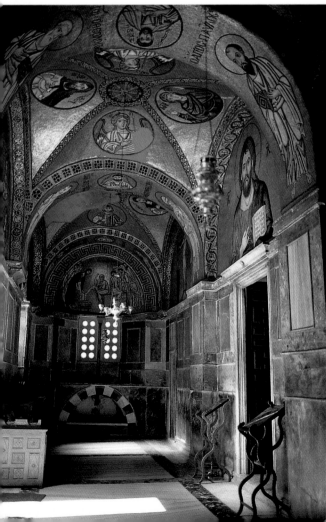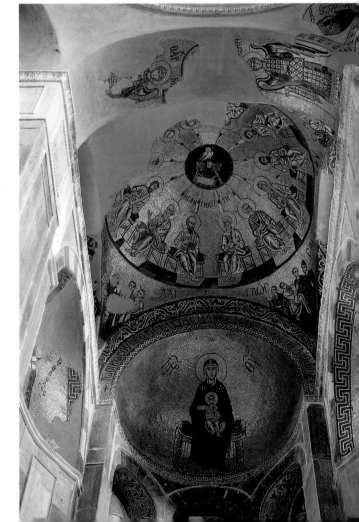

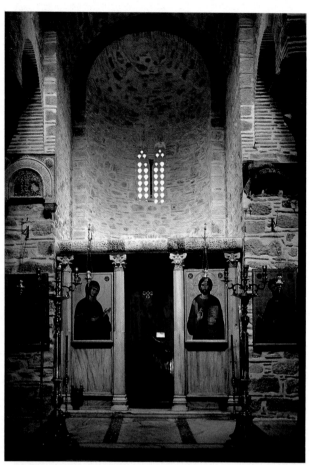

ticular in the lunettes: they include the beautiful Crucifixion, the Washing of the Disciples' Feet, the group of the female Saints including Saint Barbara, the lively *Resurrection* and *Doubting Thomas*, whose face has unfortunately been lost. In the four pendentives of the cupola are represented the Nativity, the presentation at the Temple, the effigy of Saint John Crisostomo (the Baptist) and above all the *Baptism of Jesus*, represented realistically and with the ingenious device of waves overlapping the figures. The entire interior is decorated with true masterworks, all worthy of attention; and of analogous artistic and historical value are the precious floors with *polychrome marble inlays*.

The sculptured marble *iconostasis*, with the icons of the Madonna *Pantón Helpís* ("Hope of All") and of Jesus Pantocrator, which closed off the altar of the central nave, was created in 1570 by the artist Michael Damaskinós of Crete.

Church of the Theotókos: iconostasis.

Monastery of Ossios Loukás, panoramic view: on the left the Katholikon, on the right the Church of the Theotókos.

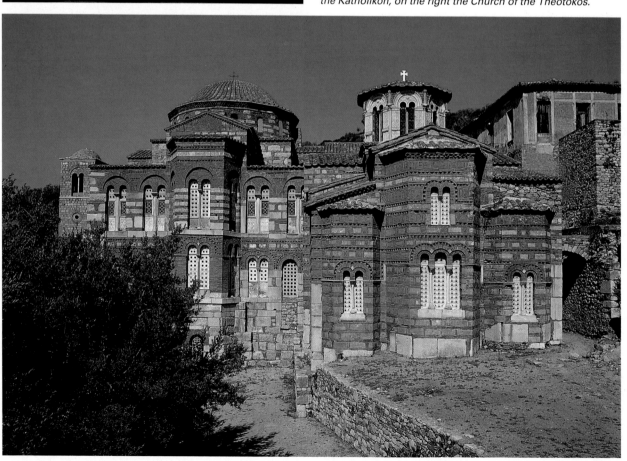

48

ARÁHOVA

A characteristic village, by now totally dedicated to tourism, Aráhova clings to an overhang on the slopes of Mount Parnassus. It is identified with the *Anemóreia* of ancient times, the strategic position of which proved vital to the Delphi sanctuary: it was here, in fact, that the Persians were stopped in 480 BC and the Gauls in 279 BC. The town is known today for its colorful *multicolored hand-woven* goods of excellent wool and for its beautiful embroideries in geometric patterns.

Panorama of Aráhova.

The characteristic local rugs.

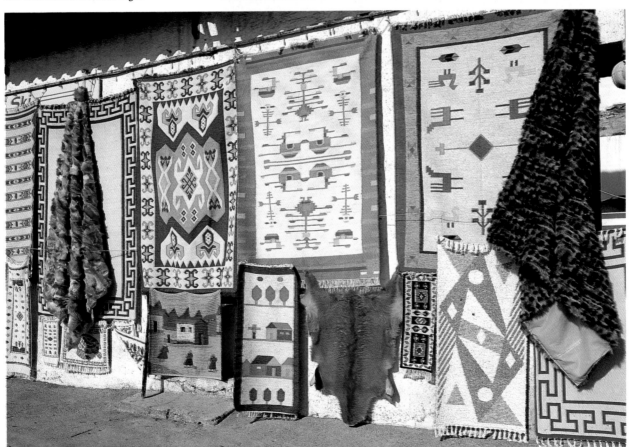

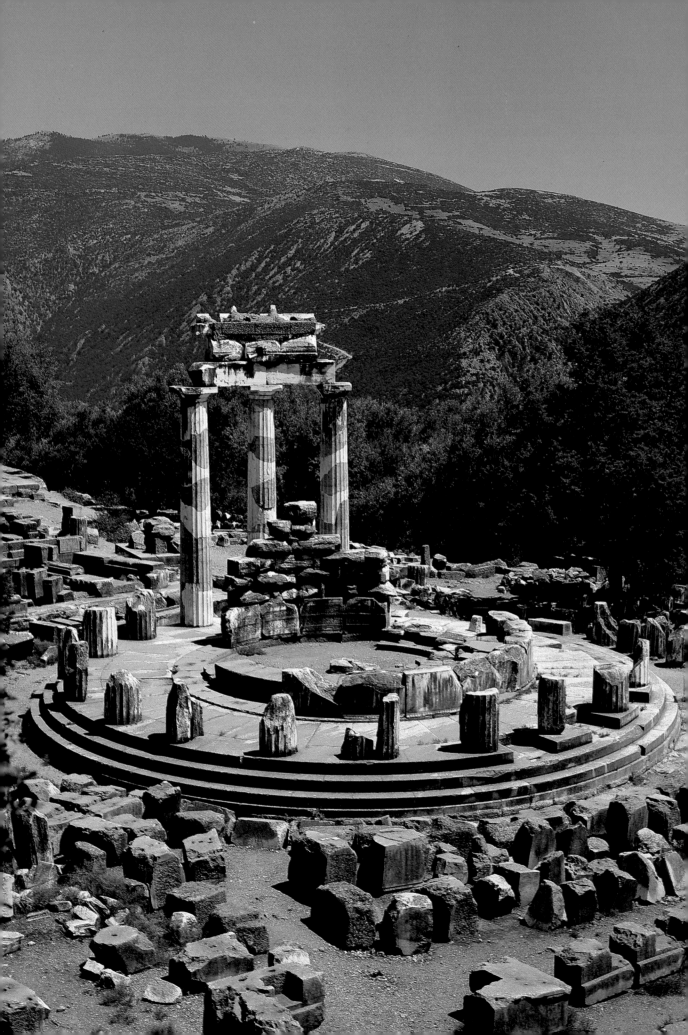

DELPHI

One of the most suggestive localities of all of Greece is the ancient sanctuary of Delphi, on the slopes of Mount Parnassus and set like a precious gem against the sparkling rose-hued *Phaidriades* rock faces where yet today a sense of the sacred pervades the visitor despite the continual presence of tourists. At about 600 meters distance along the Gulf of Itéa, the most famous **Sanctuary of Apollo** of ancient times rose in the narrow valley between the two Phaidriades (that on the right is *Yampeia*, on the left *Nauplia*) in the vast olive groves consacrated to the god Apollo.

Archaeology has demonstrated that Delphi was a holy place as early as the Mycenaean period (14th century BC) by virtue of its three springs, *Delphousa*, *Cassotis* and *Kastalia*, but above all due to its oracle. The sanctuary of Delphi in fact owes its foundation to an opening in the cliff which emitted vapors capable of inebriating and inspiring pronouncements. Around the sacred cliff there arose the primitive oracle of the goddess of the Earth (*Ge* or *Gaia*), to whom is linked the sacred conical stone known by the Greeks as the *omphalos* (navel), a clear reference to Delphi as the hub of the world. Also linked to the Earth Mother Ge is the snake, Python, the first custodian and priest of the sacred oracular cliff, killed by Apollo when he took possession of the sanctuary. The task of prophesying then passed to a priestess consacrated to Apollo, the *Pythia* (or Pythoness) who, drinking of the waters of the Cassotis spring, chewing laurel leaves and inhaling the divine spirit breathed out by the earth, fell onto a state of ecstasy and gave sibylline replies, later interpreted by the priests, to the questions posed by the pilgrims to the sanctuary.The sanctuary of Apollo extends

Thólos of Marmaria (Sanctuary of Athena Pronaia).　　　　　　　　　　　*Sanctuary of Apollo, view from below.*

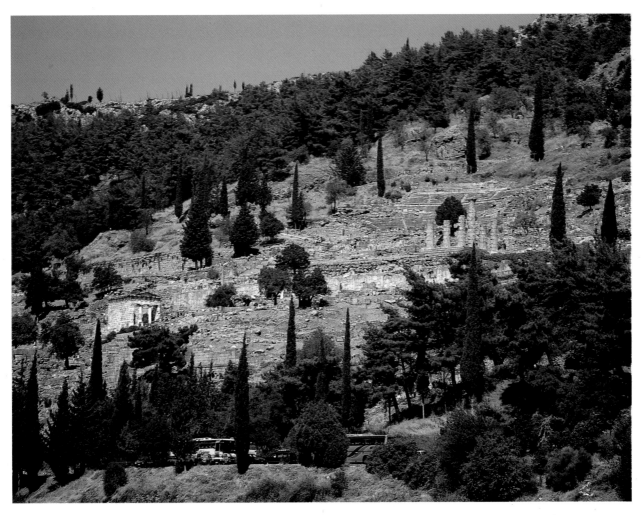

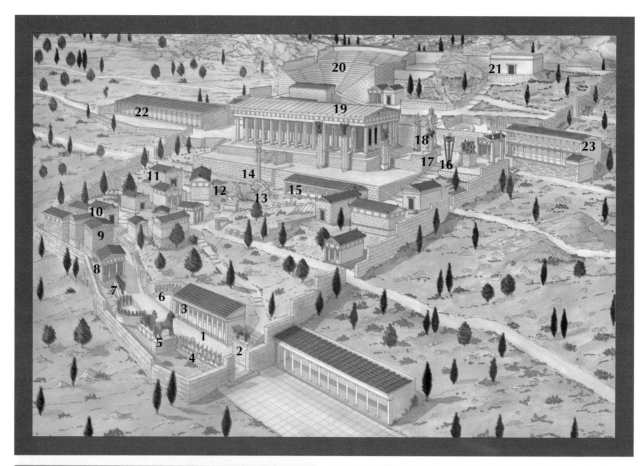

Square before the main entrance.

over different levels and is surrounded by a **circle of walls** enclosing the sacred precinct (*témenos*) into which a number of gates open. The main entrance, to the south between the museum and the **Kastalian Spring**, at the beginning of the *Sacred Way*, is preceded by a great paved square flanked by Ionic *porticoes* with shops. It was from here that the sumptuous processions set out during celebrations; in Roman times it was used as the *forum*. Along the Sacred Way, which winds through the

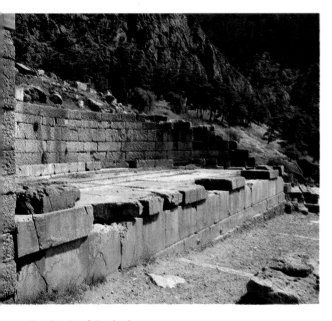

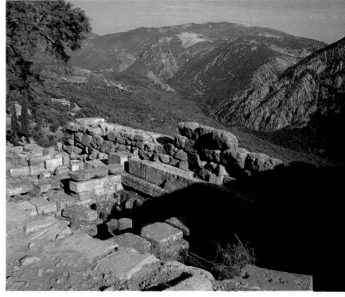

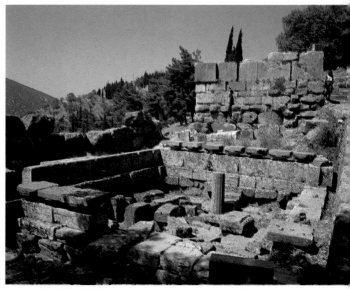

Hemicycle of the Argives.

Building probably used for the assemblies of the Prytaneis.

Treasury of Sikyon and in the background that of Siphnos.

Treasury of the Boeotians.

View of the Sacred Way.

entire sanctuary, were erected monuments and buildings of differing types and in different ages, all of great importance: these, in fact, were gifts to the god, and for this reason had to be of value, but they were also intended as expressions of the high social status of the private citizen who dedicated an *ex-voto*, or of the importance of the city that erected a small temple (*thesaurós*, treasury) containing the booty won from an enemy in battle or donations of analogous importance.

The first monument to the right of the Sacred Way

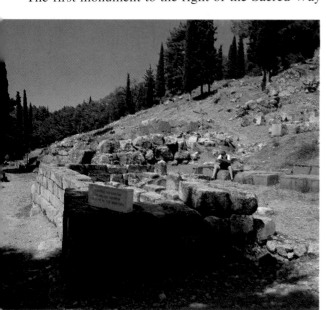

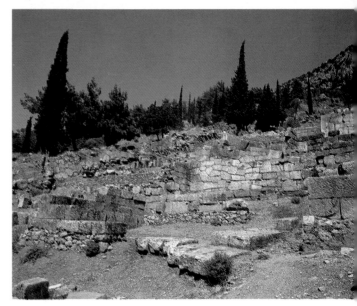

53

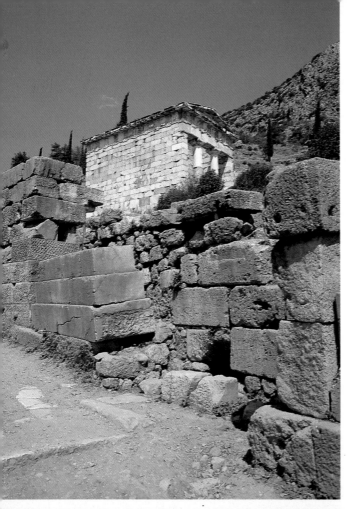

is the *base of a bronze bull* dedicated in 480 BC by *Corcyra* (Corfu) as tithe for an extraordinary catch of tuna discovered by chance thanks to a bull. Alongside, the long base for the 9 bronze statues of *heroes and heroines of Arkadia*, dedicated after their victory over the Spartans in 370 BC. Facing, on the left side of the Sacred Way, is a great base on which Sparta had dedicated 37 bronze statues after the celebrated naval victory over the Athenians at *Egospotami*. Alongside, the base of the bronze statue, by the sculptor Antiphanes, of the *Trojan Horse*, the *ex-voto* of the Argives. Argos is also responsible for the two large *semicircular structures* that flank the Sacred Way and on which stood, to the left, the statues of the Epigons, the sons of the *Seven against Thebes* (the heroes who conducted a mission to Thebes to reconquer the throne usurped by their leader Polyneices' brother Eteocles) and to the right statues offered on occasion of the founding of the city of Messene. On the left of the Sacred Way, beyond the hemicycle of the Epigons, are the remains of the imposing base of the *donarium of Taranto*, a group of bronze

Treasury of the Athenians, view from below.

Treasury of the Athenians and the Sacred Way, view from the east.

Treasury of the Athenians.

Polygonal wall of the temple and the facing Portico of the Athenians.

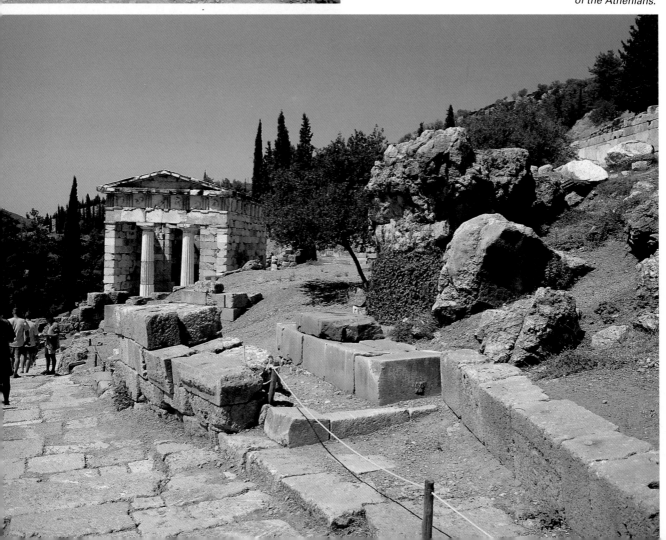

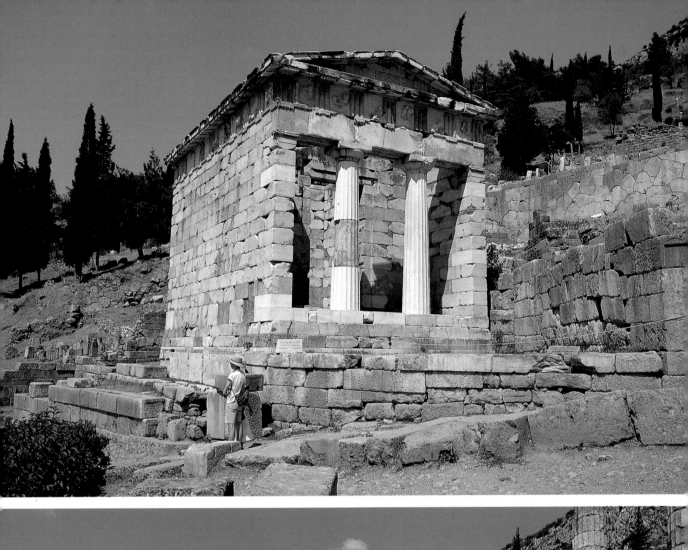

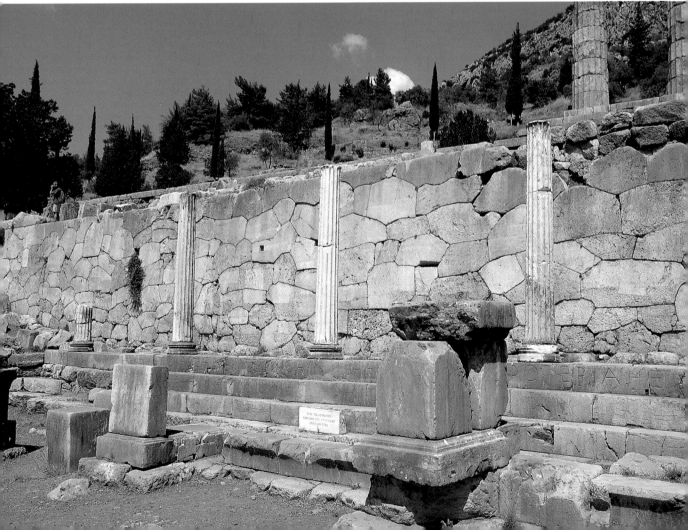

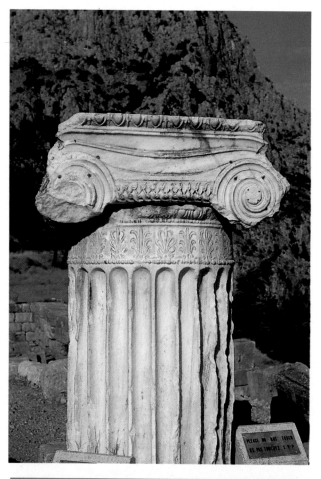

states of *horses and prisoner women* created by the sculptor Hageladas at the beginning of the 5th century BC with the booty of a victory by the Tarantines over the nearby Italic Messapians. Further ahead, on the same side, are the remains of the **Treasury of Sikyon**, built of tufa, with two Doric columns on the facade (500 BC): incorporated in the foundations are the remains of a circular building analogous to the *thólos* of the sanctuary of Athena Pronaia and those, still more important, of a *monopteral monument*, a small rectangular temple composed of 14 columns supporting a roof and which is said to have housed the quadriga with which the tyrant of Sikyon, Kleisthenes, had successfully contended during the first Pythian Games (the Olympic games of Delphi) celebrated in 582 BC. Alongside the Treasury of Sikyon rose that of **Siphnos**, which was perhaps the most beautiful and sumptuous monument of the entire sanctuary, built of valuable Parian marble in about 525 BC with the proceeds of the gold deposits discovered on the island, in the Ionic style with two caryatids on the facade in place of the columns and adorned with precious architectural decorations which are considered cornerstones of Archaic Greek art. An example of the splendor and the grace that could be expressed by the Treasuries is offered by that of the **Athenians**, reconstructed and restored (with copies) in 1906 so that today, set in the landscape of Delphi, it arouses the same admiration it inspired in ancient times. Built in Parian marble in about 490 BC in gratitude to Apollo for the Athenians' victory at Marathon over the invading Persian army and financed with the booty from the battle, it is in Doric style, with two columns on the front. The *eastern pediment* depicted stories from the life of Theseus, Athen's national hero; the western pediment, scenes of battle. The 6 metopes on the front portrayed scenes from the mythical battle between the Greeks and the barbarous Amazons, here evoking the real victory over the Persian "barbarians"; those of the long sides and the rear narrated the *exploits of Theseus and of Herakles*. A few meters beyond the Treasury of the Athenians we note two rocky formations: it was from the larger (**Rock of the Sibyl**) that the Pythia emerged to give her oracles; of the lesser of the two (**Rock of Leto**) it is narrated that it was there that Leto held up Apollo as a boy to aid him in shooting the snake Python with his bow. Between

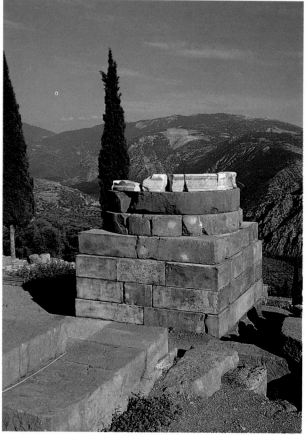

Drum of a column with Ionic capital.

Base of the monument financed by the booty of the Battle of Plataia (479 BC); three bronze serpents, entwined (today in Istanbul), supporting a golden lebete.

Temple of Apollo from the southeast: in the foreground the polygonal terracing wall.

Temple of Apollo from the east.

Temple of Apollo from the northeast and the tall stele of Prusias II, king of Bithynia (182-149 BC).

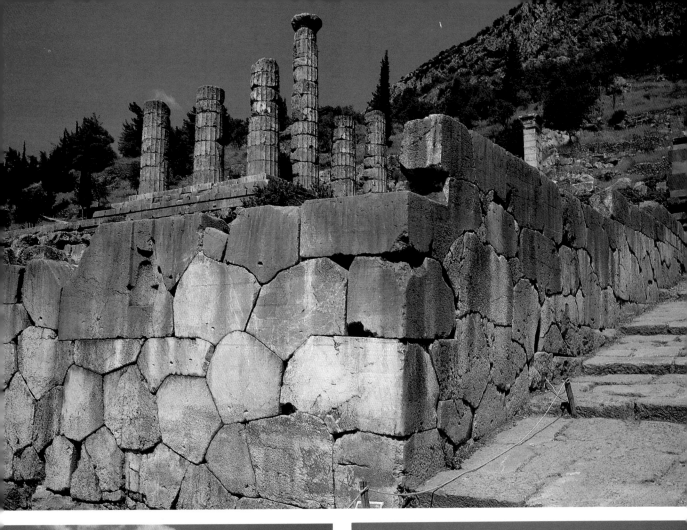

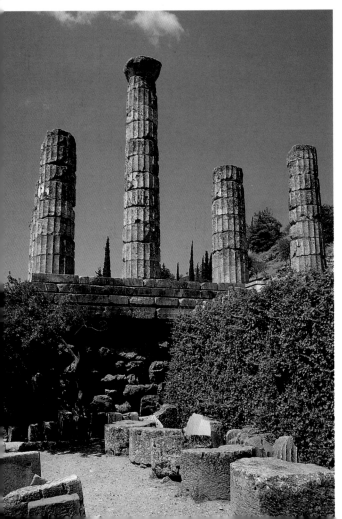

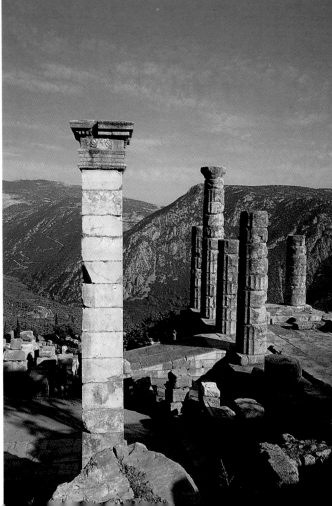

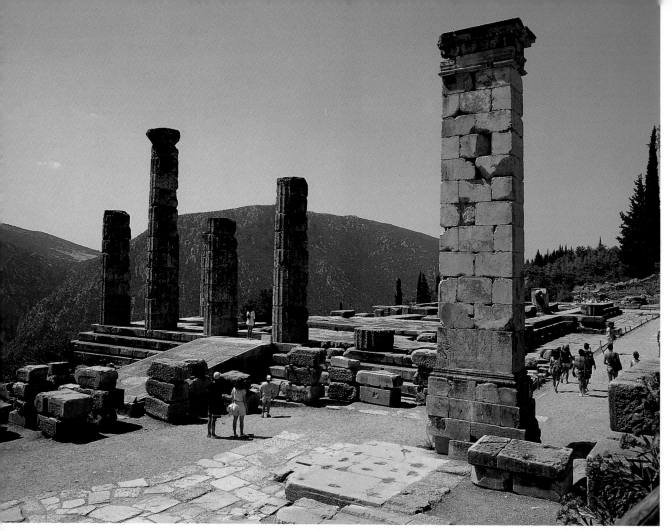

Temple of Apollo from the northeast, with the access ramp and the altar of the Chiots; in the foreground the stele of Prusias II.

Temple of Apollo from the northwest.

Theatre, aerial view.

the two rocks, up against the *polygonal retaining wall* that the Athenian Alcmeonid family had built to create the terrace for the great temple of Apollo, is the base of the tall *column with a sphynx* at its top, erected by the Naxiots in about 570 BC (fallen drums remain). Parallel to the surface of the polygonal wall (with its about 800 inscriptions) there opened out a **portico** with monolithic Ionic columns, erected by the Athenians in 478 BC to house the trophies of their naval victories. Continuing up the rise, the Sacred Way turns toward the temple, before which stands a great **altar**, built at the beginning of the 5th century BC by the inhabitants of Chios, in white and blue marble and joined to the temple by a long inclined walkway.

The **Temple of Apollo** as we see it was restructured in the 4th century BC, but it was preceded by other temples built on the same site: tradition has it that the first building was built in laurel boughs, the second in wax and feathers and the third in bronze before the stone temple was erected. Legends aside, the temple burned in 548 BC: its reconstruction was financed by all of Greece and by many foreign sovereigns. The Doric temple,

with 6 columns on the ends and 15 on the sides, was completed in 510 BC by the powerful Alcmeonid family, exiled from Athens by the tyrant Peisistratos. It was destroyed by an earthquake in 373 BC and again rebuilt. At the center of the eastern pediment was the *quadriga with Apollo, Artemis* and their mother *Leto*, accompanied by statues of young women and young men (*kourai* and *kouroi*) and flanked by lions devouring their prey; on the western pediment, the Gigantomachy.

The most important buildings uphill of the temple are the **theatre**, with a seating capacity of 5000, restored by Eumenes II, king of Pergamon, in the 2nd century BC; and the stadium dating to the 5th century BC (but the terraces were built in the 2nd century AD with a donation by Herod Atticus, the rich Athenian; before that time the spectators sat on the packed earth slope). The length of this stadium (177.55 meters) was to become the standard unit of measure and the very name of analogous constructions worldwide. At the northern extremity of the sanctuary, against the wall of the *témenos*, to the right of the theatre, arises the ***Lesche*** (**Portico**) **of the Knidians**, a hall with eight internal columns

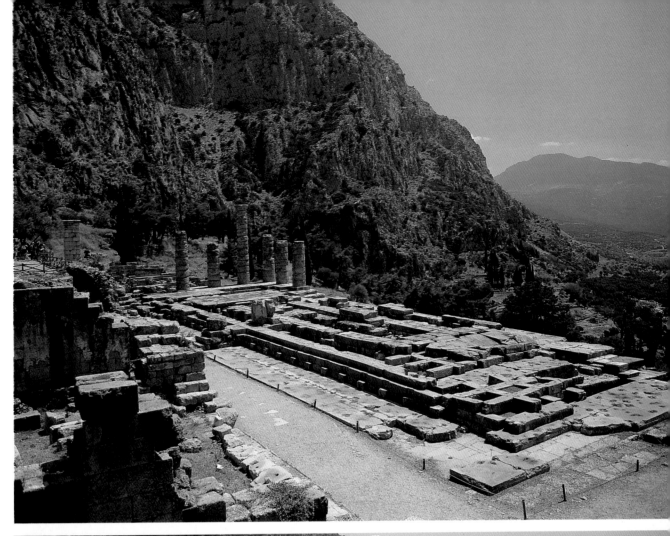

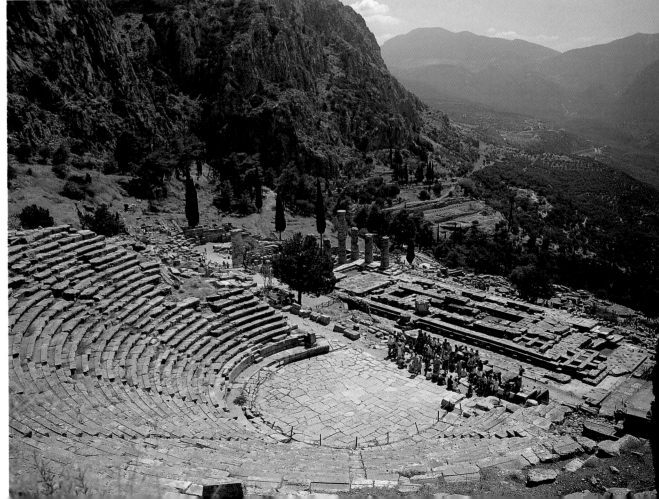

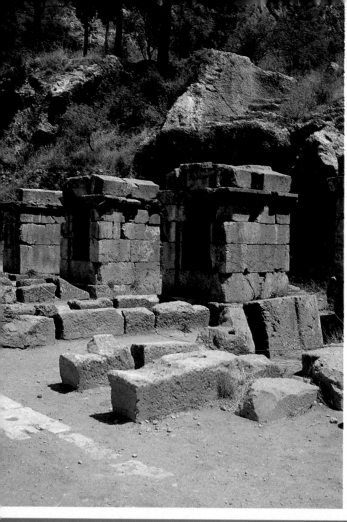

which was celebrated in ancient times for the paintings by the great Polygnotos that adorned the four walls (*The Trojan War* and the *Descent of Ulysses into Hades*).

From the rocky roots of the Yampeia, in the cleft dividing the Phaidriades, there still today gushes the sacred **Kastalian Spring**, in which the priests performed their rites of purification before each celebration and in which the pilgrims bathed. The front of the spring was, in Hellenistic and Roman times, faced in slabs 2.50 meters high with seven openings and spouts in the form of lions' heads; the niches cut into the rock above were used for receiving small votive offerings.

Across from the sanctuary of Apollo, in what is today called **Marmaria** due to the fragments of marble found there, rises the **Sanctuary of Athena Pronaia** ("before the temple"). Dating to the Mycenaean period, it stands on a terrace that preserves the remains of the *first temple of the goddess*, in tufa, dating to about 500 BC (Doric, with 6

Entrance to the stadium; in the foreground, the starting line.

The stadium, from the east.

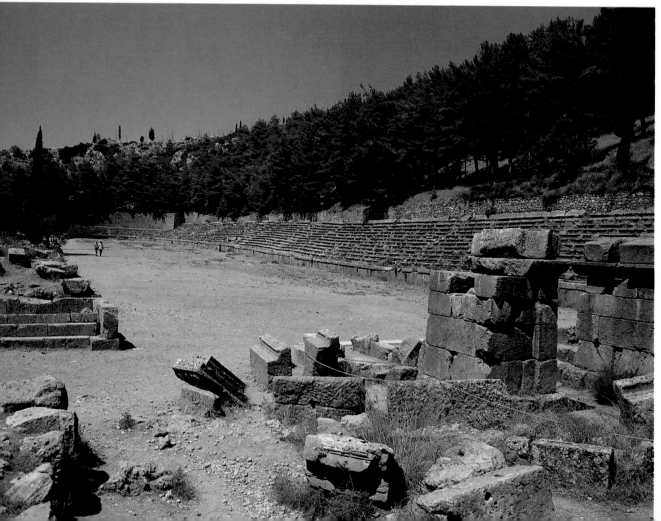

columns on the ends and 12 on the long sides), two small Parian marble *Treasuries* (one in Doric and one in Eolic style: 480-470 BC), the **great *thólos*** and the second temple of Athena, in limestone, erected after the destruction of the first by the earthquake of 373 BC. The most significant building is the *thólos*, with its circular layout and 20 Doric columns that supported architraves, triglyphs, metopes and a sculpted cornice, and with Corinthian half columns inside. The *Gymnasium*, between the Kastalian Spring and the sanctuary of Athena, below the level of today's road, includes the track (half covered) on the upper terrace and the changing-rooms, palestra, pool and baths on the lower level. The Gymnasium was famous in ancient times because, according to the myth, it was while hunting in its adjacent wood that Ulysses received the wound from a wild boar that caused him the famous scar by which his nurse Euriclea recognized him upon his return from the Trojan War.

Kastalian Spring: basin and votive niches.

Marmaria: Sanctuary of Athena Pronaia, aerial view.

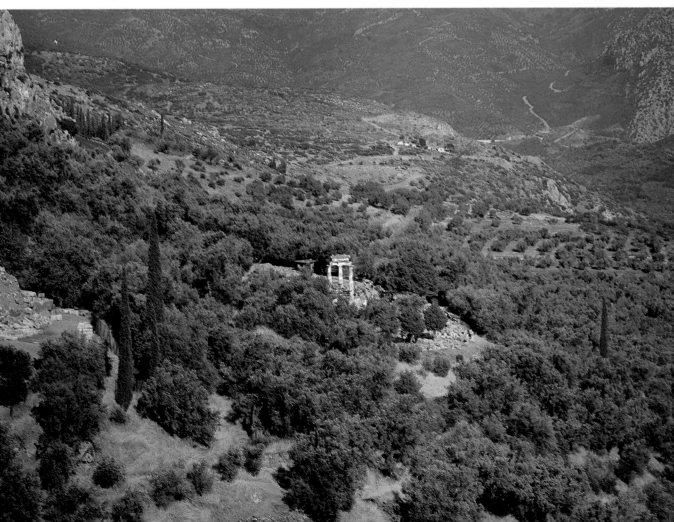

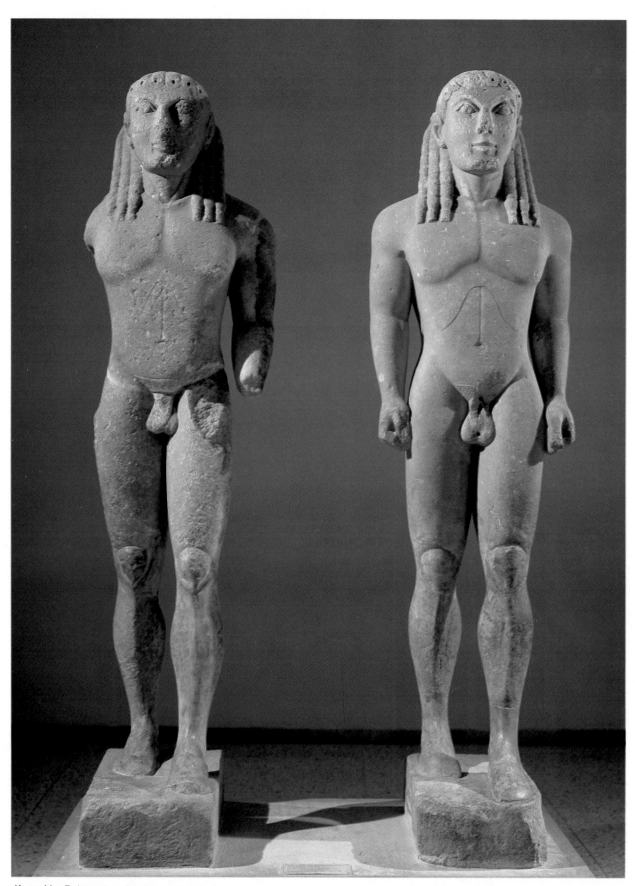

Kouroi by Polymedes: Cleobis and Biton.

DELPHI MUSEUM

As we enter what is one of the largest museums in Greece, we see in the **Entrance Hall** the most important object of the cult of Apollo, the *omphalos*, a copy in marble of the renowned stone navel swathed in the web of the sacred *agrenon* and conserved near the statue of the god inside the temple. According to the myth, Zeus had sent out two eagles which, flying from the opposite ends of the Earth, met in Delphi, demonstrating that the city was the hub or navel of the world; the original *omphalos* was in fact adorned by two golden eagles. Also in the Entrance Hall, the long relief in white marble, depicting the Labors of Herakles, that decorated the proscenium of the theatre.

The **Hall of the Bronze Shields** is home to evidence of the great *bronze tradition* of the Greeks in the 6th century BC; of particular note the three *adorned shields*, a small Cretan statue of Apollo dated about 630 BC, and the *griffons' heads* that adorned large containers (*lebetes*) and tripods sacred to the god. The room also contains a *large marble basin supported by caryatids*, for the lustral waters (early 6th century BC).

The **Hall of the *Kouroi*** takes its name from the statues of the brothers *Cleobis* and *Biton* from Argos (by Polymedes of Argos, 600 BC). Esiodos relates that when their mother, Hera's priestess, had to travel to the sanctuary of the goddess, the two brothers pulled her chariot in place of the oxen which were needed in the fields. Upon reaching the sanctuary, the mother prayed Hera to grant her sons the greatest of gifts; the goddess allowed them to sleep forever in her sanctuary. Although apparently cruel, the story is perfectly aligned with the aspiration of the ancient Greeks to a heroic death in the moment of their greatest splendor. In the same room are five of the 14 sculpted metopes of the *monopteral monument of Sikyon*, depicting the ships of the Argonauts, with Orpheus playing the lyre and the Dioscuri ("Sons of Zeus") Castor and Pollux; the abduction of Europa by Zeus in the guise of a bull; the Dioscuri and their cousins the Apharids stealing a herd (note the painted inscriptions); the Calydonian boar hunt; Frissos on the Ram of the Golden Fleece.

The **Hall of the Bull** contains the material found in two votive pits discovered in 1939 in front of the Portico of the Athenians, including the outstanding *large bull* (2.61 meters in length) of silver sheet beaten on a wooden form and once held in place on a bronze frame with silver nails: the dewlap, horns, forehead and hooves were gilded. Of exceptional interest are also the fragments of various life-size *chryselephantine statues* ("of ivory and gold"), the heads, hands and feet of which were in ivory, the hair and headdresses in gold and the body in wood.

Heads of chryselephantine statues: faces in ivory with golden ornaments.

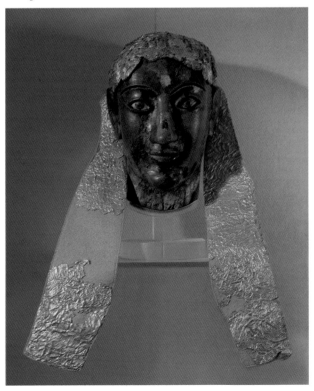

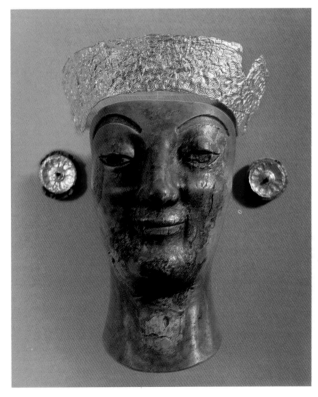

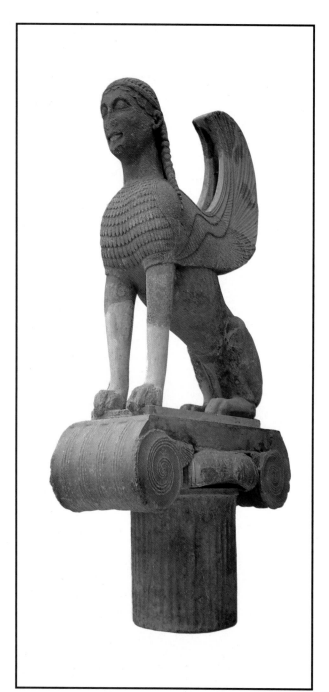

Also from the votive pits excavated along the Sacred Way are the precious *ivory reliefs* of mythological scenes that decorated wooden furniture, caskets and thrones, and the numerous bronze statuettes of *athletes and divinities*, among which the *girl wearing a peplos* holding a *lebete* for burning incense, a true sculptural masterwork from 450 BC.

The **Hall of the Siphnian Treasury** is home to some of the best-known works of Greek sculpture. The *east pediment* represents the dispute between Apollo and Herakles as the latter attempts to steal the sacred tripod (at the center, Athena attempting to placate the contenders); the *eastern frieze* shows the Trojans Aeneas and Hector, dismounted from the chariot, in combat with Ajax and Menelaos (King of Sparta and husband of Helen, whose kidnapping was the cause of the Trojan War), armed with the shield decorated with the head of the Gorgon Medusa, over the body and the weapons of the fallen Sarpedon. Watching the battle are the gods of Olympus, who take sides: to the left are Ares, Aphrodite, Artemis and Apollo, in favor of the Trojans, separated by Zeus enthroned (alongside Thetis, now lost) from Athena, Hera and Demeter, supporters of the Greeks. The *northern frieze* depicts the battle between the gods and the Giants: note Hephaistos working the bellows to unleash the winds against the Giants, Cybele driving a chariot pulled by lions, one of which is attacking a Giant; alongside, the twins Artemis and Apollo fighting together, followed by Athena battling two adversaries; and the bearded Ares, Hermes with cap and

The Sphynx of the Naxiots, on an Ionic capital.

Eastern frieze of the Siphnian Treasury: Aphrodite, Artemis and Apollo.

Eastern frieze of the Siphnian Treasury: Aeneas and Hector engaged in battle with Ajax and Menelaos over the body of the fallen Sarpedon.

East pediment and frieze of the Siphnian Treasury.

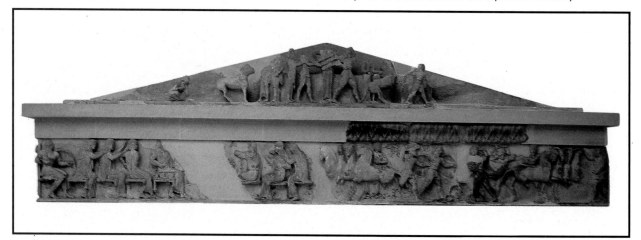

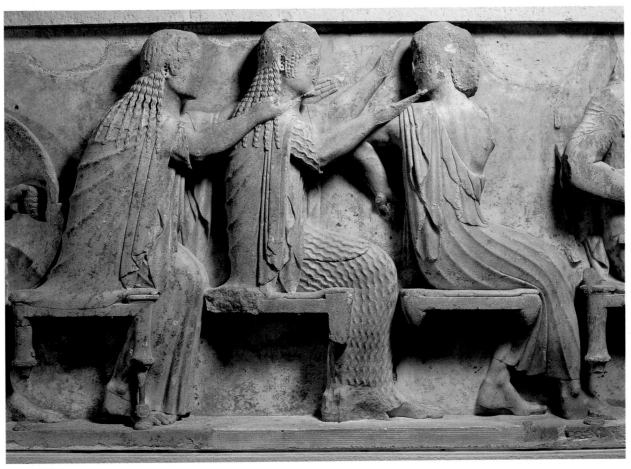

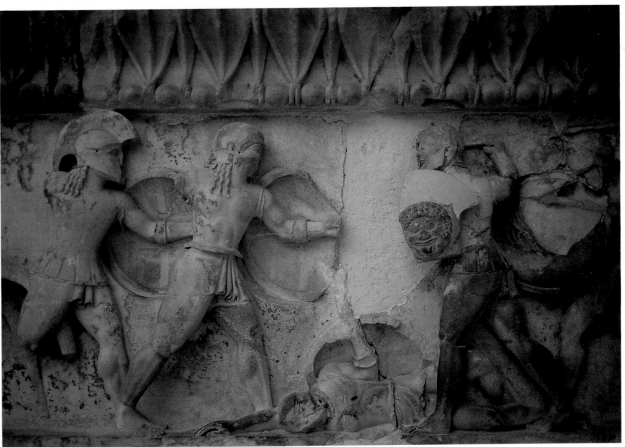

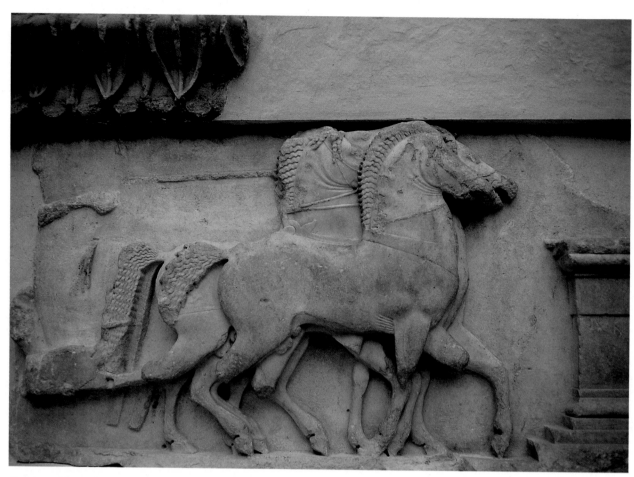

Southern frieze of the Siphnian Treasury: quadriga before an altar.

Northern frieze of the Siphnian Treasury: the lions of Cybele, Artemis and Apollo, the dead Giant Ephialtas; three Giants with shields (one bearing the signature of a sculptor).

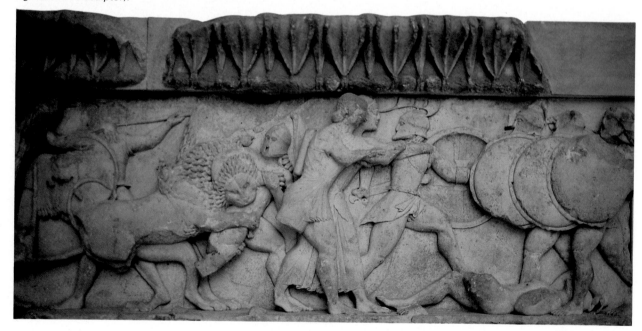

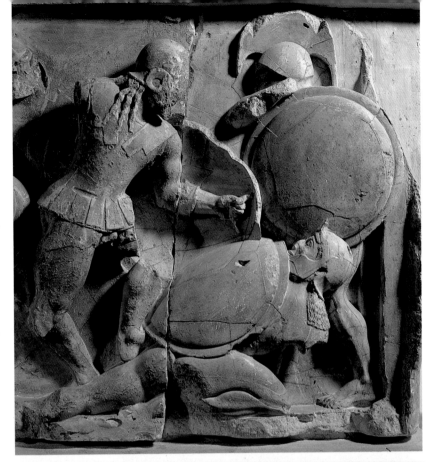

Northern frieze of the Siphnian Treasury: battle between an unidentified god and the Giants.

Northern frieze of the Siphnian Treasury: two Giants, adversaries of Zeus, with Hera in the foreground.

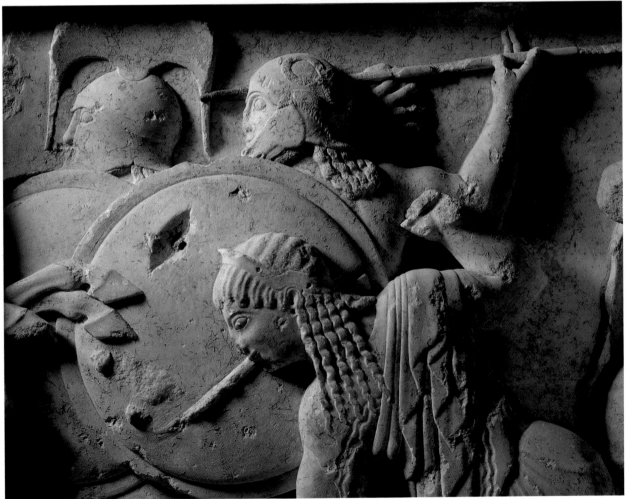

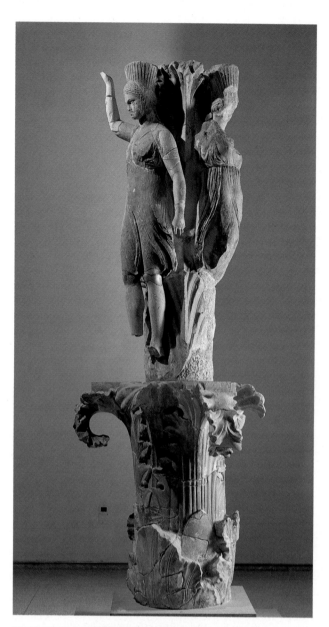

sword and Poseidon, all engaged in battle with pairs of Giants.

The *western and southern friezes*, of which many parts are missing, show the Judgement of Paris that sparked the Trojan War, with the winner Aphrodite descending from her quadriga to award the golden apple to Paris, and the abduction of the daughters of Leucippos, King of Messenia, by the Dioscuri. In the same room are the great *Sphynx of the Naxiots*, the *caryatids of the Siphnian Treasury* and the noteworthy head of another caryatid, part of an unknown Treasury and once thought to belong to that of Knidos.

The **Hall of the Athenian Treasury** displays the 30 metopes that decorated the building with the exploits of the heroes Theseus and Herakles. They are the work of a number of different artists: although at least two styles are visible, one of which is conservative, the other more innovative, the whole nevertheless expresses the admirable balance of Attic art.

In the two **rooms dedicated to the Temple of Apollo** are exhibited the *pediments of the temple of the Alcmeonids* by the Athenian Antenore (510 BC): the lively figures of the west pediment depicting scenes from the Gigantomachy (in stuccoed and painted tufa) contrast with the more static figures on the east pediment (in Parian marble) showing the Epiphany (that is, the solemn apparition at Delphi) of Apollo with Artemis and Leto. Again in the first room, the mural *inscription* with hymns and musical signs (notes) between the different verses; in the second room, the winged *Nike* (Victory) that was the acroterion of the Temple of Apollo.

In the **Hall of the Steles** are the funerary monuments of athletes of the Classical period (5th-4th centuries BC) and the statue of Dionysos from the east pediment of the temple built following the earthquake of 373 BC.

Monument to the daughters of the Athenian King Cecrops.

Marble altar from the sanctuary of Athena Pronaia.

East pediment of the Temple of Apollo.

Winged Nike (Victory), acroterion of the Temple of Apollo.

Dionysos, from the east pediment of the Temple of Apollo (4th century BC).

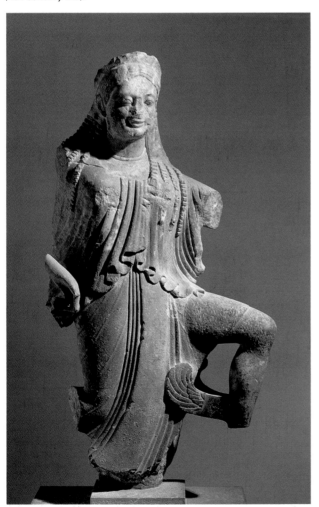

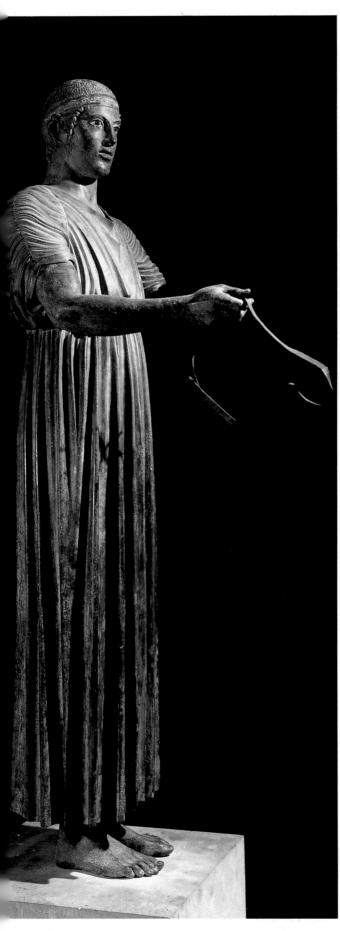

Two rooms are dedicated to the **Sanctuary of Athena Pronaia at Marmaria**, with reliefs (influenced by those of the Parthenon) and architectural elements above all from the *Thólos*. In the **Hall of the Dancers**, one of the museum's masterworks: the group of the daughters of Cecrops, dedicated by Athens, dancing on the tall *acanthus column* (330 BC); at the sides, the important statues from the *Monument of Daochos*, representative of the Thessalians in the Delphi Assembly, with the statue of his nephew Agias, numerous times the winner of the Games of Delphi, Nemea and Isthmia, a copy of a work in bronze by Lysippos.

The **Hall of the Charioteer** is home to the celebrated bronze sculpture (1.80 meters in height), part of the *quadriga* consacrated by Polyzalos, tyrant of Gela in Sicily, after his victory in the Delphic Games in 478 or 474 BC. Of noble and elegant simplicity, the statue seems to follow us with its eyes of colored stones.

In the **Hall of Greek and Roman Antiquities**, a collection of precious *small bronzes* (among which Ulysses escaping from the cave of Polyphemus, clinging to the ram) and the statue of *Antinoüs of Bithynia*, the beautiful favorite of the Emperor Hadrian, who after the premature death of the youth by drowning in the Nile filled the Roman Empire with his likenesses.

The Charioteer of Delphi, votive offering by tyrant Polyzalos of Gela.

Statue of Antinoüs (2nd century AD).

Mosaics from the paleo-Christian basilica (5th century AD): details.

White-background cup: Apollo holding a lyre.

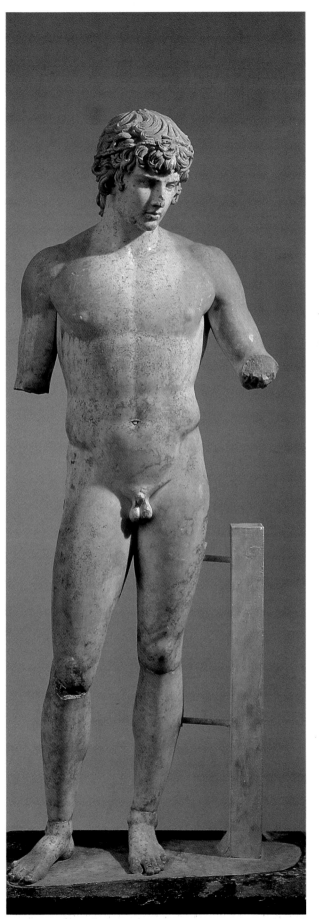

THE PELOPONNESE

PERAHORA - CORINTH - NEMEA - MYCENAE - ARGOS - TIRYNS
NAUPLION - EPIDAUROS - TEGEA - SPARTA - MYSTRA
MONEMVASSIA - MANI REGION - GYTHIO - KALAMATA - KORONE
PYLOS - METHONE - MESSENE - MEGALOPOLIS - BASSAE - OLYMPIA

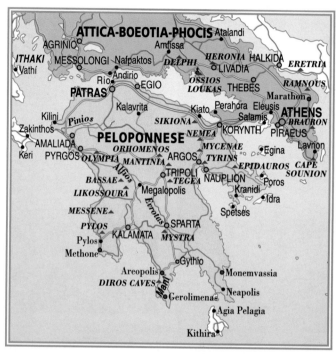

*T*he Peloponnese was for the ancients the island (nesos) of Pelops, son of Tantalus, who arrived there from Asia Minor and settled this poor territory, giving rise to the accursed family that as tradition has it dominated during the semi-legendary Mycenaean era. Although this vast region of Greece was once joined to the continent by a thin strip of land, today the man-made Corinth Canal separates it from the mainland, making it a true island.

The sight of this long canal (6343 meters) dug between two imposing walls of rock, viewed from the railway bridge or the road bridge that cross it, is extremely suggestive and contributes to creating the first symbolic image registered by those visiting the Peloponnesian territory. It is interesting that the idea of uniting the waters of the Aegean and the Ionian Seas was first advanced in ancient times under the tyranny of Periander (7th century BC); the work was then very costly and technically difficult, and so an ingenious system, consisting of pulling the boats on a sort of trolley that ran on a paved roadway called the diolkós (dielkein means "to pull") in order to avoid their having to circumnavigate the Peloponnese, was invented. The digging of the canal was re-proposed by both Caesar and Caligula, but the only ruler who saw fit to undertake even the preliminary work for this formidable feat of engineering was Nero; the project was completely abandoned after his death, and it was not until the 19th century (1883-1893) that it was finally concluded. This immense area, bathed by the waters of the Aegean, Ionian and Mediterranean Seas, is subdivided into seven territorial districts, the names and the borders of which have remained unchanged since antiquity: Argolis (to the east), Korinthia (to the north-east), Achaia (to the north), Elis (to the north-west), Messinia (to the south-west), Lakonia (to the south-east) and Arkadia (at the center). The geographical configuration of the region, which extends south from the Isthmus of Corinth like an enormous mulberry leaf (hence the

medieval epithet of "Morea") has been a determining element in the evolution of its important and intricate history. The astounding variety of the natural landscape is a suitable background to the complicated interweaving of the innumerable historical events that have left their very evident marks on the territory. The material evidence of the civilizations that followed each other in the territory, and of which they have become an integral part, today unites with the present to create fascinating contrasts: as we travel through the different Peloponnesian districts we encounter expanses of green plain, often covered by the colorful cloak of the citrus plantations, gentle in contrast to the majestic peaks of the mountains, like the Taÿgetos range, or the less imposing hills where in prehistoric times the inhabitants of the peninsula erected fortifications which still stand powerful and isolated. Completing the list of stupendous natural landscapes are paradisiacal beaches separated by small, picturesque ports set close one on the other. A territory so rich in natural assets could not but possess an equally complex history. Innumerable myths recount the origins of the oldest centers, such as Mycenae, Tiryns, Argos and Orchomenos, settled by the Indo-European tribes of the Achaians, evidence of whose greatness may be found not only in Homer's epic poems but also the material remains they left on the territory.

As we visit the archaeological sites of Argolis, still suggestively structured with their mighty fortresses, citadels and sumptuous royal palaces, we re-live the history of what was a glorious epoch for this territory, where, differently from all the other regions of Greece, there reigned a powerful landed and mili-

The Isthmus of Corinth: the canal, over 6 km in length and 23 meters wide, was constructed between 1883 and 1893.

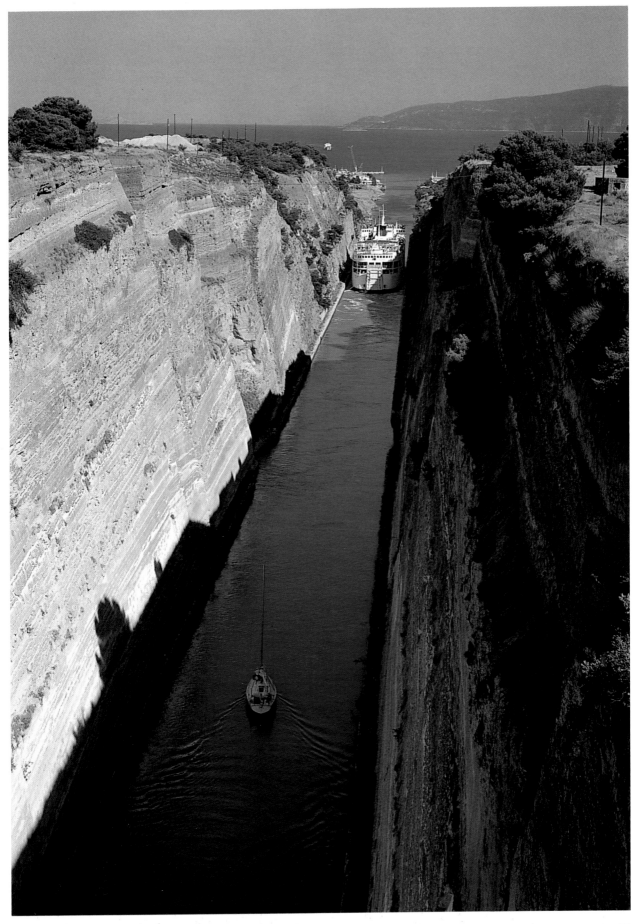

A romantic sunset on the coast of the Peloponnese,
a region offering landscapes of rare beauty.

tary aristocracy around which gravitated a perfectly
rational social organization which was both eco-
nomically and culturally prosperous. But this was
certainly not the peninsula's only moment of glory.
The Doric invasions inaugurated a dark age in the
Peloponnese; the region emerged from these
obscure centuries thanks to the prestige of cities
such as Corinth, Sikyon and Sparta, which in the
7th and 6th centuries BC became extremely impor-
tant centers. During these two centuries, social and
economic development was accompanied by great
artistic splendor in all fields of expression, from
ceramics and the plastic arts to glyptography and
architecture. In the 5th century BC, Sparta was the
unchallenged hegemon of the entire region and,
after having routed the Persians and come through
the Peloponnesian War victorious, became for a
brief period the center of all of Greece. The proud,
independent spirit of the inhabitants of the different
districts of the Peloponnese, who throughout their
history created alliances and fought together in
defense of their freedom, even against Sparta her-
self, was heavily taxed in the centuries that followed
by foreign domination, first by the Thebans and the

Macedonians and later, from 146 BC (the year of
the destruction of Corinth) through 250 AD, by the
ferocious Roman rulers. The Roman era was fol-
lowed by another dark age, that of the barbarian
invasions. After a period of Byzantine supremacy,
all of Morea, as it was then called, was parcelled
out into feuds by the Frankish barons, and became a
bastion of Latin power in the East during the 13th
and 14th centuries. When the Byzantines returned
for the second time, Morea became the most repre-
sentative center of a what was then a declining
empire. Mystra is the example par excellence: its
monasteries, its churches and its elegant buildings
suggest a fortunate artistic and cultural moment
come down to us intact.
The Turks and the Venetians later disputed the
coastal cities (Monemvassía, Nauplion, Methone,
Korone, Pylos), where they left imposing signs of
their long-lasting military dominions. The
Peloponnese became part of the independent
Greek state following a hard-fought struggle
against the Turkish oppressor, and proposed
Nauplion as the first capital of liberated Greece
(1829-1834).

PERAHÓRA

Along the road from Athens to Corinth, after having passed through the pleasant thermal resort of *Loutráki* (the ancient *Thermai*), already in the district of Corinth, we reach the characteristic village of *Perahóra*, located on a rise not far from the coast and close by Lake Vouliagméni. To the west of the modern village are the **ruins** of an *agora*, two *temples* and a *stoa* which must have in antiquity been situated on the splendid bay where the ancient port was located: traces of two supply *cisterns* also seem to support the hypothesis of the port. The temples, in the 8th century BC, were probably home to the sanctuaries of *Hera Limenia* (protectress of ports) and *Hera Akraia* (protectress of the highlands). The site, excavated by the archaeologist Payne and his wife, offers a beautiful view of a countryside in which the colors of the sea blend with those of a still-untamed nature, a contrast characteristic of much of Greece.

Remains of the apsidal foundations of the cistern.

The beautiful bay on which rose the ancient port and the Heraion of Perahóra, seen from the site of the temple of Hera Akraia.

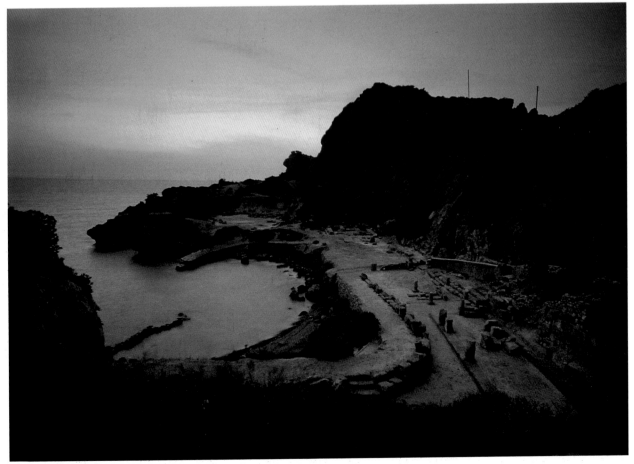

CORINTH

The city of Corinth, just west of the isthmus, is the administrative center of Korinthia, the territorial district that extends across the north-western portion of the Peloponnese. Ancient Corinth, a short way from the modern urban center, is borne witness to by the ruins still standing at the foot of the natural **Acrocorinth** stronghold (575 meters above sea level) that rises as majestically as a great fortress. This center, opulent since Archaic era thanks to its controlling position over the isthmus dividing the Ionian and Aegean Seas, rose to unchallenged economic power in historical times. The myth narrates that the city's founder was Sisyphus, known for having attracted the fury of Zeus and having been condemned to eternally rolling an enormous boulder up a hill, which one version of the myth identifies with Acrocorinth. In truth, Corinth, first settled in the Neolithic Age, rose to power during the 7th and 6th centuries BC when it established the colonies of Corcyra (Corfu), Potidaeia and Syracuse and was governed by the powerful tyrannies of the Bacchiades, the Cypselids and Periander. In eternal competition with Athens for dominion of the seas,

which it renounced only during the period of Spartan hegemony over the Greeks, Corinth was razed to the ground and humiliated by the Roman troops of the Consul Mummius in 146 BC. Only after about 100 years was the city rebuilt by Caesar and did it again flourish, winning a name for luxury and frivolity. The excavations, begun in 1886 by the German Institute and continued by the Greek Archaeological Society and the American School, have brought to light many remains of Caesar's colony but very few from the pre-Roman era. Among the latter there dominates, on the ancient **agora**, the peripteral *Temple of Apollo*, which, with its 38 monolithic Doric columns, was the model for the Temple of Athena on the Athens Acropolis. The *Lechaion Way*, bordered by *porticoes*, *shops* and *public baths*, leads to the *agora* and once linked it to the ancient port. West of the monumental gate is one of the most sumptuous monuments of the Imperial age, the **Peirene Fountain**, named after the young Peirene who, after having shed many tears over her dead son, was transformed by Artemis into a spring.

The temple building, dominating the Corinthian agora, consecrated to Apollo: the heavy columns rise against the dark background of Acrocorinth.

Remains of the Temple of Octavia.

Panoramic view of the ruins of the Corinthian agora.

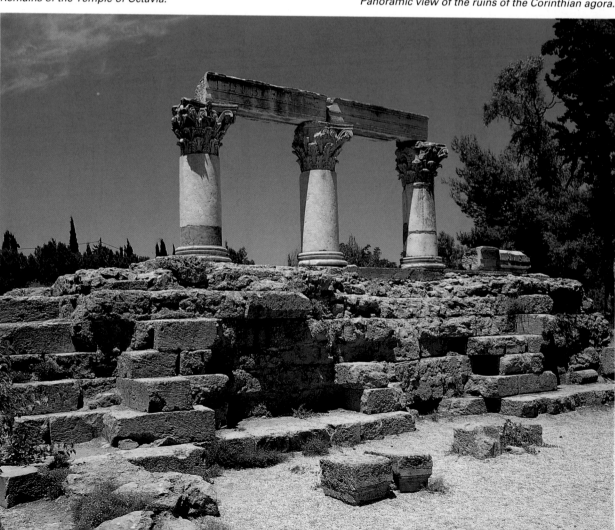

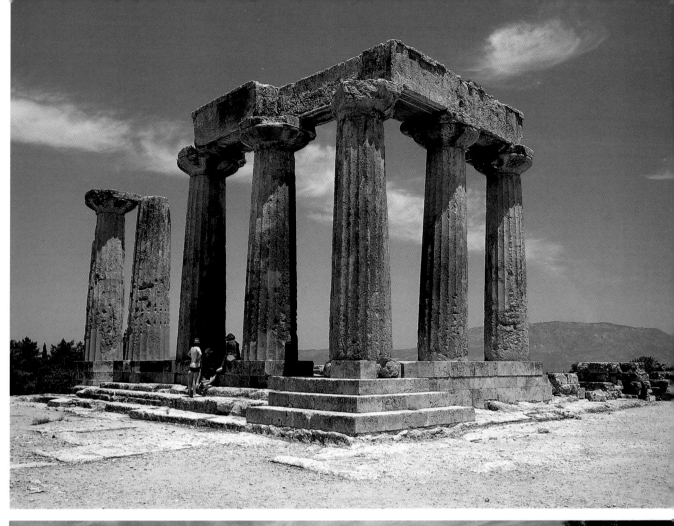

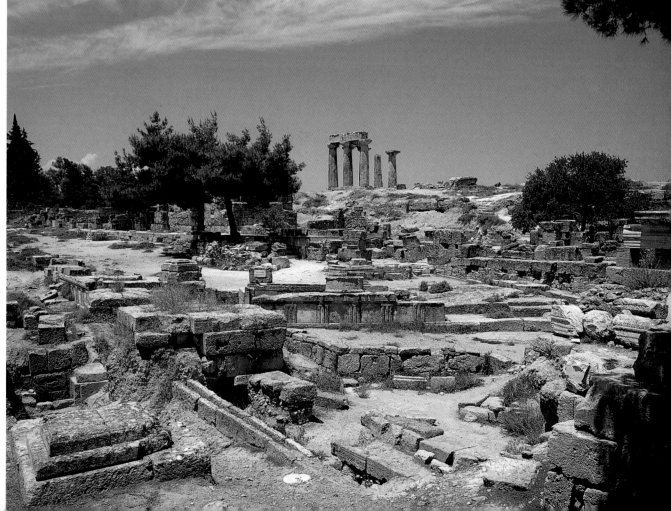

The lines of ramparts and gates rising to the Acrocorinth stronghold.

Near the fountain is situated the *Peribolos of Apollo* (1st century BC) with its Ionic colonnade, north of which have been excavated thermal buildings identified as the *Baths of Eurykles* extolled by Pausanias. On the west side of the Lechaion Way are visible the remains of the *Roman Basilica*. At the center of the *agora*, delimited to the south by the foundations of a *stoa*, arises the *bema*, a marble podium on which the Roman officials addressed the people and Saint Paul preached. The most significant monument outside the perimeter of the *agora* is the *Temple of Octavia*, dedicated to the deified Empress. From the *acropolis*, closed in by close-set Byzantine and Turkish gates and ramparts, we can enjoy an enrapturing panorama and feel the influence of the many traces left by time, the most ancient of which are the remains of the *Temple of Aphrodite* which at one time stood on the highest point of the ancient natural stronghold.

ARCHAEOLOGICAL MUSEUM

The museum, located at the foot of Acrocorinth, houses collections of the most interesting discoveries made during excavation of the *agora*. The *ceramic art* of Corinth is well-represented: it is said that the most ancient of the great Greek schools of painting originated in the center of the city. In the museum we also find some pieces in the Mycenaean style, among which the tall *cups* from the 8th century BC, and in the Geometric style, but the most fascinating finds are those dating to the Proto-Corinthian and Corinthian periods. These went beyond the very strict limitations imposed by Geometric art: the elegance with which the Corinthian artists created the filigree of the painted

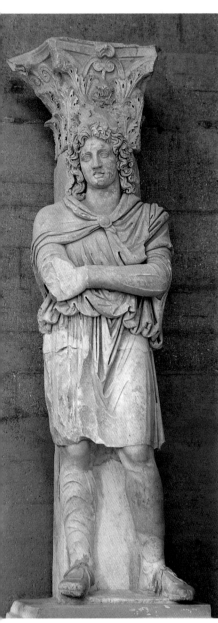

Colossal statue of a barbarian prisoner from the facade of the Roman basilica (2nd century BC).

Corinthian oinochoë with animal motifs (6th century BC).

Refined example of a Proto-Corinthian olpe (7th century BC) with hares: of note the use of graffito and the pictorial resolution.

Bucolic scene in a floor mosaic from a Roman villa (2nd century BC), thought to be a copy of a 4th-century BC painting by Pausias of Sikyon.

Mosaic from a Roman villa: head of Dionysos framed by concentric geometric patterns.

compositions and the first plant and animal motifs are superb examples of an art that dominated the Mediterranean from the mid-7th century to the mid-6th century BC. The Proto-Corinthian ceramics were the first to be widely exported from Greece and their fortune declined only in about 560 BC with the rise of Attic ceramics, which reached a never-equalled level of quality. The most representative finds of early Corinthian production, still linked to orientalizing motifs, are a 7th-century BC *oinochoë* with superimposed friezes in which are painted processions of animals and background ornamentation consisting of refined rosettes, and a small *olpe* (early 7th-century BC), the form and the central motif of which, a dog chasing a hare, bear witness to the superb taste of the Corinthian masters, who were capable of using simple means of expression to create extremely refined scenes. The globe-shaped *aryballos* from the 6th century BC, depicting a scene of a dance and with an inscription

running along the figures, is considered a masterwork of measure and elegance and is testimony to the development of Greek painting as it learned to impart a sense of movement to the figures and to adapt them to the pottery surfaces. In the section dedicated to the sculptures and reliefs of the Roman era, of particular note are the two colossal statues of barbarian prisoners, from the Roman basilica on the *agora*, where they were placed to symbolize the prostration of the enemy before the Roman conqueror. Another interesting piece from the Roman era (1st century AD) is the marble head of the *goddess Tyche* (Fortune) wearing a curious crown showing the walls of Corinth. Also extraordinary are the floor *mosaics* from Roman buildings of the 2nd century BC: one of these is thought to be a copy of a 4th-century BC painting by Pausias of Sikyon. In the same room as the mosaics, a series of objects in *bronze, ivory and glass* and various *Byzantine ceramics*.

NEMÉA

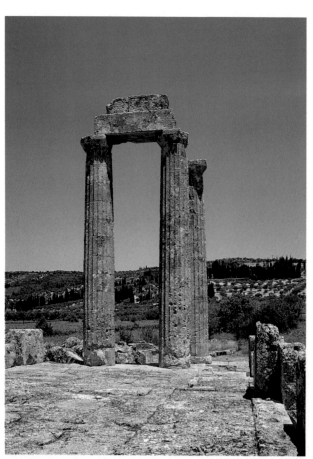

Neméa, situated on the border between Argolis and Korinthia, is universally known for Herakles' "labor" against the lion bearing the city's name. But there is another story linked to this ancient center: that the Seven, on their march against Thebes, stopped at a spring where they found the young Hypsipyle with the infant prince Opheltes in her arms. The woman, in order to respond to the questions posed by the heroes, set the child on the ground, where he was bitten by a snake and died. It was in his honor that the pan-Hellenic Nemeian Games, open to all of Greece, were celebrated every two years. Of the ancient site there remain the ruins of the imposing **Temple of Zeus** (330/320 BC) on which the sculptor and architect Skopas worked. The peripteral Doric (6x12) edifice was distinguished by extremely tall columns (10 meters), of which three are still standing and support fragments of the architrave. Not far from the temple are the ruins of a palestra and a track: the latter probably belonged to the nearby stadium for the pan-Hellenic games, excavated only recently.

The new **Archaeological Museum** is of great interest.

The three remaining standing columns of the Temple of Zeus in Neméa; the two columns of the prónaos support fragments of the architrave.

View of a portion of the peripteral Doric temple, consisting of the prónaos and the adyton reserved to the cult of Opheltes.

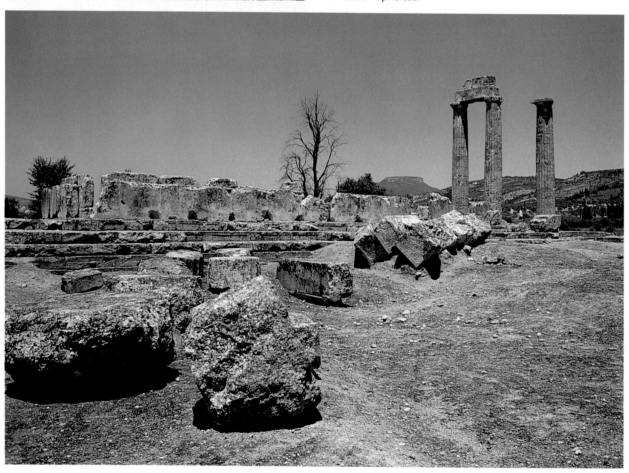

MYCENAE

This Peloponnesian city, rising above the Inachos valley at the north-west edge of the fertile plain of Argos, has been highly favored by its geographical position. The natural fortress, ringed by the deep Kokoretsas and Chovos gorges and protected by Mounts Agios Ilias and Zara, still hosts the suggestive ruins of a kingdom which for 400 years (1600-1200 BC) was the most powerful in all of Greece. The charm of Mycenae is linked to the Homeric poems that tell of the kingdom of Agamemnon with its "beautiful palaces and rich in gold". According to tradition, the original founder of the city was Perseus, son of Zeus and Danae, and the city walls were raised by the mythical Cyclops'. The kingdom passed to Atreus and Thyestes, sons of Pelops, who following their father's curse sought shelter in Mycenae. Here they gave rise to the glorious and unfortunate dynasty of the Atreids, which earned the condemnation of the gods after the macabre banquet at which Atreus served his brother the flesh of the latter's own sons. Agamemnon, son of Atreus, hero of Homer and Aeschylus, commander of the Achaian army in Troy, is the symbol of the great power achieved by the city in historical times; his death, by the hand of his wife Clytemnestra and her lover Aigisthos, is symbolic of the destiny of the

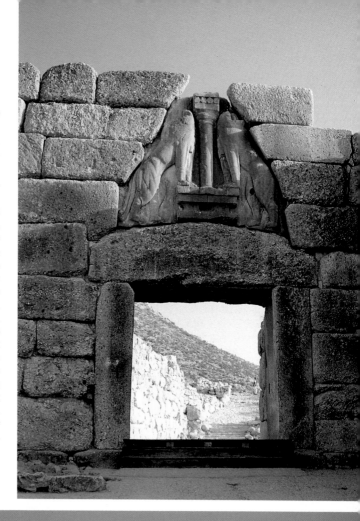

The Lion Gate with the Atreid arms sculpted in the "relieving triangle".

View of the Argolid plain from the Mycenae fortress.

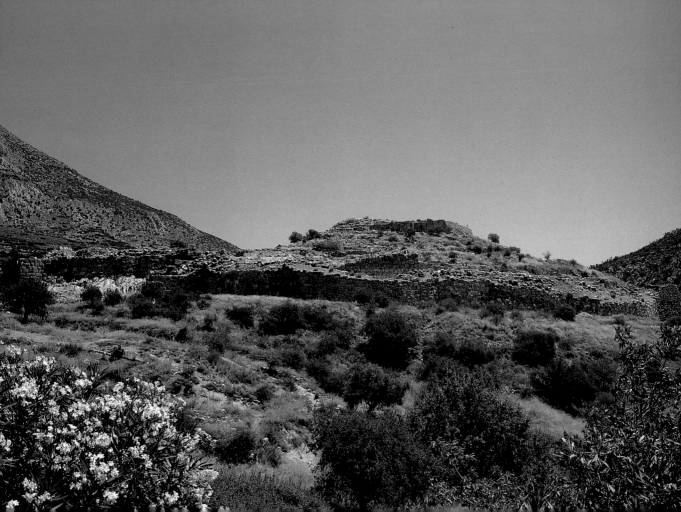

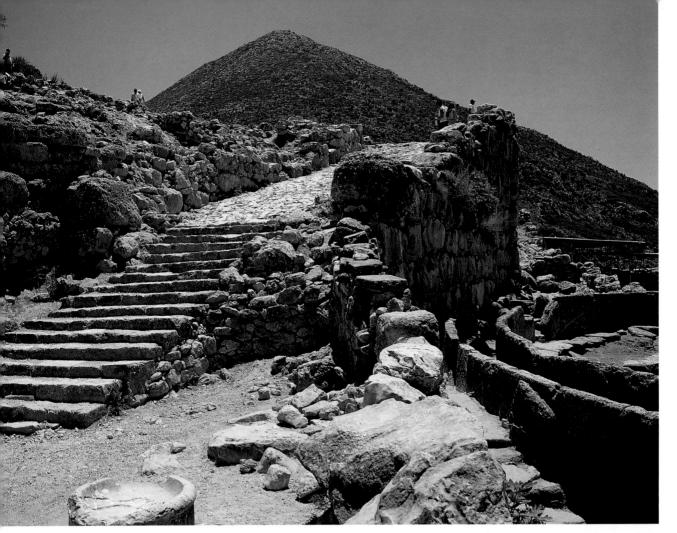

The initial portion of the great ramp leading up to the citadel.

Grave Circle A of the Royal Tombs: the area is delimited by a double row of stone slabs (1.50 meters) planted in the earth.

wretched dynasty. Evidence of settlement dates as far back as the Early Bronze Age (3000-2000 BC) and continues through a phase of the Middle Bronze Age (2000-1600 BC) and the rise of a new population which left us the first royal shaft graves in Circle B, located outside the walls and discovered during excavations conducted in 1952. The Late Helladic I period (1600-1500 BC), characterized by the considerable development of that civilization, was followed by a moment of extreme artistic and economic splendor culminating in the years of the destruction of Knossos (1440 BC); that is, in the Late Helladic III, during which the acropolis was fortified, homes and storehouses were built, and the monumental *thóloi* were raised. After two sacks, one on the heels of the other, the 11th century BC marked the fall of Mycenaean civilization. Traces of the occupation of the acropolis in the centuries that followed are confused but persistent testimony to the continuity of this center, which, after having participated in the Persian Wars, was taken by Argos in 468 BC and later occupied by the Romans. It was the great Schliemann who, after having discovered Troy, in 1876 began excavating, together with his wife, the long-lost tombs on the acropolis, where he hoped to find the bodies of the members of the mythical Homeric dynasties; he did recover an enormous quantity of gold objects, among which the famous mask presumed to portray the face of Agamemnon,

now in the National Museum of Athens, together with numerous funerary steles. In 1877, the Greek Stamatákis discovered the sixth royal tomb and in 1878 completed excavation of the Treasury of Atreus. From 1880 onward, excavation was resumed by the Greek Archaeological Society, in collaboration between 1919 and 1956 with the British School of Athens. We approach the imposing ruins through the entrance to the citadel, the **Lion Gate**, so named for the relief on the architrave representing two facing lionesses, their front paws resting on two altars with a column at the center: the symbol of the power of the Atreid house. The gate, the only example of large-scale sculpture from this period, is constructed of four blocks of conglomerate stone, a sill and two uprights; it is 3.10 meters wide at the top and 2.95 meters at the bottom. Since it was protected on the right by a deeply jutting section of the wall, enemies nearing the gate could be attacked on the flank not protected by their shields. It would seem that the gate itself was composed of two wings and that it was closed by means of a sliding bar, signs of which remain in the form of holes on the uprights. Inside the mighty **circuit walls** (6 meters average thickness), we see on the right **Grave Circle A** of the Royal Tombs, in which are found the 6 shaft graves discovered by Schliemann and Stamatákis. The necropolis includes family and royal tombs, in which the corpses of 19 persons have been discovered.

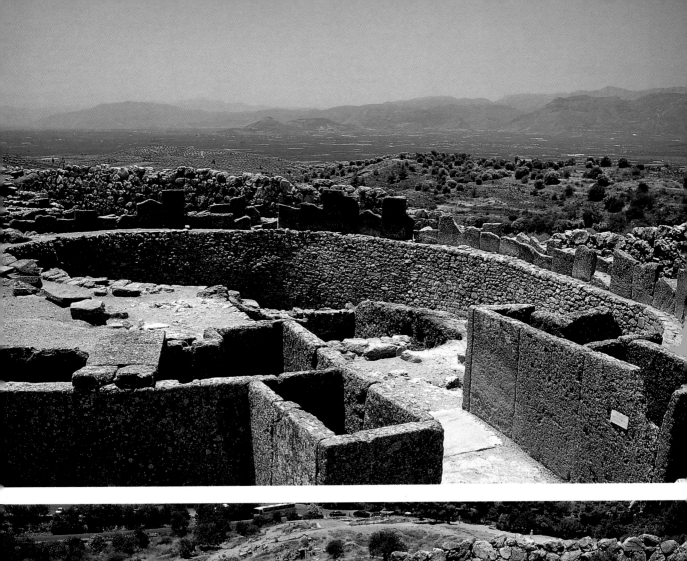
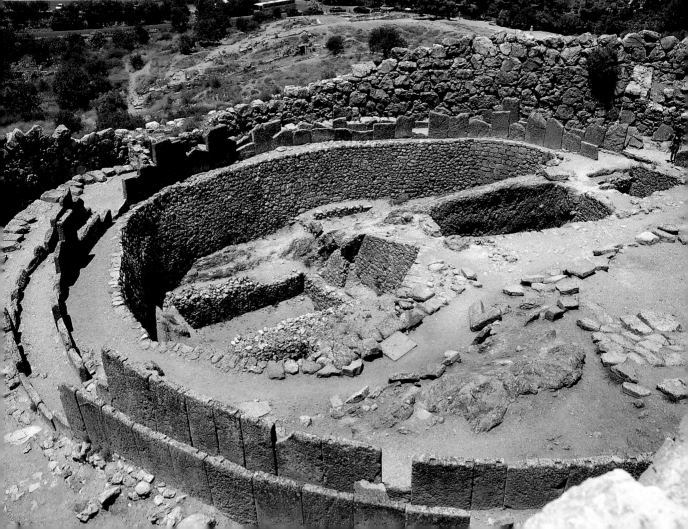

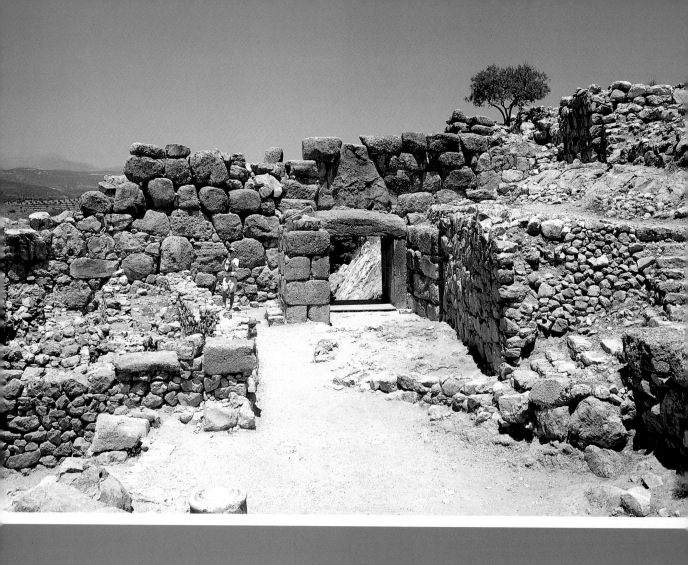

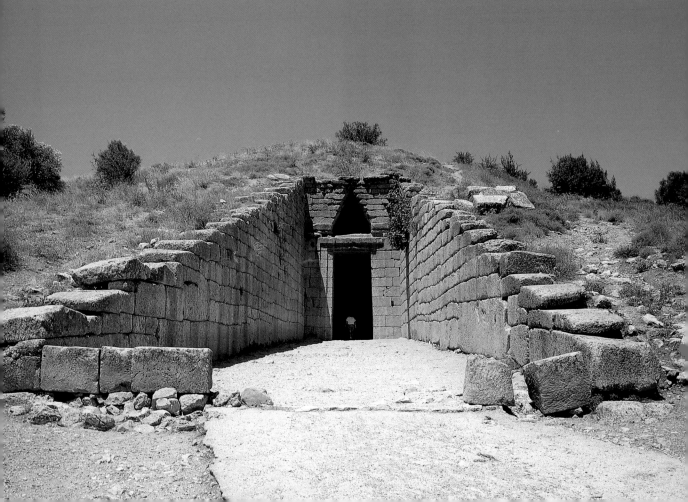

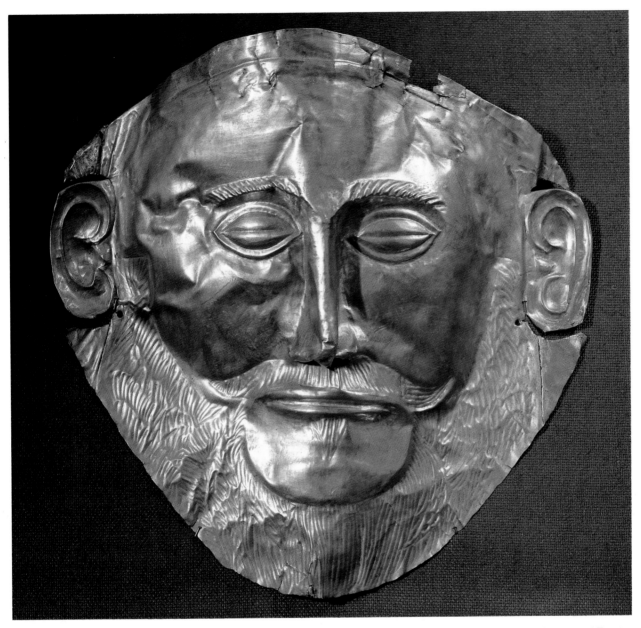

The Lion Gate from inside the fortified acropolis.

The corridor (dromos) and the facade of the thólos known as the Treasury of Atreus (ca. 1250 BC).

Gold mask found in Grave Circle A of the Royal Tombs: attributed by Schliemann to Agamemnon.

North of Grave Circle A are visible the remains of the **granary**, and to the south those of **homes**. The great ramp of an imposing "royal way" rises from the Lion Gate to the palace, the earliest portions of which date to 1350 BC. The simple layout centers on the **large courtyard**, surrounded by corridors and private rooms from which, through the throne-room, the vestibule and the portico, we enter the **megaron** in the southeast wing. The *megaron* is a noble and richly decorated unit, characterized by four central columns surrounding a circular hearth in painted stucco. At the northernmost point of the citadel is the *rear or North Gate*, from which, according to the myth, Orestes fled after having killed his mother, so completing the tragic destiny of the royal house of Atreus. At the northeast corner is the *cistern*, flanking the postern gate. Outside the citadel we find,

beyond **Grave Circle B**, mentioned above, two **tombs** thought to be those of **Aigisthos** and **Clytemnestra**, characteristic examples of the evolution of the domed *thólos* tombs. Our visit to the ***thólos* of Atreus**, also known as the Treasury of Atreus, brings to a close our journey through the monuments of Mycenae. This is one of the most mature examples of a royal tomb, with a circular funerary chamber hewn into the slopes of a rise and accessible through an uncovered passageway. The *corridor* (*dromos*) approaching the Treasury is 36 meters long, with walls in enormous, uniformly-cut blocks of stone. On the *facade* (11 meters high), in the past flanked by two decorative half columns, is a "relieving triangle" which was probably originally decorated with marble panels. The *thólos* is an isodomic structure with an opening in the ceiling.

ARGOS

The innumerable myths linked to the origins of Argos and to the succession of royal dominions there are testimony to the power of this city on the Argolid plain and the prestige of its progeny in classical Greece. Even the River *Inachos*, which irrigates the fertile plain, is the subject of a fascinating myth in which it is at once god and sovereign of the city and later father to that Phoroneos who in the Peloponnesian legends is the bringer of civilization, of the use of fire and of the cult of the Argive Eve. The myth recounts how the eponym of the city was Argos, son of Zeus and of Niobe, and how many centuries later Danaos, progenitor of the line from which descended Perseus, founder of Mycenae, and the great Herakles, came there from Egypt. Argos rose to power at the beginning of the 7th century BC under Fidon, and competed with Sparta for supremacy in the Peloponnese. Its decline, following Roman occupation, began with the Gothic invasions. At the foot of the hill-fortress of **Lárissa** lie the ancient *agora* (5th century BC), and the majestic *theatre* hewn into the rock of the acropolis at the beginning of the 3rd century BC (and later converted by the Romans), with a presumed capacity of 20,000 spectators: the largest

Partial view of the ruins pertinent to the Roman baths, to the northeast of the agora.

The theatre, built into the southeastern slope of the Lárissa Hill (late 4th to early 3rd century BC).

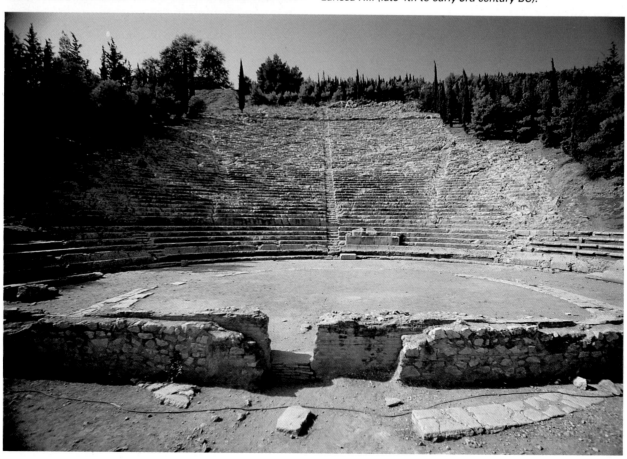

theatre discovered in Greece. Nearby are the remains of the *odeion*, of the sanctuary of Aphrodite and of the Roman baths, one of the most imposing examples of this type of structure in all of Greece. On the Lárissa Hill, fortified as early as the 6th century BC, are the foundations of two *temples* dedicated, respectively, to Zeus and to Athena.

MUSEUM

The museum displays the finds of the excavations by the French Archaeological School in the Argos area and by the American School around Lerna. As we enter, we see in the **vestibule** the enormous funerary *pithoi* as well as many examples of Middle Helladic, Mycenaean and finally Geometric *ceramic art*. The high level of quality attained by the Argive potters during the Geometric period can be seen in numerous vases with refined linear decoration, often depicting horses and horsemen, the artistic level of which equals the monumental results attained by coeval Attic ceramics. The fragment of a *krater* showing Odysseus and Polyphemus (7th century BC) is an extremely rare document of the development of Argive art. Also from the ancient necropolis is a group of objects including a beautiful bronze *suit of armor*, complete with helmet (8th century BC).

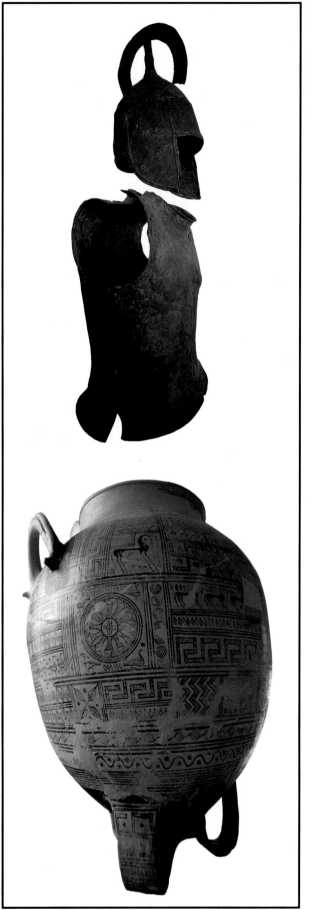

Bronze suit of armor with helmet from a late Geometric tomb (8th century BC).

Monumental vase supported by three feet, with painted geometric and animal motifs (8th century BC).

Geometric krater (8th century BC): in the central metope, the characteristic Argive ladder fret design.

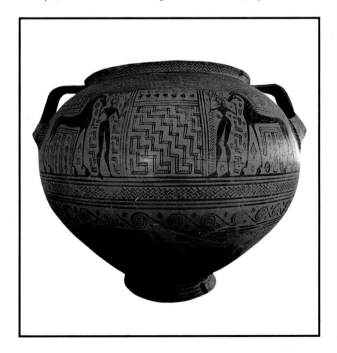

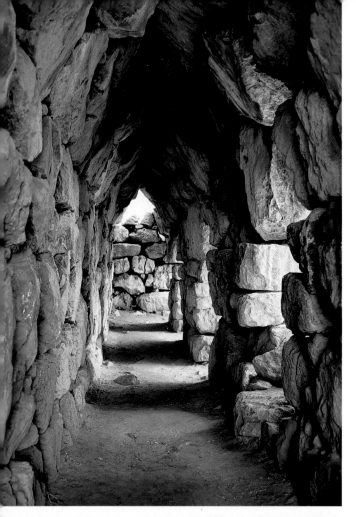

TIRYNS

An intricate mythological plot links Argos, Mycenae and Tiryns, the three principal cities of Argolis. Of Tiryns, a short distance from Nauplion and only 2 kilometers from the sea, there remains the ancient settlement that menacingly dominates, from its **Cyclopean walls**, the fertile plain with its citrus groves. Legend interpreted the heavy toil involved in building the fortress of enormous blocks of stone (estimated to weigh 14 tons each) as a prodigious event: Proitos, descendent of Danaos of Argos and founder of Tiryns, was aided in the work by the Lycian Cyclops', to whom are attributed many other monuments of prehistoric Greece. The **acropolis**, the history of which spanned the centuries from 1400 BC through 1200 AD, when the fortress was taken by the Dorians, never again to regain its ancient splendor, developed on **three levels**: upper, middle and lower. Today there remains evidence only of the latter and of the palace area. A *great ramp* leads through a gate (the dimensions of which are similar to that of Mycenae) to the citadel, the interior of which is animated by the long narrow *corridors* linking the walls with the courtyards and the *casemates*, often used as store-rooms, that opened off the central courtyard. Here stood the **Royal Palace** with its characteristic *megaron* containing the throne; the magnificence of the decoration is apparent in the frescoes preserved in the National Museum of Athens.

One of the galleries built into the thick walls of the fortress: the casemates were used also as store-rooms.

Access ramp to the acropolis.

Floor-plan of the palace.

One of the long, narrow corridors between the walls.

Angular view of the huge stone blocks used to build the encircling walls.

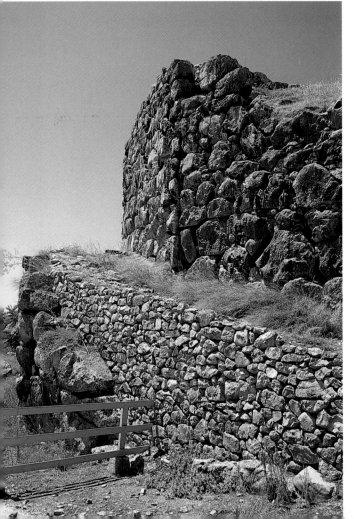

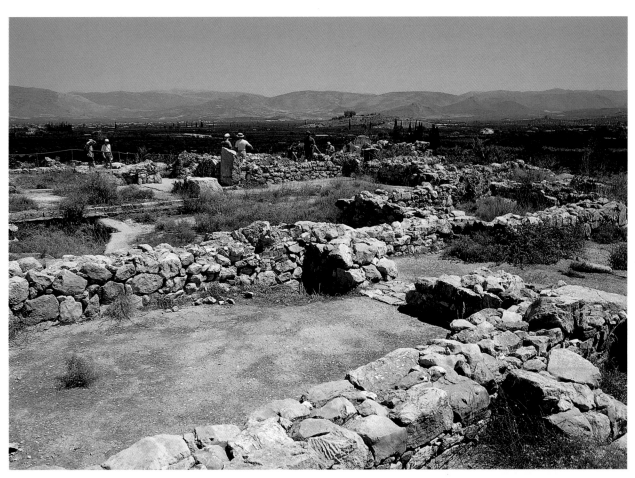

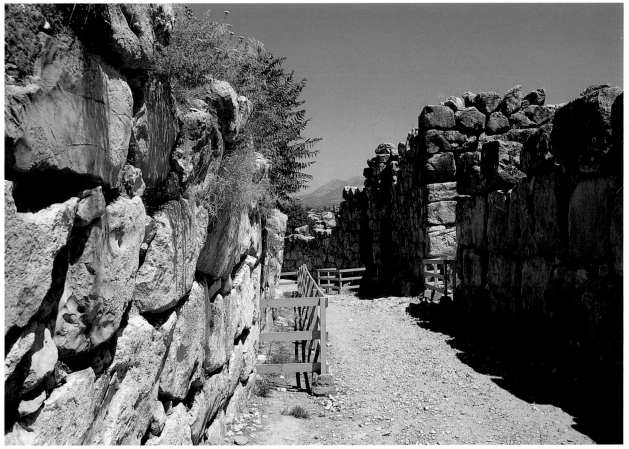

NAUPLION

The small coastal city of Nauplion, today Náfplio, is the most attractive on the Gulf of Argolis. The city center, guarded by the **Boúrdzi Fort** built by the Venetians on a picturesque islet at the entrance to the gulf, extends along the shores of the bay and is protected by the powerful **Palamedes Fort** and the **Citadel of Acronauplia**. From the Palamedes stronghold, fortified by the Venetians in 1686 and reached by 1000 steep steps, we can enjoy magnificent views of the surrounding panorama. Of the city, said to have been founded by the great navigator Nauplios, nothing instead remains. The name *Palamedes* is the only testimony to that ancient time when the astute and brilliant Palamedes, son of Nauplios, made the city famous through his invention of the game of dice and the letters that completed the Greek alphabet. The city became an important center in the 12th century under the Byzantines of Prince Sgourós, who left their mark in the form of fortifications (*Acronauplia*), and remained so under the Franks and the Venetians, until proudly becoming the capital of the independent Greek state from 1829 to 1834.

View of the city.

The Palamedes Fort rising above the rocky hillside (altitude 215 meters).

View of the city of Nauplion and of the Acronauplia from the Palamedes Fort.

The port in the shadow of the fortress.

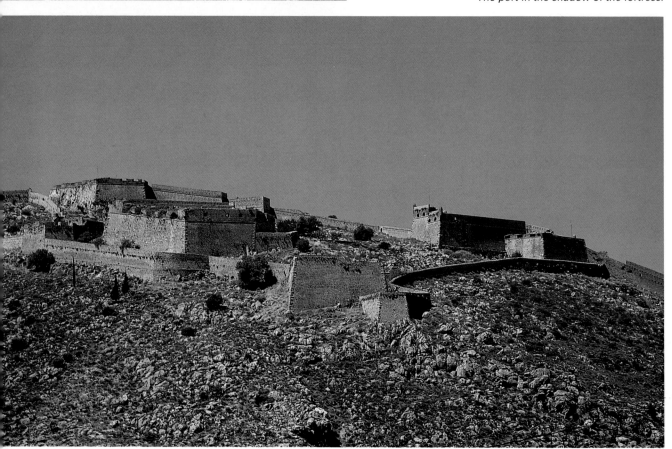

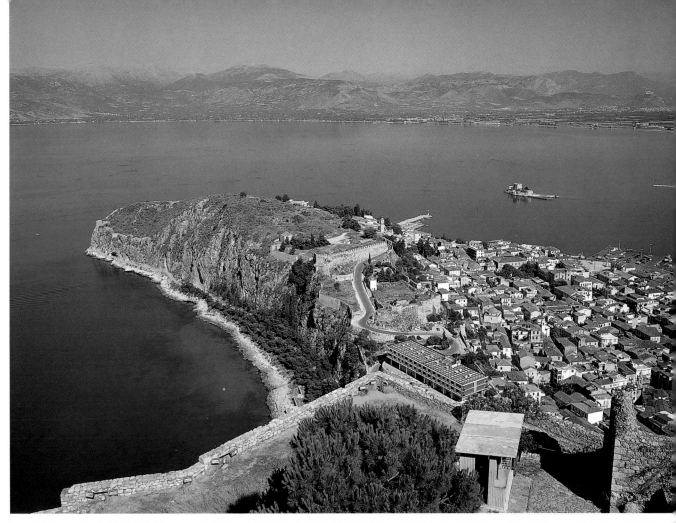
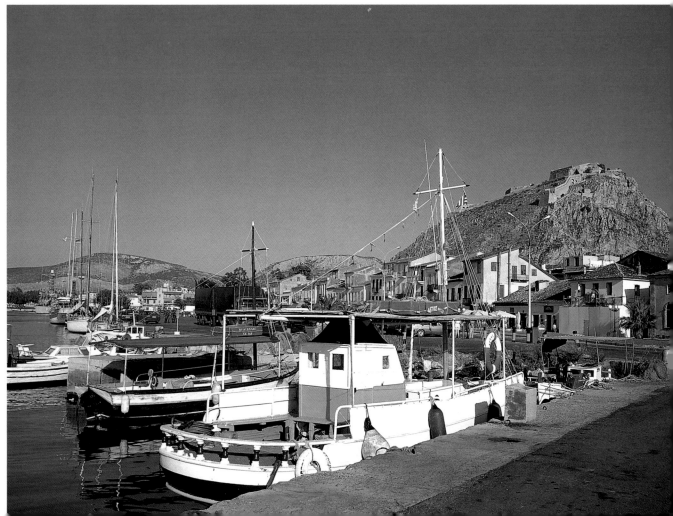

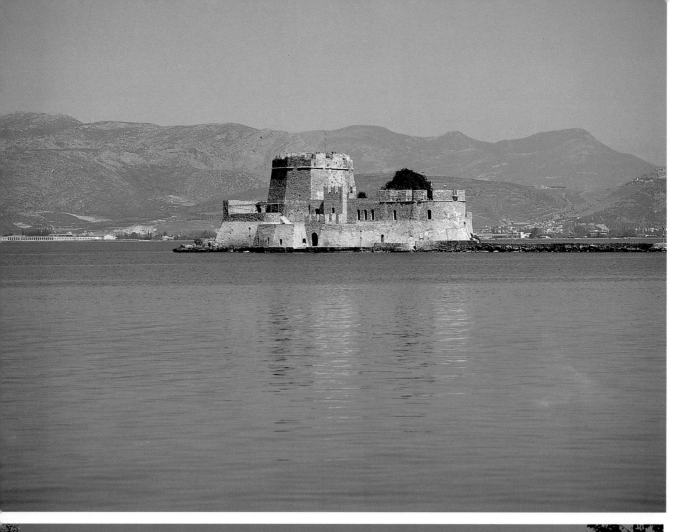

MUSEUM OF FOLK ART

The museum is located in an elegant **neo-Classical building** in the historical center of the city, surrounded by other significant monuments to Nauplion's modern history such as the **Byzantine Church of Saint Sophia**, the Venetian church of **Saint Nicholas** and the **Vuoleftikon**, the Turkish mosque in which subversive meetings were held during the period of Greek liberation. The museum houses an interesting collection of local *folk costumes*, on display together with jewelry and *weapons*, and an even more fascinating collection of *weaving tools*, complete with accurate descriptions of the use of each. Its extremely rational exhibit plan won the museum a prize in 1981.

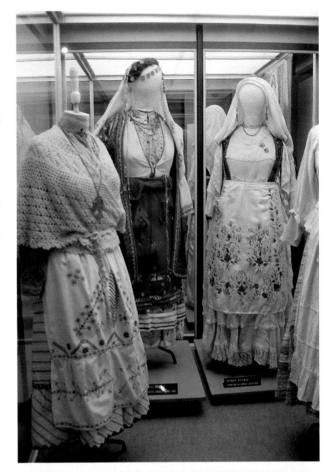

Boúrdzi: the islet fortified by the Venetians in the 15th century.

One of the most beautiful buildings on the city's main square, built by the Venetians, today the home of the Archaeological Museum.

Exhibits of local costumes.

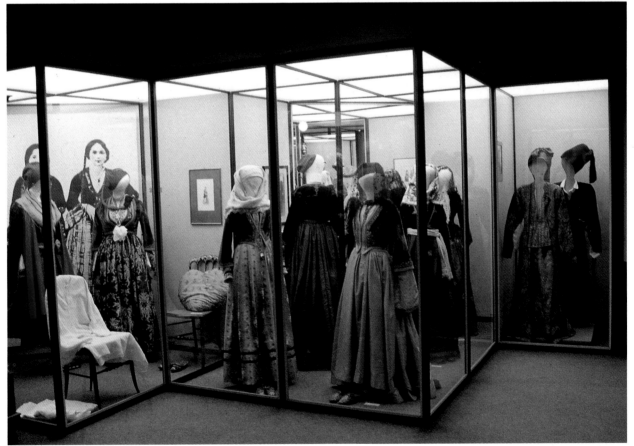

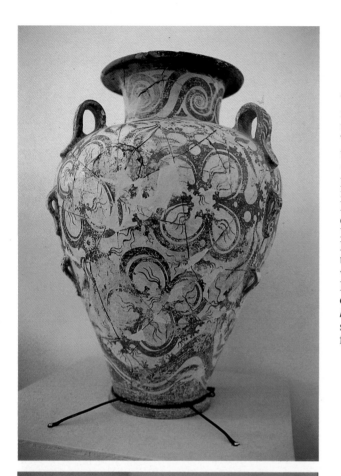

ARCHAEOLOGICAL MUSEUM

This museum is located in another of the center's most beautiful buildings, built in Baroque style by the Venetians in 1713 and later used as an arsenal. The museum exhibits archaeological finds from throughout Argolis, from the *prehistoric era* to the *Classical* and *Hellenistic* periods: the archaeological patrimony of this region, on the whole prehistorical, is thus shared out between the local museum and the National Museum in Athens. All the phases of the evolution of ceramic art are represented, from the Neolithic (finds from Asine e Berbati) through the Late Helladic and Mycenaean to the Geometric and the Archaic periods; the collection includes the work of the different Argive, Attic, Corinthian and Boeotian *ateliers*. From *Asine*, one of the oldest centers of Argolis, comes the well-known *male head in painted terracotta*, which remains an outstanding work among the scarce examples of plastic finds of this period. Alongside are various *small ter-*

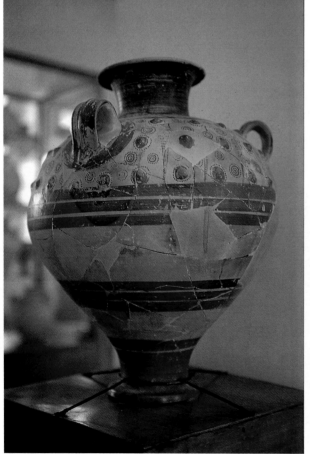

Mycenaean funerary amphora with floral friezes (13th century BC).

Funerary amphora with animal and geometric elements.

Series of small Mycenaean idols (13th century BC).

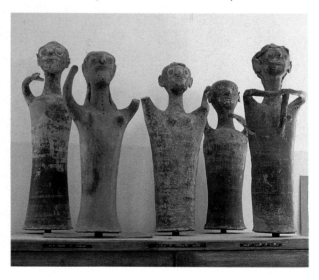

racotta figures, most of which from Mycenae, testimony at once to the early appearance of the Ctonic cult among the prehistoric inhabitants of the area and to their desire to create plastic representations of the human figure. Outstanding among the objects from extremely remote times, including the *Linear B tablets*, is the 16th-century BC *bronze suit of armor* found in Dendra (Midea), crowned by a *boars' tooth helmet* identical to that described by Homer in the *Odyssey*.

Further evidence of the military art of prehistoric times can be found on the second floor: the beautiful *bronze helmet* from a tomb in Tiryns and a series of miniature *terracotta shields*, used as votive offerings. Together with the *steles*, from the shaft graves of the great Grave Circles in *Mycenae*, with figures in low relief, we also find many *frescoes* from the palaces of Tiryns, Pylos, Orchomenos and of Mycenae itself. Most are from the post-Palace period (13th century BC) and their figurative repertory is quite uniform: processions of female figures, in which the participants are painted in clothing and with hair-styles very similar to those of Minoan decoration.

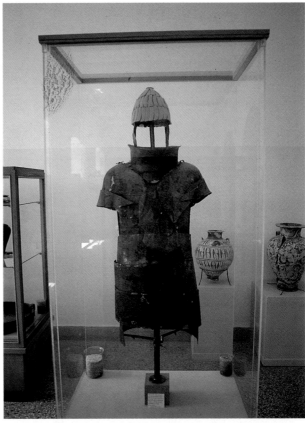

Armor found at Dendra, composed of overlaid sheets of bronze. The boars' tooth helmet (15th century BC) is identical to that described by Homer.

Fragment of a fresco from the Tiryns Palace: female figure holding sheaves, perhaps in a procession.

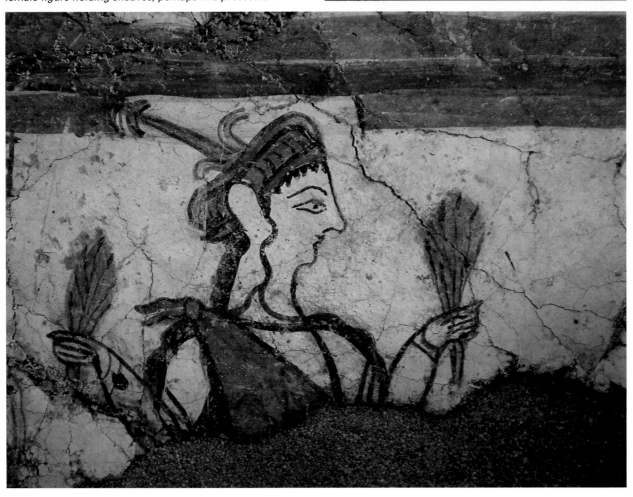

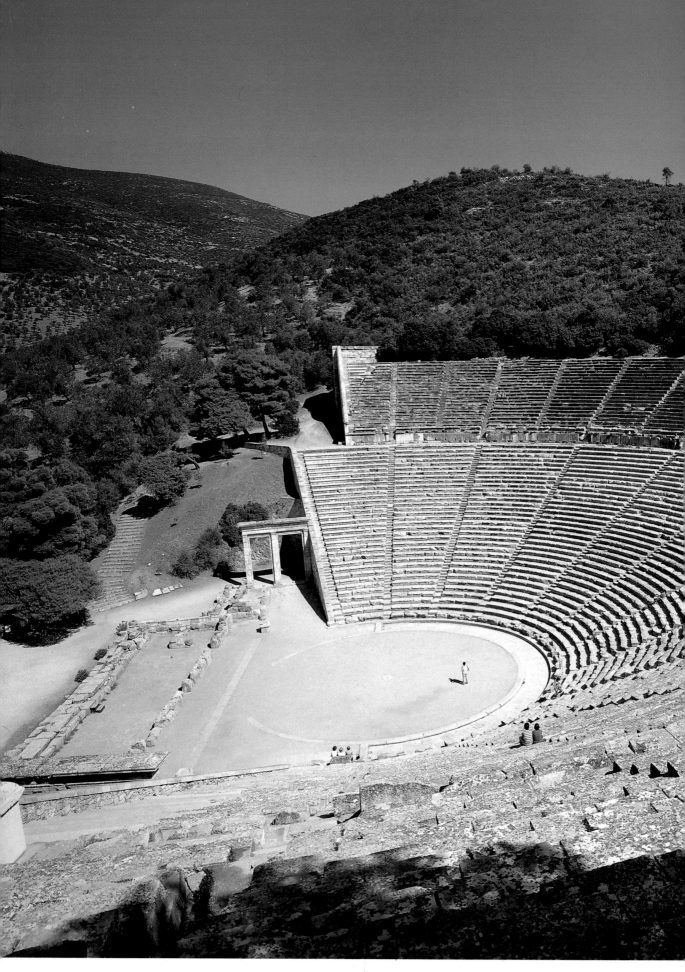

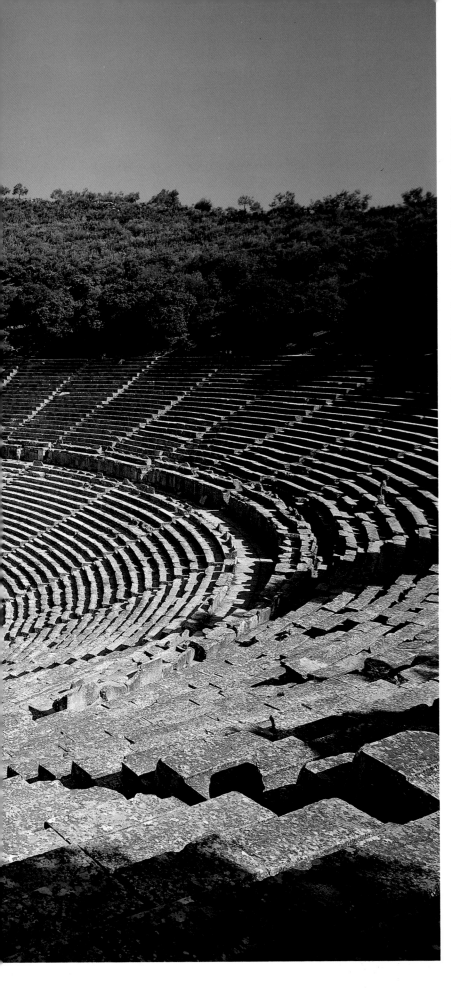

EPIDAUROS

The impervious, mountainous district of Epidauros in Argolis turns on the ancient city of Epidauros and its port, which provided the inhabitants of the city an excellent outlet onto the Aegean Sea, and the solemn sanctuary of Asklepios, around which the life of the inhabitants of this territory centered. The history of the city is not particularly significative, even though despite its being overshadowed by Argos it succeeded in maintaining its independence and in affirming itself as a maritime and commercial center of some importance. The history of Epidauros is in truth that of its **sanctuary**, which arose in a plain delimited by the *Tithion*, *Koryphasaion* and *Kynortion* mountains and was bathed by numerous natural springs and watercourses with acknowledged therapeutic virtues. Asklepios, the Thessalian demi-god son of Apollo and the mortal Koronis, was educated by the centaur Cheiron, who taught him the art of medicine which he used to bring many heroes back to life. He was, however, for this reason struck dead by Zeus, who feared the terrestrial order would be upset by such power. The **Asklepieíon** (the same name was given to all the various sanctuaries dedicated to the god) came into being in about the 6th century BC. Initially, the cult coexisted with that of Apollo Maleatos, whose sanctuary stood on the northern slopes of *Mount Kynortion*. Of the latter there remain the ruins of the *Classical building* (4th century BC) which arose on an ancient site of worship where in the Mycenaean era sacrifices were offered to the god of health. The sanctuary of Asklepios, the most famous in Greece, was built in the 4th century BC by the architect Theodotos and after its destruction by Sulla in 86 BC was rebuilt by Antoninius Pius. It

The theatre built by Polykleitos the Younger (ca. 350 BC): the cavea divided into two sectors, the orchestra, the monumental entrance of one of the two access corridors (parodoi) and the remains of the skena.

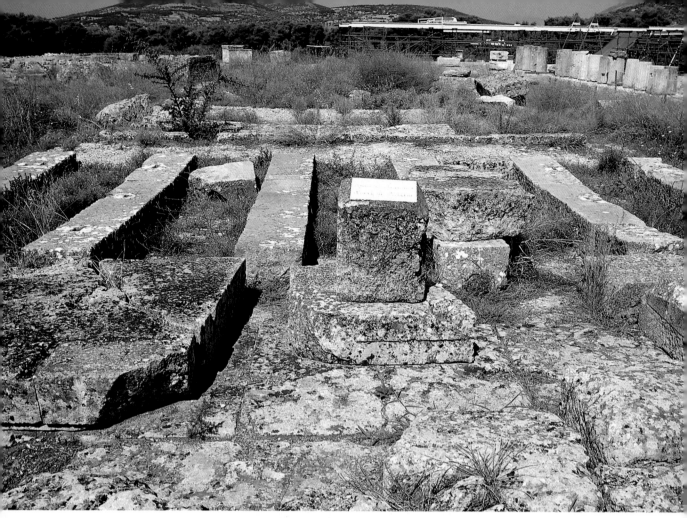

Foundations of the temple of Asklepios, built by the architect Theodotos (380 BC), the cella of which contained the huge statue of the god seated on his throne.

The perimeter and a few rows of stone seats of the stadium, located south-west of the sanctuary.

The ruins of the famous and mysterious Thólos, a masterpiece of Classical architecture.

was definitively closed by the Emperor Theodosius. The Doric peripteral **temple** (6x11) consisted of a cella in which was set a gigantic gold and ivory statue of Asklepios with a staff and a serpent, the god's characteristic attributes. To the east arose an altar, and nearby was the most characteristic cult monument: the *abaton*, a double-columned portico within which the faithful, after having purified themselves in the healing waters of the nearby well, lay down awaiting to dream the prescriptions of the god. A short distance from the temple are the foundations of the **Thólos** built by Polykleitos the Younger as a circular peristyle with two concentric colonnades, a central cella and subterranean chambers. Other buildings of which ruins remain were the *katagógeion*, hotel for the pilgrims to the sanctuary, the *gymnasium*, the *odeion* and the *stadium*. The cult complex, which in ancient times was accessible through the monumental *propylaia* to the

north, today stands behind the most famous and best preserved **theatre** in all of Greece. Pausanias, ecstatic over the sight of this monument, defined it the most "harmonious" construction ever created by the Greeks. It was built in the 4th century BC by the same architect who designed the *thólos*, with a circular orchestra and 34 tiers of seats (the *theatron*) divided by 12 staircases; in the 2nd century BC, 21 rows of seats were added, bringing the overall capacity of the theatre to 12,300 spectators. The portion of the theatre in which the performances took place was divided into a true stage, in the facade of which, with its Ionic columns, the scenery panels slid, and a front proscenium (podium). Yet today, during the summer, we can attend theatrical performances and enjoy the sensational acoustics created by the theatre's perfect design and the magnificent adaptation of the construction to the natural site.

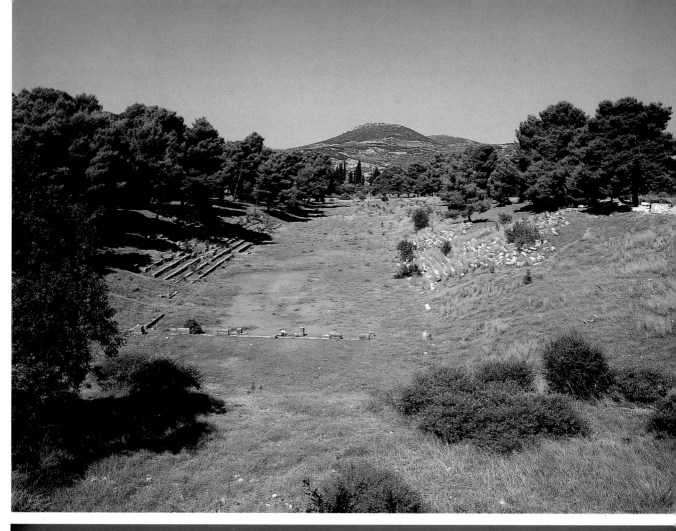

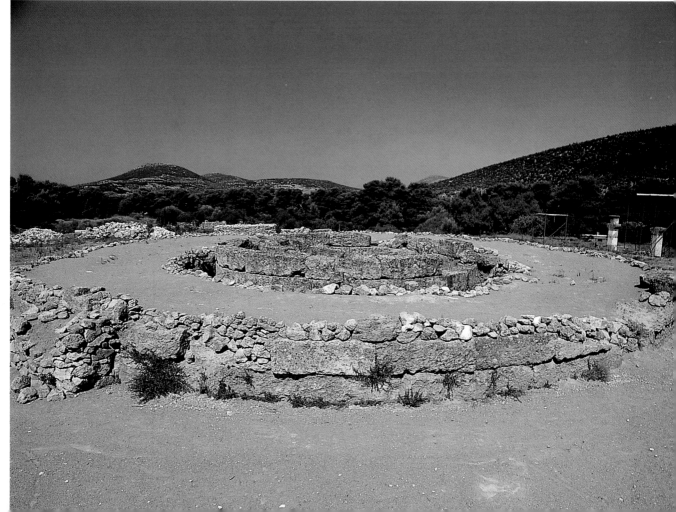

MUSEUM

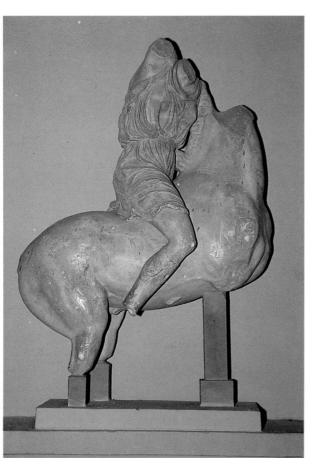

The museum is a creation of the architect Kavvadiás, who in 1879 began excavation in the sanctuary area for the Greek Archaeological Society, work that is today carried on by the French Archaeological Society. The collection of *inscriptions* is the liveliest nucleus of the exhibits of finds linked to the famous cult site: passages commenting *votive offerings*, accounts of the miracles performed by the god, texts explaining the ritual practices and even the construction of the buildings in the complex are the life-giving soul of so many inert monuments devastated by time. Together with these documents there are also showcases dedicated to the *surgical instruments* used by the priests for their operations. Typical examples of 4th-century BC *sculpture* are the *votive statues* representing *Asklepios*, *Hygieia* and *Aphrodite*. Still more refined are the *reconstructions* of the temples of Asklepios and of Artemis exhibited together with the casts of the plastic figures that decorated their *pediments*. The raised portion of the *Thólos* has also been reconstructed, using elements recovered during the excavations. With its colonnade, the entablature, the sumptuous frieze that ran above it, the monumental door, the coffered ceilings and polychrome pavement, it was one of the most richly decorated monuments of antiquity. Last of the architectural exhibits are the reconstructions of the propylaia which in ancient times gave access to the sanctuary.

Amazon from the west pediment of the temple of Asklepios.

Sculptures portraying Hygieia and Athena (4th century BC).

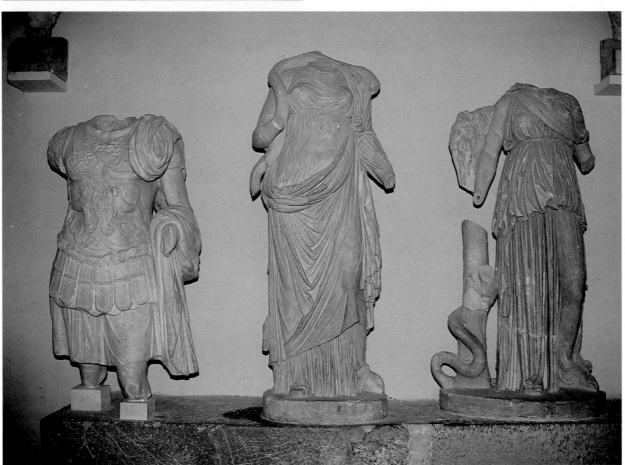

102

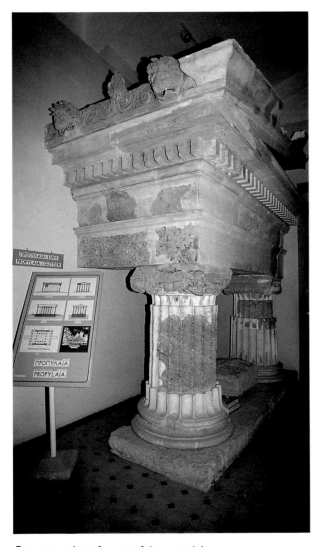

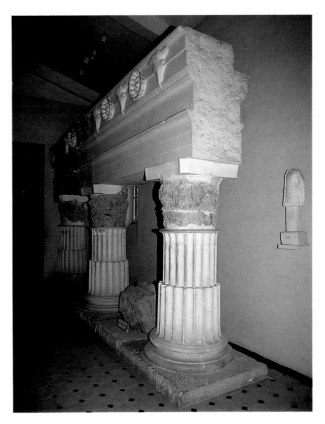

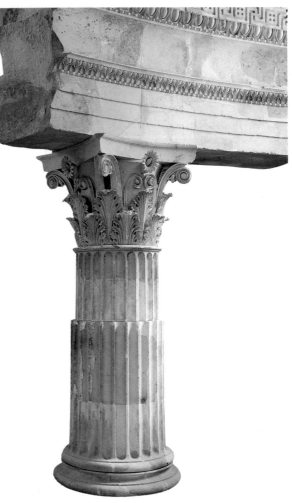

Reconstruction of a part of the propylaia.

Doric entablature inside the Thólos.

Example of the interior entablature of the Thólos.

Corinthian capital from the interior colonnade of the Thólos, believed to have been designed by the Polykleitos the Younger.

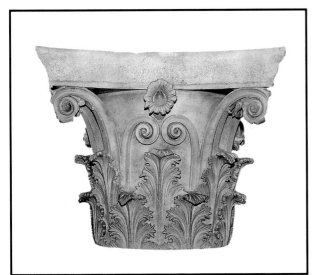

103

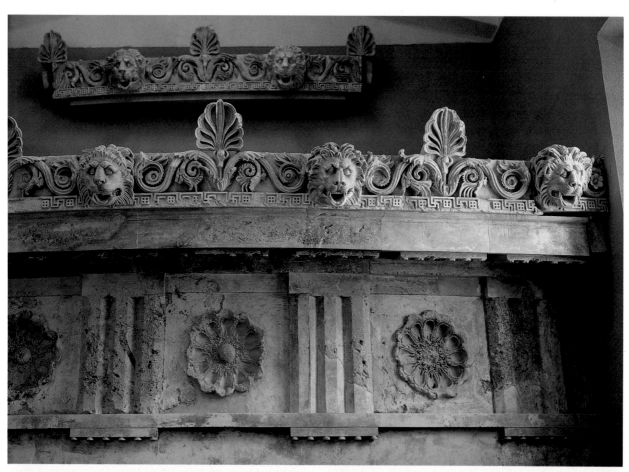

104

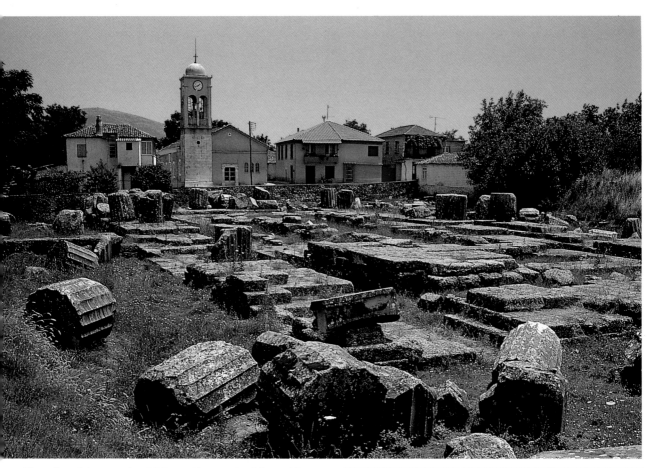

The ruins of the temple of Athena Alea, work of the architect Skopas of Páros (4th century BC).

Details of the sumptuous decoration of the Thólos: the eaves and the exterior tiling and the coffered ceiling of the colonnade.

Head of Hygieia, Health, from the temple of Athena Alea, preserved in the Archaeological Museum of Athens.

TEGÉA

Arkadia is the central region of the Peloponnese. The image of its rural pastoral territory, encircled by mountains in a sort of torpid isolation, has always evoked the myth of an enchanted place populated only by nymphs and shepherds and pervaded by the harmonious sound of the pipes of Pan, who it is said lived in this region. However that may be, the literary evocation of Arkadia as an earthly paradise is founded in the solitary lives led by its inhabitants, engaged prevalently in sheep-herding and related activities from ancient down through modern times. The cities of Orchomenos, Mantineia, Tegéa and Phigaleia, separated the ones from the others by a terrain more mountainous and impervious than one would expect of an idyllic landscape, united to give rise to this district in which myth narrates that Pelasgos, arising from the bowels of the earth, was born and ruled as its first sovereign, bringing civilization. Tegéa was the main city of the Arkadian

Scenes of pastoral life in the Arkadian region: the inhabitants continue a centuries-old tradition that has always seen them involved in pastoral activities consonant with the rocky and not particularly green land of Arkadia. The region is still today the symbol of an uncontaminated and idyllic landscape.

highland during ancient times. Of this implacable rival of Mantineia, destroyed in the 5th century AD by the Goths and rebuilt and renamed Amyklai by the Byzantines, there remain only the foundations of the famous temple of Athena Alea, to the south-west

of the walls of the ancient site along the road from Sparta to Corinth, facing the modern-day village. The **temple** was built by the great master Skopas of Páros over a pre-existing wooden building destroyed by a fire in 394 BC. The architect, who had been commissioned to realize the sculptural decoration of the building as well, gave complete and elaborate form to the architectural approach of the time which preferred the union of the orders and stressed the decorative element. The peristyle, with its singularly tall (9.47 meters in height) Doric columns (6x14), encloses a single naós surrounded by beautiful Corinthian columns in local marble, within which was set the ivory statue of Athena Alea. As original and unique evidence of the mastery of Skopas' hand remain the fragments, preserved in the Museum, of the *pediment sculptures* representing mythological scenes: the Calydonian boar-hunt on the east; Achilles and Telephoros on the west.

SPARTA

This famous city represents in history the symbol of the affirmation of the Dorians in the Peloponnese and of the birth of a civilization which was radically new with respect to the palatial monarchies that went before. The figure of Menelaos, who sought asylum in Sparta, where he married Helen and ruled, is none other than the mythical version of the history of a Mycenaean kingdom in the city then known as Lacedaemon. The original inhabitants of Sparta and indeed of all of Lakonia were probably the Lelegians. Ionian and Achaian immigrants later added to their number and founded many Mycenaean centers in the territory; under the new Dorian invaders, these peoples became the famous Helots, or natives who, although formally free, were to all effects treated as subjects. Sparta still today the capital of Lakonia, was completely rebuilt by Otho of Wittelsbach, the first King of Greece, in 1834 on the site of the ancient city in the midst of a vast growth of olive trees in the Eurotas Valley, dominated by the peaks of Mount Taÿgetos. The rigid constitutional dictates of Lycurgus, the mythical legislator, left their indelible mark on Sparta as an austere and severe city, in which the education of the young and social organization took on an essentially military cast. Public power was in the hands of

an assembly of elders (*gerousia*), over which ruled two kings known as *archegetes*, descendants of the two most ancient Lacedaemonian bloodlines, the Agiads and the Europontids. With time, their power was limited by that of the five elected ephors, and by that of the people, represented by an assembly (*apella*). The Lycurgan order nevertheless established the city as a great power in the Peloponnese and later hegemon of Greece and victor over Athens. Sparta's glory did not last long: the city was surpassed by Thebes and suffered both Macedonian and Roman rule; in the 12th century AD, after the Frankish and the Byzantine occupations, it was abandoned, to be rebuilt only in the eighteen-hundreds near the ancient center of Spartiate domination. Besides some remains of the 4th-century BC city walls and the Roman and Byzantine fortifications around the **acropolis**, the ruins inside the fortified area are very few; there are visible traces of the Archaic foundations of the Temple of *Athena Halkoikos* (Athena of the Bronze Temple), and the clearly-defined structure of the **theatre**, the cavea of which dates from the Roman period (2nd-1st centuries BC). The most important monument excavated by the English Archaeological School and by the Greek Archaeological Society is the sanctuary of

The remains of the ancient agora, abandoned among the olive trees.

The vestiges of the ancient Sanctuary of Artemis Orthia.

Remains of the theatre dating to Roman times.

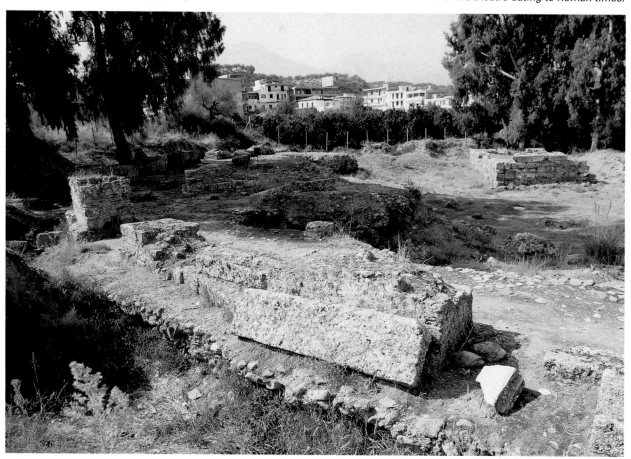

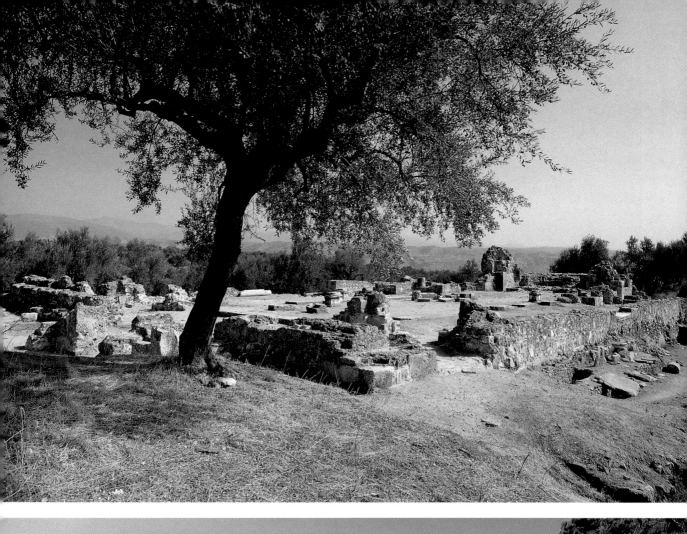

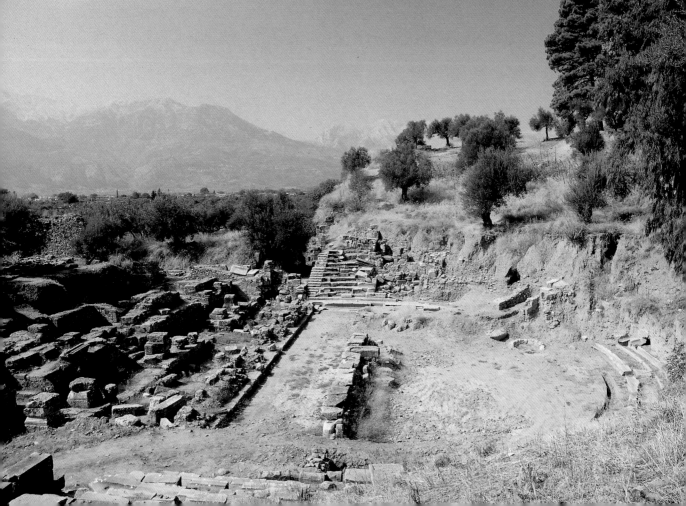

Artemis Orthia (meaning "straight") on the right bank of the Eurotas River. The structure of the sanctuary is datable to the 2nd century BC, although the presence of two nearby altars, one from the 9th century BC, bear witness to the ancient origins of the cult practices honoring the goddess; in the Roman period the temple was surrounded by an amphitheatre. It is worthwhile mentioning two monuments that evoke the great Spartan commander Leonidas, martyred at the Thermopylae Pass: a *small Hellenistic temple*, outside the acropolis, which once probably contained his mortal remains, and a *marble statue*, displayed in the local museum, of a Lakonian warrior, romantically identified with the hero; in truth, even though it may not be Leonidas, it is nevertheless a superb and highly suggestive statue with its bitter, drawn and disquieting expression, emblematic of all Sparta's warriors. This important find is not the only attraction of Sparta's museum: we must also remember the famous terracotta *head of a warrior* from the nearby *Sanctuary of Apollo* at *Amyklai*, and the series of *ivory carvings* recovered from the votive store of the Sanctuary of *Artemis Orthia* (all 7th century BC).

The marble bust of a Lakonian warrior, thought to be Leonidas (590 BC).

The facade of the museum building.

Roman relief displayed in the garden of the Museum.

Lakonian tomb sema, showing a lion, in the garden of the Museum.

The Lakonian plain, bathed by the Eurotas River.

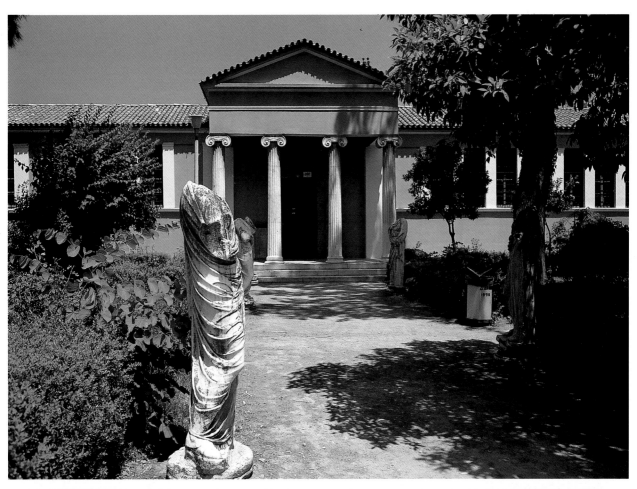

MYSTRA

During the obscure Medieval period, there arose at the foot of majestic *Mount Taÿgetos*, which dominated ancient Sparta, the *Mystra* fortress. The powerful Frankish seigneur Guillaume II de Villehardouin chose the Myzithra (or Mezthra) hill for building at its top an imposing and impregnable castle. The name *myzithra*, which means "ricotta", transformed into "Mystra" by the French, is believed to derive from the abundant and traditional production of the cheese on this high hill.

The **fortress**, built in 1249, soon fell into the hands of the Byzantines led by Michael VIII Palaiologos who, after imprisoning Guillaume, demanded it as ransom together with the *Monemvassía* and *Great Maina* fortresses: Mystra was raised by its new Byzantine rulers to the rank of capital of the Kingdom of Morea; its territories became the appanage of the Empire for a long period, from 1259 to 1460. Under the Byzantines, the fortifications were extended with powerful walls which began west of the fortress and embraced some noble residences and a few homes of simple citizens. Two *gates*, that of *Nauplion* and that of *Monemvassía*, gave access from the exterior, and a

road joining the two gates inside the fortress area separated the more important buildings from the humbler dwellings. When, in the 13th and 14th centuries AD, the many churches and monasteries (the *Vrontohión Monastery* with the *Churches of the Odigítria* and *of the Saints Theodore*, the *Cathedral of St. Demetrios* and the *Perívleptos Monastery*) and the residences of a few outstanding local personages were built, it was decided to draw a second fortified line dividing the new nucleus, called the *Kato Hora* (lower town) from the older quarter, called instead the *Pano Hora* (upper town). The history of the city over the centuries during which reigned the sons and the brothers of the Emperor with the unusual title of Despots of the Kingdom of Morea was marked by brilliant cultural and artistic development that persisted even after the Turks banished the last Byzantine Despot, Demetrios, in May of 1460. In the mid-14th century AD an illustrious school of philosophy was founded by the celebrated humanist Gemistos Plethon (1355-1452); it attracted all the illuminated spirits of the Byzantine Empire. In the wake of the Turkish advance, many of Plethon's disciples moved to Florence, where

Suggestive view of the Mystra hill, with the Frankish fortifications at the summit and the Odigítria Church below.

View from the eastern slope: the fortress at the summit and the church of the Pandánassa Monastery below.

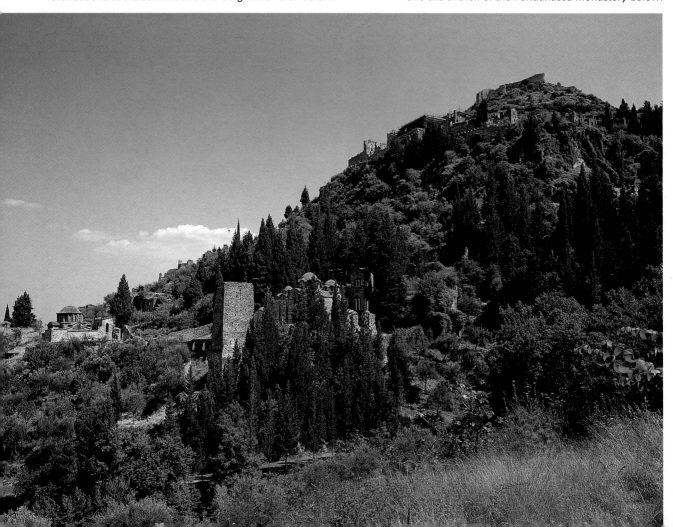

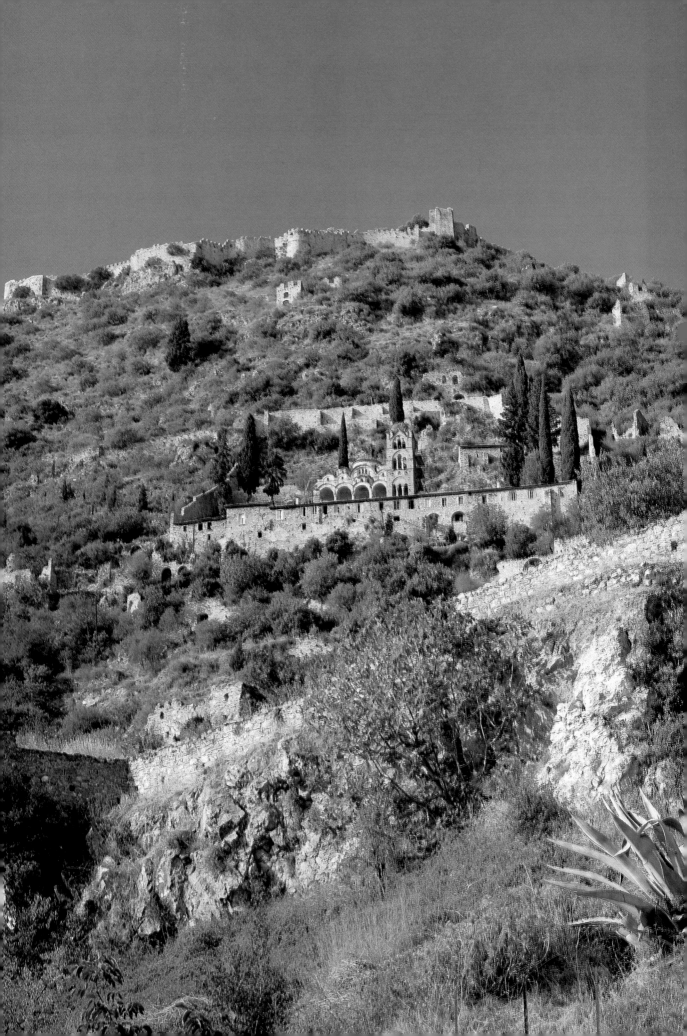

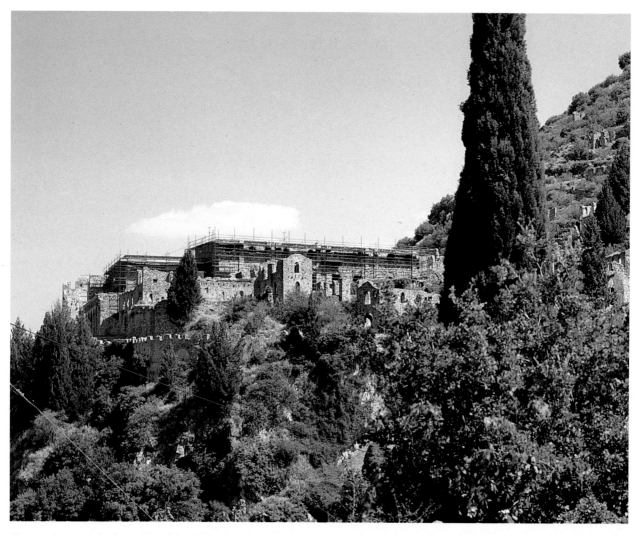

Restoration work in the residential neighborhoods.

The Palace church: Saint Sophia.

The ruins of the Despots' Palace.

they founded schools of thought destined to leave their marks on the Italian Renaissance. Under the Venetians, beginning in 1687, Mystra became a crowded and busy business center (the population is estimated at having been 40,000), but following the new Turkish overthrow in 1715, historical events turned against the city until in 1825, after sacks by the Russians and the Albanians, it was burned by Ibrahim Pasha and immediately there-after abandoned by the population. Today the ves-tiges of what was a great Byzantine center, immersed in the silence of a luxuriant nature which would seem almost protective, conserve the splen-dor and the charm of times past; we may even say that this ghost city, abandoned by man, is the great-est monument to the Byzantine renaissance.

Our tour of the area, along narrow paths through the precious churches, the crumbling palaces, the imposing monasteries, all dominated from above by the rude Frankish fortifications, is one of the most

suggestive offered by this region, after the vestiges of more remote times. From the **fortress**, built by Guillaume and enlarged by the Byzantine despots and by the Turks, we look out over an ample expanse of green dotted with buildings clinging in groups to the slope of the Mystra hill. We enter the fortress through a gate protected by a high tower built by the Byzantines. On the outermost perimeter is a mighty corner tower near which is a platform designed to hold a cistern. The **Monemvassía Gate** opens into the upper town (*Pano Hora*), where the **Palace of the Despots** stands out as an immense complex of buildings on a natural terrace overlook-ing the Eurotas Valley. Although its walls are in ruins and its beautiful windows are half-filled with debris, this palace seems still to express something of its past splendor. Behind the Palace is the monu-mental **Nauplion Gate**, flanked by two towers. Within the second circle of walls are found the Turkish **Saint Nicholas** and the Byzantine **Saint**

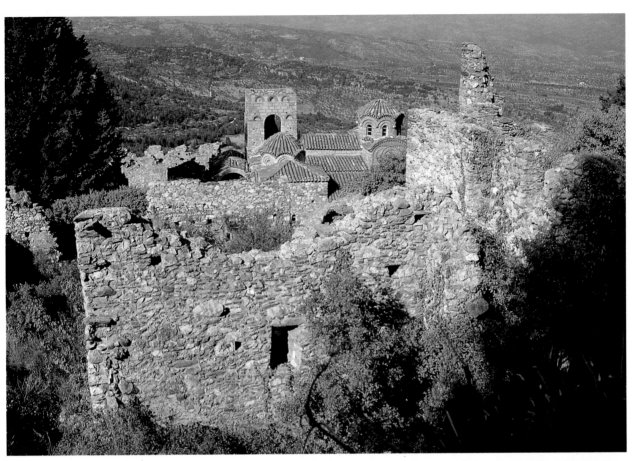

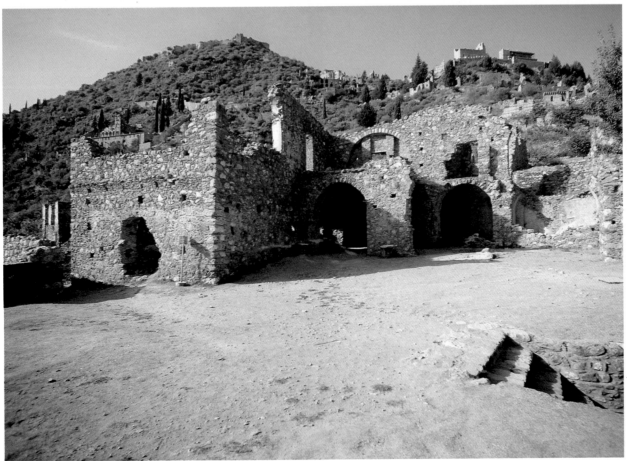

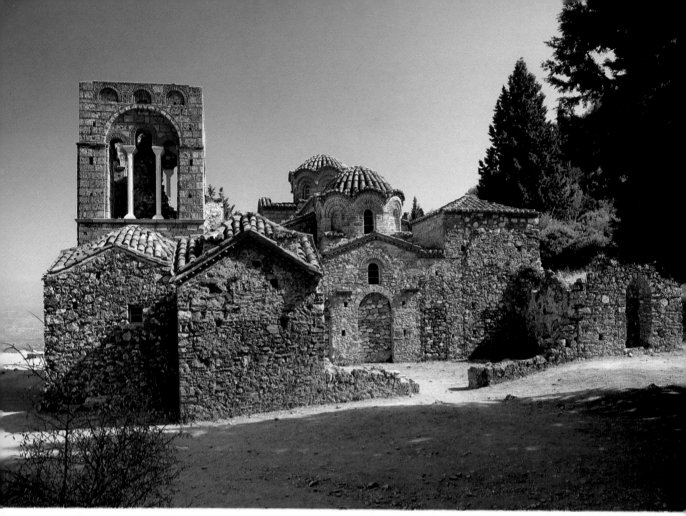

Saint Sophia: view of the exterior.

Sophia churches. The latter was also the
Archbishopric and the burial place for the first
Despot of Morea. Through the Monemvassía Gate,
we follow the city walls south to the largest build-
ing in the lower town, the monastery consecrated
by the minister Phrangopoulos in 1428 to the
Queen of the Universe (*Pandánassa*). This typical
Byzantine edifice astounds us with its refined archi-
tectural structure and decoration, the stupendous
paintings in the interior and finally the marvelous
view from the porticoed terrace over the boundless
Lakonian landscape. Not far from the *Pandánassa*
monastery is the home of Minister Phrangopoulos
himself, which with the *Láscaris* house is among
the best-preserved of the patrician residences. To
the south there emerge from the dense vegetation,
one after the other, a series of monasteries that con-
stitute highly representative examples of Byzantine

architecture and art, re-discovered in all their radi-
ant splendor thanks above all to excellent recent
restoration work. The **Perívleptos** monastery, the
first building along the path that descends south,
offers a seductive as well as highly atypical con-
trast of refined architecture against the rough rock
on which it stands. Before reaching the next
monastery we note the *Chapel of Saint George* near
the *Mármara fountain*, one of the most elegant
examples of a private chapel. The **Metropolitan**,
instead, is a cathedral church built in the 13th cen-
tury but amply retouched two hundred years later.
Today the cathedral boasts a delightful courtyard,
and the *stoa* encircled by balconies. Leaving the
cathedral behind, we come to the last monastery,
that of **Vrontohión,** once the richest of Mystra,
with its two churches: *Saints Theodore's* and the
Odigítria or *Aphendikó*.

SAINT SOPHIA

The Church of Saint Sophia was erected at the entrance to the *Pano Hora* (Upper Town) to contain the mortal remains of the despot Manuel Kantakouzenos and later became the seat of the Archbishopric: the great fascination of this Byzantine edifice is lent by the beautiful *frescoes* that decorate the walls and the vaults of the chapels. In the first chapel, which opens off the portico at the entrance, are *Scenes from the Life of Christ*: on the lower walls are the Annunciation, the Passion of Christ and the Resurrection; on the vault of the cupola, Christ with the Choir of Angels. In the other chapel, within the sacred precinct to the right of the apse, we may admire the *series of paintings dedicated to the Virgin*: the Virgin in prayer, the Virgin with an image of Christ and the *Nativity of the Virgin*.

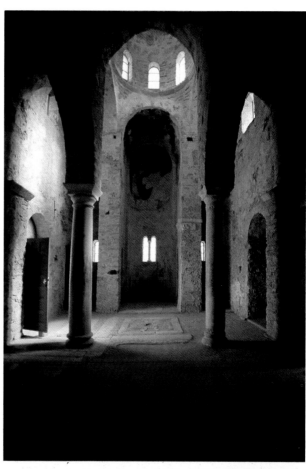

Saint Sophia: view of the interior.

Saint Sophia: fresco of the Nativity of the Virgin.

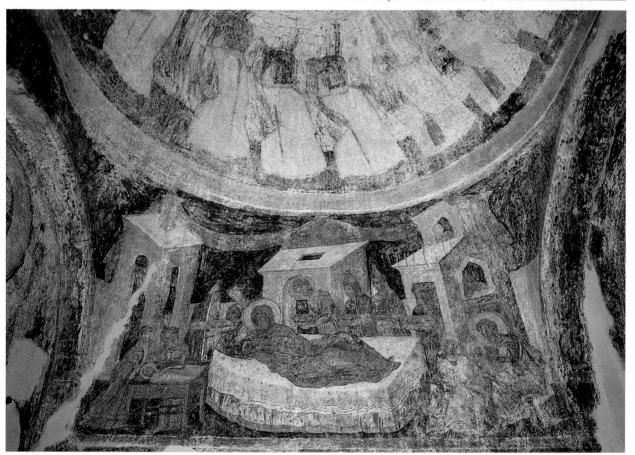

VRONTOHIÓN MONASTERY
ODIGÍTRIA CHURCH

This was once the richest monastery of Mystra, where cultural activities were held and where the Byzantine despots were buried. The sacred complex includes **Saints Theodore's Church** and the **Odigítria Church** (or *Aphendikó*). The architecture of the latter, erected in 1311, is more stylistically refined than that of than any of the other churches: the classical proportions and the purity of the lines lend to the building a sublime harmony that blends perfectly with the refined sculptural decoration. In the right chapel, the *fresco* portraying Theodore I Palaiologos surrounded by the Saints, and in the left chapel the corner with the medallion of Christ.

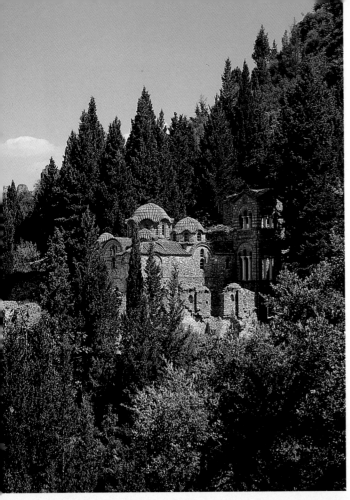

Vrontohión, Church of the Odigítria (Aphendikó): view of the exterior.

Vrontohión, Church of the Odigítria (Aphendikó): figure of a Saint in adoration of Jesus and view of the nave.

Vrontohión, Church of the Odigítria (Aphendikó): frescos in the narthex depicting the Resurrection of the mother-in-law of Peter and the miracle of the Marriage in Cana.

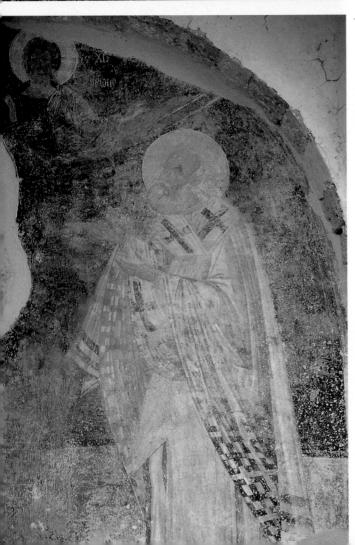

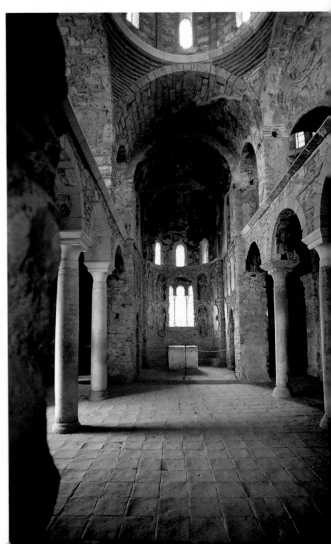

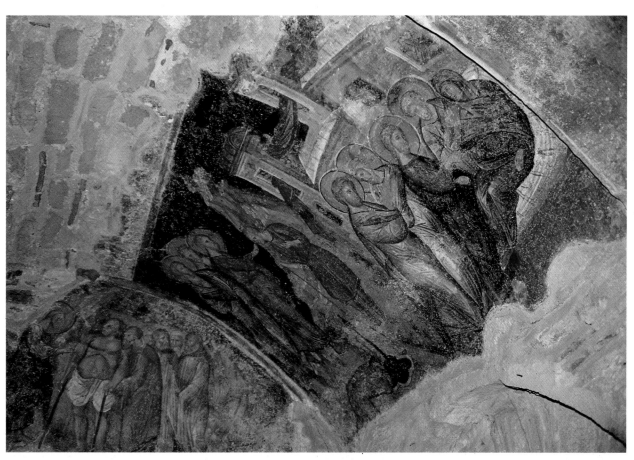

119

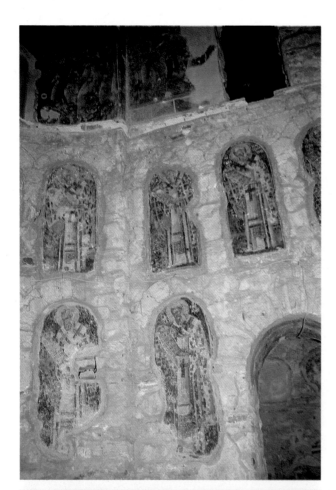

VRONTOHIÓN MONASTERY
CHURCH OF THE SAINTS THEODORE

The church, one of the first buildings of the new Lower Town (*Kato Hora*), dating to 1296, is decorated with a *cycle of frescoes* of lesser quality than those of the *Aphendikó* but equally significative and fascinating. The architecture of the church is quite simple and in a certain sense coarser than that of the other churches. As we enter we may admire on our left the fresco of the *Archangel Gabriel*. Of particular note are the paintings of the *Saints* in the stone-framed niches along the walls of the church, and the strikings contrasts between the radiance of the colors and the dark weight of the stone. In the left-hand chapel is the fresco of Despot Manuel Palaiologos kneeling before the *Theotókos*; in the chapel on the right, instead, are scenes from the *Life of the Virgin*.

Vrontohión, Church of the Saints Theodore: cycle of frescoes of the Saints.

Vrontohión, Church of the Saints Theodore: view of the interior.

Vrontohión, Church of the Saints Theodore: detail of the frescoes with figures of the Saints.

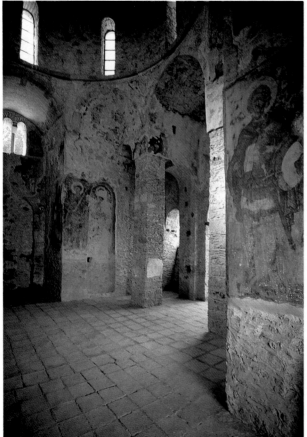

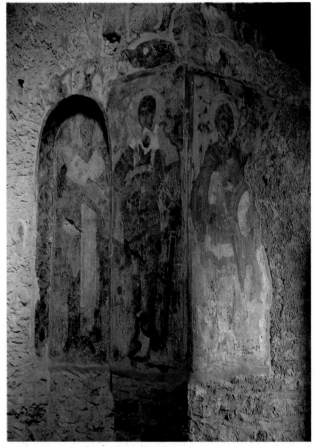

PERÍVLEPTOS CHURCH

The *Perívleptos* monastery, partially cut into the rock, offers a beautiful contrast between the elegance of its architecture and the rough rock from which it emerges. The *cycle of frescoes* in the church, painted during the reign of the Kantakouzenos' (1348-1384), remains one of the most valuable examples of Byzantine painting. The frescoes were painted using a rich palette of colors, the lines are highly refined and the composition of the cycle as a whole is extremely harmonious and well-organized. The entrance is dominated by the moving series dedicated to the *Virgin*, in which the image of the *Birth* dominates. In front of the small apsidal chapel is the superb painting of the *Divine Liturgy* celebrated by Christ in the guise of a Byzantine patriarch. Overshadowing all the mural paintings is the painting in the center cupola of the *Transfiguration of Christ Pantocrator* with the Virgin, the twelve Apostles and the Prophets.

Perívleptos: main entrance, built by Panaiotis of Thebes in 1714, with inscription above.

Perívleptos, frescoes in the central dome: Christ Pantocrator with the Apostles, the Prophets (between the windows) and the Virgin between two Angels.

Perívleptos: details of the frescoes of scenes from the Life of Christ.

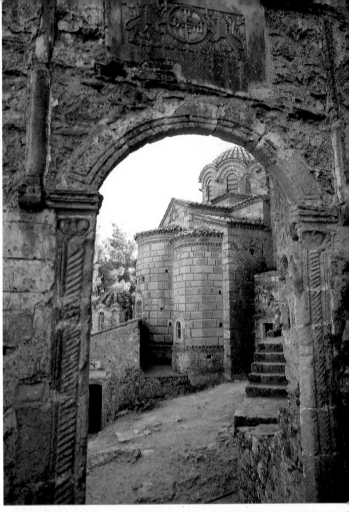

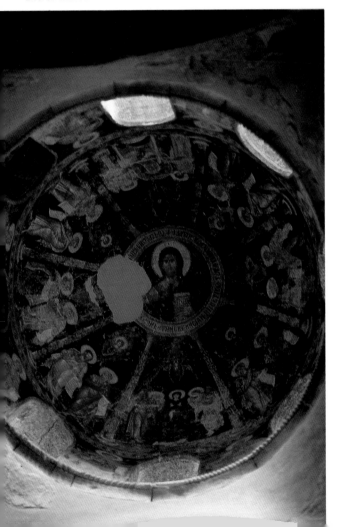

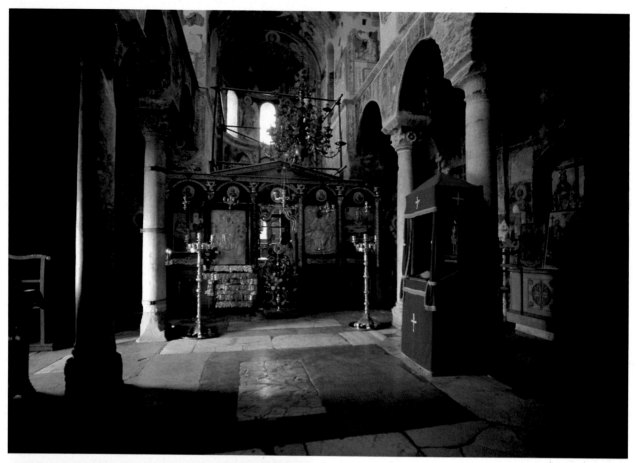

Pandánassa Monastery: view of the interior.

Pandánassa Monastery: frescoes with scenes from the Life of Mary (detail).

PANDÁNASSA MONASTERY

The nuns of this convent are the faithful guardians of all the deserted churches in this abandoned city of which they are the only inhabitants. The Pandánassa monastery was built in the 14th century. The plastic reliefs of the stone facade, the decorative ornamentation of the interior, the structure similar to that of the *Aphendikó* but more graceful, perhaps due to Gothic influences, heighten the suggestiveness of the *frescoes* with which the principal monastery church is decorated. The most representative painting, the *Resurrection of Lazarus*, is marked by its daring use of color and the extreme vitality characteristic of the entire *cycle dedicated to the Virgin*; it may well be said that these frescoes represent the supreme expression of late Byzantine art. Completing the beauties of this church dedicated to the Mother of God and Queen of the Universe is the spectacular *porticoed terrace* overlooking the fertile Eurotas plain.

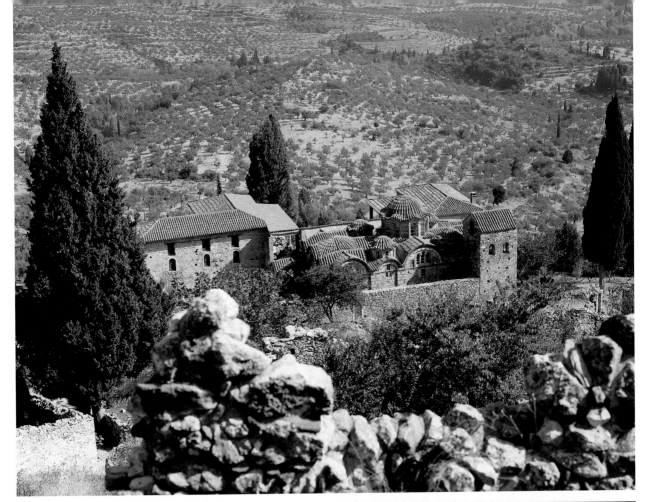

Metropolis Monastery: the Church of Saint Demetrios and the flanking building (today the museum) surrounded by the precinct wall.

Metropolis Monastery, Church of Saint Demetrios: view of the Diakonikós, with its frescoed vault (Angels before the Throne of Christ Judge).

METROPOLIS MONASTERY

This cathedral-church dedicated to Saint Demetrios was erected, as an epigraph would seem to indicate, in 1309 by the metropolite Nikephoros Moschopoulos. But when significant modifications were made to the original building in the 15th century, many of the paintings were mutilated and the sculptures re-used elsewhere.

The building is encircled by a portico and balconies. The *mural paintings* are extremely interesting, characterized by a sober, vigorous realism: the *Last Judgement* is outstanding. The interior is given a particularly sumptuous air by the precious sacred paraments, the furnishings and even the floor itself, with its marble inlay of the *Imperial Eagle of Byzantium*. Next to the church arises the small **Museum** in which are preserved fragments of frescoes, icons, vases, epigraphs and architectural decorations as well as some ancient finds including a sarcophagus dating to Roman times.

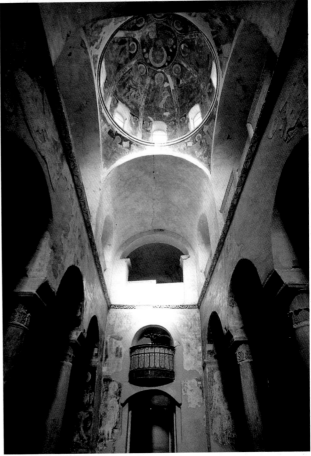

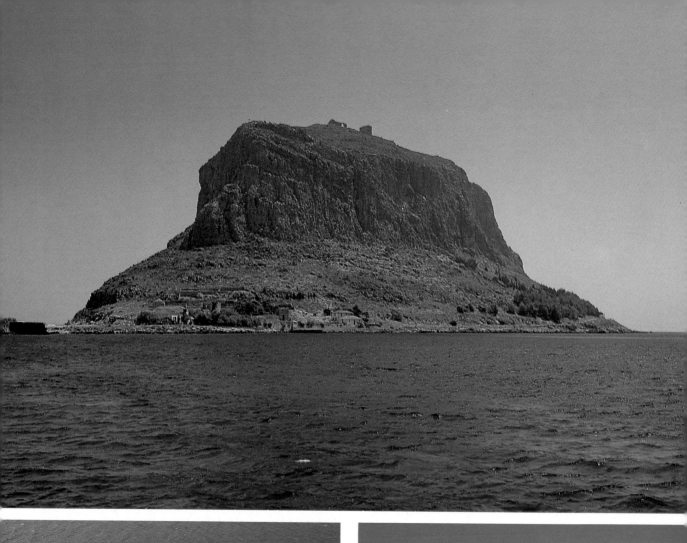

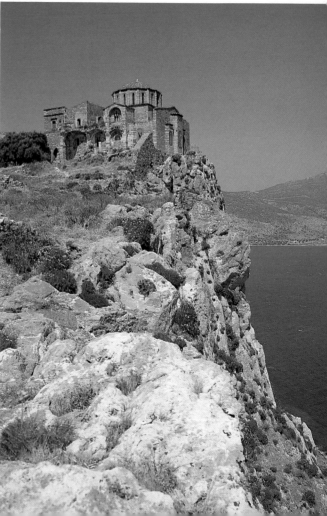

MONEMVASSIA

The imposing rock of Monemvassía arises from the waters of the Aegean Sea off the eastern Lakonian coast. A narrow strip of land is its only link to the mainland. From the city of *Gefyra* on the coast facing Monemvassía, the island would appear completely deserted were it not for the ruins of the fortress that rise on the summit of the rock. After having crossed the bridge and started up the road that leads to the citadel, we encounter the remains of the town. Of the ancient city, dominated in turn by the Franks, the Byzantines, the Turks and the Venetians, there remain the **walls** of the fortification, which reach all the way to the top of the island, and the modest village that is the *Kato Polis* (lower city) where the Venetian coats-of-arms with Saint Mark's lion are a frequent sight. Characteristic Byzantine houses dot this ancient settlement in which are also found a number of churches in ruins: the only church still standing is the *Hristos Elkomenós* (Church of Christ in Chains), the foundations of which date to the 13th century. On the esplanade of the fortress, the most suggestive monument after the ruins of the walls and the ramparts of the citadel is the **Church of Saint Sophia**.

The island of Monemvassía seen from the coast.

Characteristic view of the lower city (Kato Polis) of Monemvassía.

The Church of Saint Sophia arising on the steep peak of the fortress-island, overlooking the sea.

GYTHIO

Gythio has always been the natural seaport for the inhabitants of the fertile plain that slopes gently down from the Taÿgetos to the coast of the Lakonian Gulf. Sparta used it as an arsenal for its fleet, as did the Romans in later times. The city prospered under Roman rule; today's center rises at the foot of Mount *Larysion* (or *Koumaron*) and is protected by the facing small island of *Marathónissi*. Mythology recounts that this delightful slice of land bathed by the waters of the Mediterranean was the stopping-place of Paris and Helen on their first night together after fleeing from Troy. Atop the hill overlooking the city are the ruins of the **kastro** and at its foot an *altar dedicated to Zeus Therastios*. North of the urban center are remains dating instead to the Roman era: a *theatre*, a *temple*, an *aqueduct* and other buildings which have given us interesting floor *mosaics*. Gythio is the point of embarkation for Kythera, the island of Aphrodite.

The port of Gythio and the characteristic buildings fanning out in the shape of an amphitheatre on the slopes of the Larysion hill.

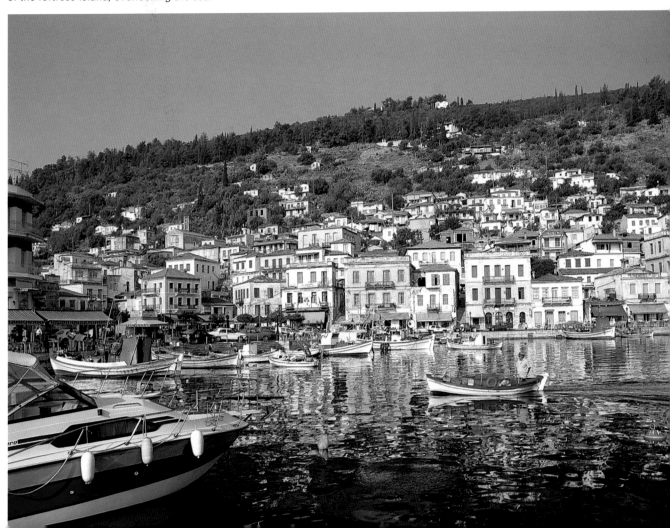

MÁNI REGION
DIRÓS CAVES - TOWER HOMES

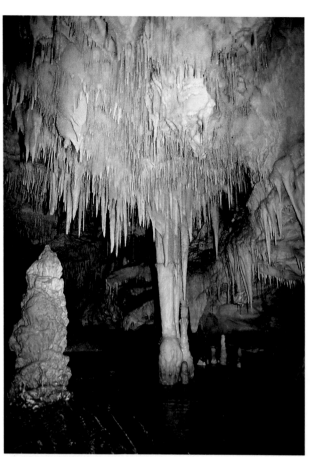

The Máni territory, in Lakonia, is an extremely arid, barren and inaccessible peninsular projection on which vegetation seems not to dare venture beyond producing the bushes of wild flowers that crop from among the rocks to color the landscape. This region, which defies the rules of nature, has defied those of history as well: the inhabitants, descendants of the Spartans, maintained their independence even from the Turks, despite their being themselves divided into enemy clans. The imposing and austere **stone towers**, built as homes and shelters during the civil strife among the Maniot peoples, dominate every village and reflect the hard, proud, solitary character of their inhabitants. An attraction of this area are the **Dirós Caves**, discovered in 1949 by Mr. and Mrs. Petrochilos, who, taking their inspiration from the forms, named the concretions with poetic titles: the Palm Forest, the Three Wise Men, the Fox's Lair, etc. The caves have yielded up archaeological finds from prehistoric times, such as graffitti, skeletons, weapons and vases. But besides their historical relevance, they are famous for their many stalagmite and stalactite formations, among the most beautiful in the world.

A magnificent view of the interior of one of the Dirós caves.

The fortified towers, built as homes and shelters, of the Maniot village of Vathía.

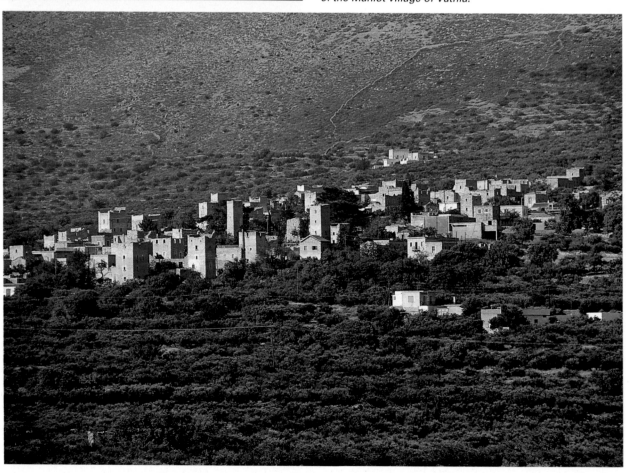

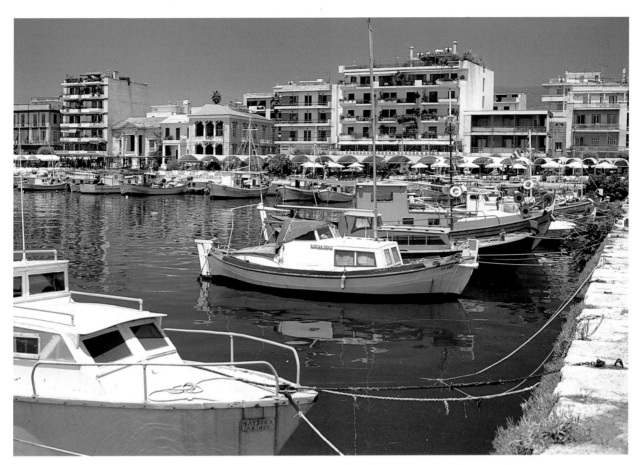

The characteristic port of Kalamáta.

The surviving constructions of the Korone fortress: view from the sea.

KALAMÁTA AND KORONE

These two cities dominate the broad curve of the gulf that takes its name from the region of Messinia, the coasts of which are dotted with medieval fortifications. Kalamáta, which has retained its name since medieval times, still preserves its old quarter dotted with Byzantine churches; the castle built by the Franks in the 13th century stands on the hill behind the fortress. The **kastro** recalls that of Korone, which since ancient times has dominated the southern extremity of the same gulf. The characteristic port of Korone is the starting-point of a road which passes through the entire city, built at the foot of the hill, to the castle fortified by the Venetians who occupied the site in the 13th century.

This outstanding example of the art of fortification is unfortunately mostly in ruins today. Both Kalamáta and Korone are nevertheless singular examples of the medieval sites that rose along the coasts of the ancient Despotate of Morea and which continue to characterize the Peloponnesian landscape.

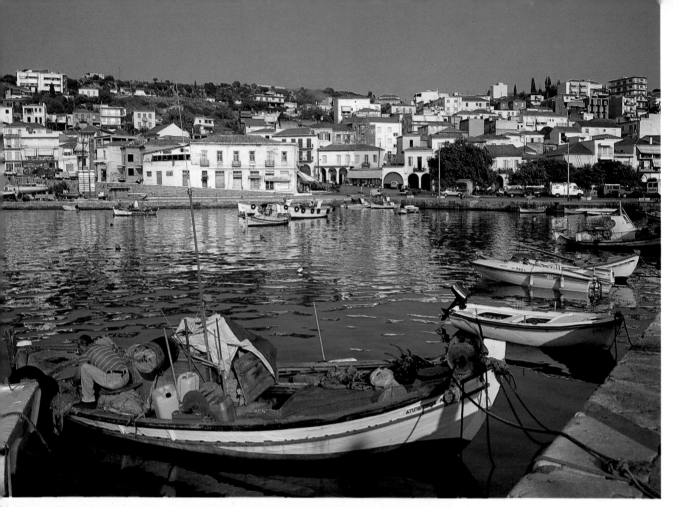

The port of Pylos at the southernmost tip of the Bay of Navarino.

View of the walls of the Niókastro, or new citadel, built by the Turks. It is one of the best-preserved examples of military architecture in all of Greece.

PYLOS

The small city of Pylos, built on a radial plan, lies on the gentle slope of Agios Nikólaos and looks out from its beautiful natural port onto the extreme southernmost tip of the *Bay of Navarino* and the island of *Sphaktiría*. Today, these sites bring to mind above all the naval Battle of Navarino of 20 October 1827, in which the English, Russian and French fleets defeated the Turks and the Egyptians and paved the way for Greek independence. The modern urban center lies between two **fortresses** built in different eras, known as the *Paliókastro* (old fortress) and the *Niókastro* (new fortress). Of the oldest walls, north of the center, almost nothing is left, but

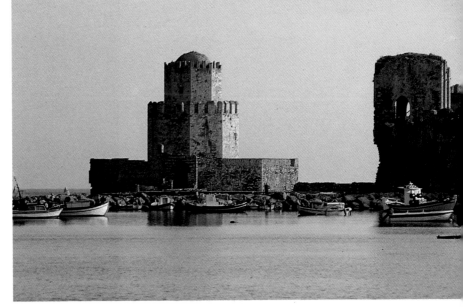

One of the powerful corner towers of the great citadel of Methone, built by the Venetians.

The octagonal Boúrdzi tower facing the Methone fortress.

the remains of the fortifications built by the Turks in 1573 south of the port are still in excellent condition, with an *external circuit wall* surrounding the citadel itself, which was built on the highest point of the hillside. Its hexagonal plan is well-defined by the mighty corner towers. Within the fortifications are to be found a few *Turkish mosques* and mysterious underground passages.

METHONE

Today the city, the great port of which was famous even in Homer's time, is known for its fascinating medieval castle standing at the water's edge and for its beautiful beaches bathed by the Ionian Sea. According to Strabone, this is the *Pedasos* ("rich in olive-trees") cited by Homer and named *Methone* after the second Messinian War, when it was surrendered by Sparta to the inhabitants of Nauplion. Of those times, however, no traces remain; the **fortress**, built by the Venetians in the 13th century on a thin strip of land projecting toward the sea, has imposing walls broken by powerful towers and monumental gates. One of these, at the southern extremity of the circle of walls, opens toward the small fort of *Boúrdzi,* an octagonal tower built by the Turks in the 16th century to defend the port and today linked to the castle by a stone *road-bridge*.

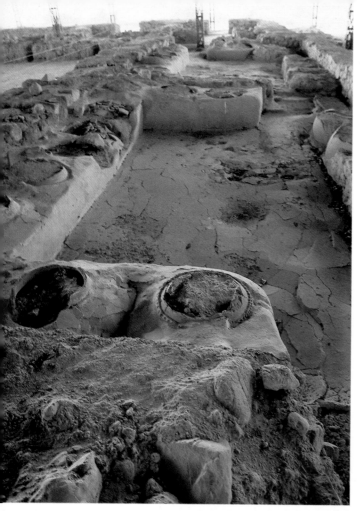

NESTOR'S PALACE

An air of mystery surrounds the "sandy Pylos" of the Homeric epics, which, founded by the Thessalian Neleos, won everlasting fame thanks to its wise and valorous King Nestor, hero at Troy. With the Doric invasion, the city was burned and abandoned, and slowly forgotten. Strabone was the first to relate the controversy over the site of ancient Pylos where the palace of the great sovereign arose. In 1939, the exploratory excavations by Blegen at *Epano Englianós*, in western Messinia, finally revealed the remains of a **palace** similar to those of Tiryns and of Mycenae. More precisely, it was located north of the *Koryphasaion* and not very distant from the Ionian coast. The palace, perched on the hill, was without circuit walls, as the role of defense was left to the cliffs. Overall, the structure consists of a central palace and another, older building. In the central palace (50 x 32 m), where the King's quarters were located, are the typical *portico* and the *vestibule*, which gave access to the throne room (*megaron*) at the center of which was a round hearth (4 meters in diameter), surrounded in turn by

One of the storerooms, with a capacity of 6000 jars of oil and other foodstuffs.

The hearth at the center of the throne-room (megaron).

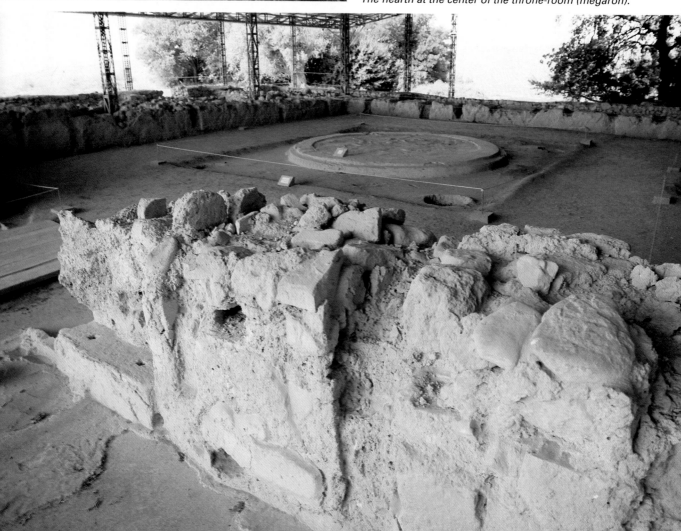

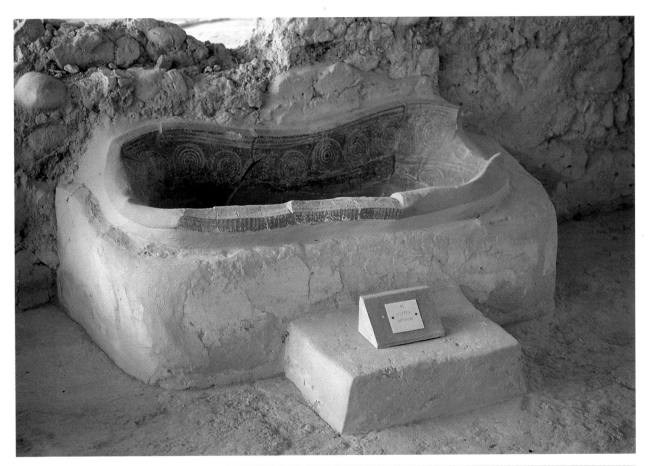

Terra-cotta bathtub with painted decorations, in one of the Queen's rooms.

15th-century BC thólos, from a group of tombs south-west of the palace.

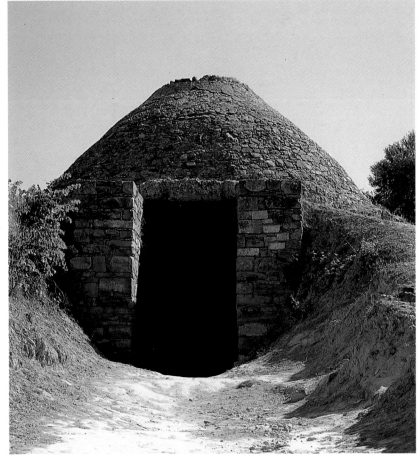

four columns which could have supported either a ceiling or a second story. The structure of the *queen's apartments* is similar. The *store-rooms* opened fan-like off the king's hall; in two of these were found the over 1000 clay tablets in *Linear B* script, hardened by the fire that destroyed the city and excellently preserved. Numerous tombs have also been found near the palace, for the most part the well-known *thóloi* with richly-decorated interiors. The *Pylos* palace is testimony to a complex and well-organized civilization which, legend aside, must certainly have been led by a powerful dynasty.

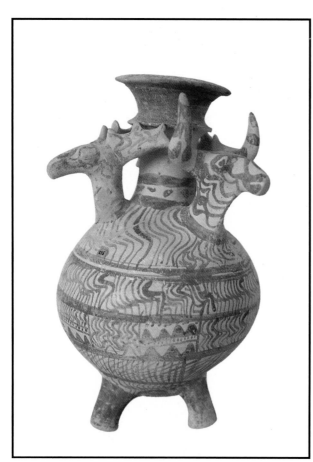

MUSEUM OF HÓRA

In the small but excellent museum of Hóra, a few kilometers north of *Pylos*, are gathered all the finds of the excavations of the palace and the nearby necropolis. Those of *Peristéria* and of *Routsi* are the most famous, due both to the type of tomb found there, the monumental *thólos*, and to the wealth of decoration and objects they contained, including ceramic vases of different forms: *pithoi*, amphoras or vases decorated with animal protomas. The decorations in the Palatial style are typical of local production: sumptuous plant and animal elements alternating with painted geometrical decoration. The richest of the tombs also contained extremely precious gold grave goods, finely-worked cups, and jewelry. All these objects testify to the wealth of the families that gravitated around the palace and its king.

Vase with animal protomas, painted in red, from a tomb.

Funerary amphora with floral decoration in Palatial style.

Funerary pithos decorated with raised bands, with cover.

Mycenaean gold cups, with embossed decoration, found in the Peristéria necropolis.

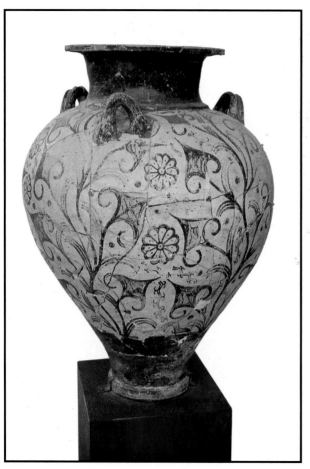

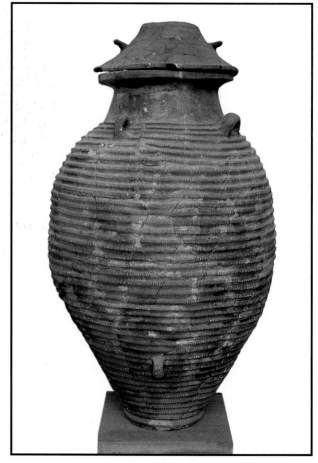

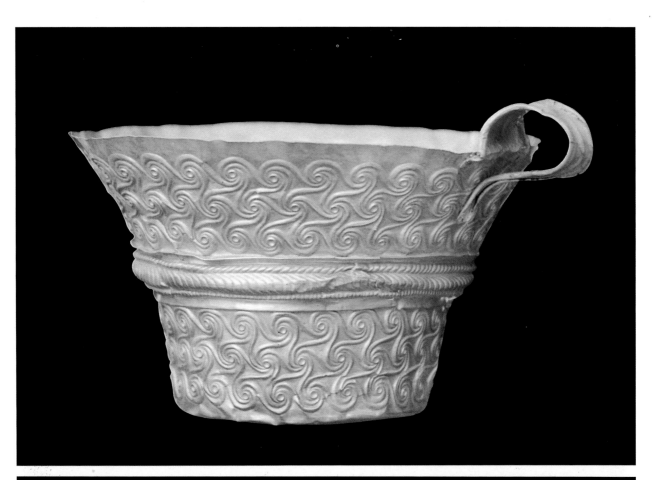

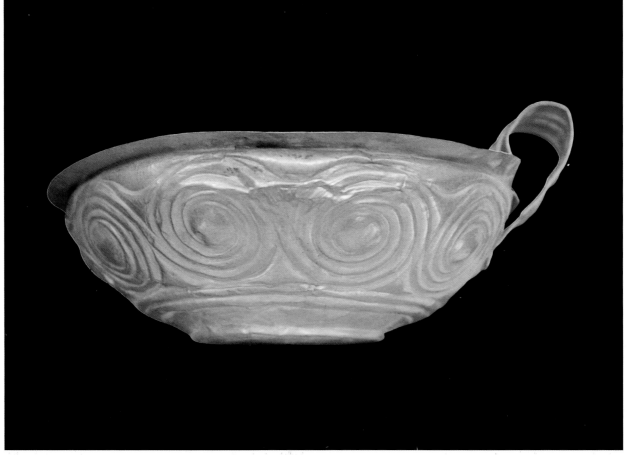

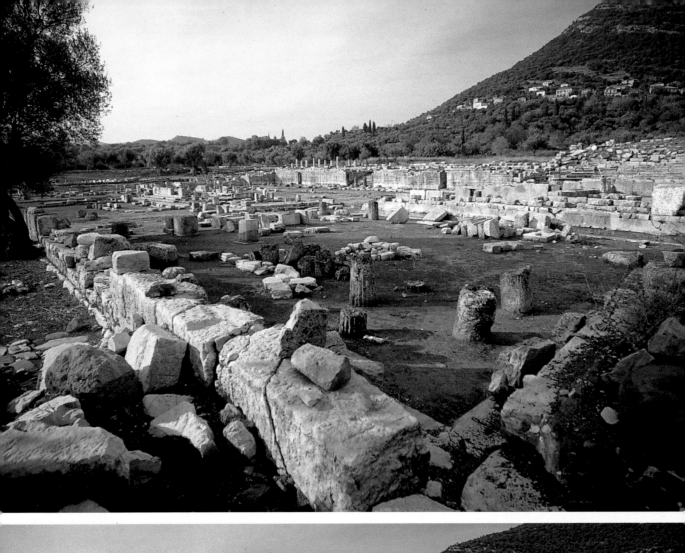
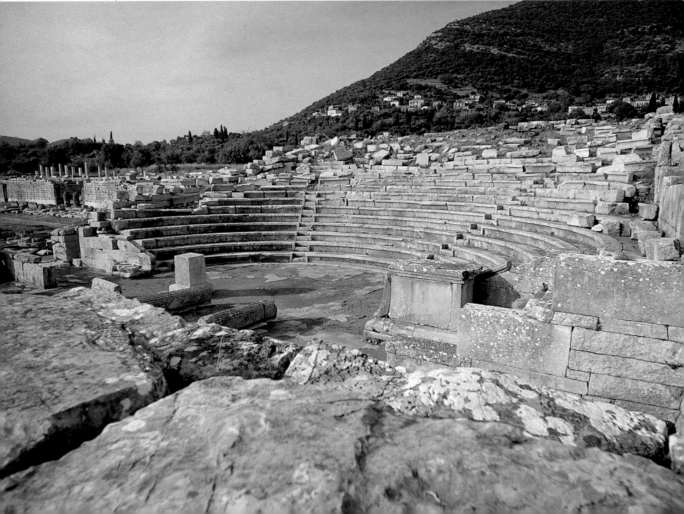

MESSENE

Excavations conducted by the Greek Archaeological Society since the late 1800s have brought to light Messene, the ancient capital of Messinia, founded by Epaminondas during the same period in which he constructed Megalopolis (369 BC). In truth, the origins of the new center, a rebellious subject of Sparta, were much more ancient: it has been identified as that *Pherai* sung by Homer. In the 4th century BC, around the ancient fortress-sanctuary on the slopes of *Mount Ithómi* (hence the second name of the city), was erected a mighty **circle of walls** almost 5 miles in length. Of these walls, admired by Pausanias, there remain today only a few scattered ruins that nonetheless indicate their path. From the **Arkadia tower-gate**, a road leads to the ancient site where we can still admire a vast courtyard accessible through a *propylon*, a Roman *theatre*, a *temple* which arose above a vast natural terrace, and the *agora*; on the latter arose the Temple of Asklepios, the *Synedrion* of Hellenistic times and the fountain of Arsenoë.

Ruins of the Asklepieion of Messene.

Odeion of the sanctuary.

Remains of the ancient walls with the so-called Arkadia tower.

Plan of the sumptuous Synedrion, the assembly hall.

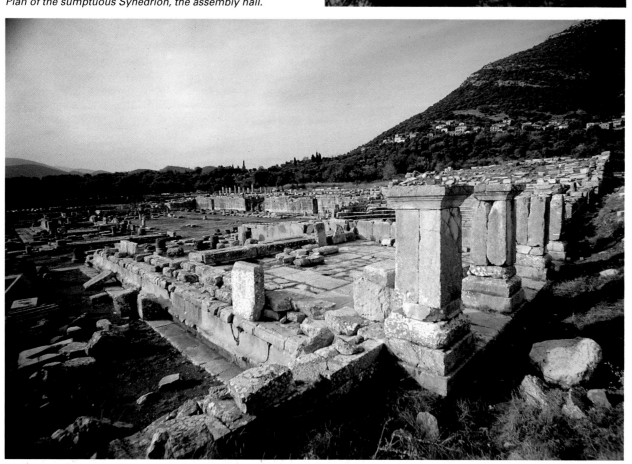

MEGALOPOLIS

Between 371 and 368 BC, the Theban general Epaminondas, responsible for extending the hegemony of Thebes to encompass a large part of the Peloponnese, ordered the founding of Megalopolis, the new capital that was to shelter citizens from the various minor centers of Arkadia which had resisted the Theban invasion and had been destroyed or depopulated. The city plan was on a grandiose scale because the city was intended as a symbol of unification. The vast foundations of the *Thersilion*, near the present-day village of *Megalopolis*, still bear witness to the epoch of the well-attended assemblies of the anti-Spartan "Arkadian League". The impressiveness of the urban structures is also reflected in the ruins of the **theatre**, once the largest in all of Greece: the cavea and the remains of the orchestra (the *prohedria* seats for the city authorities) are in fact of enormous size.

View of the village of Megalopolis.

Stone seats of the enormous theatre facing the Thersilion.

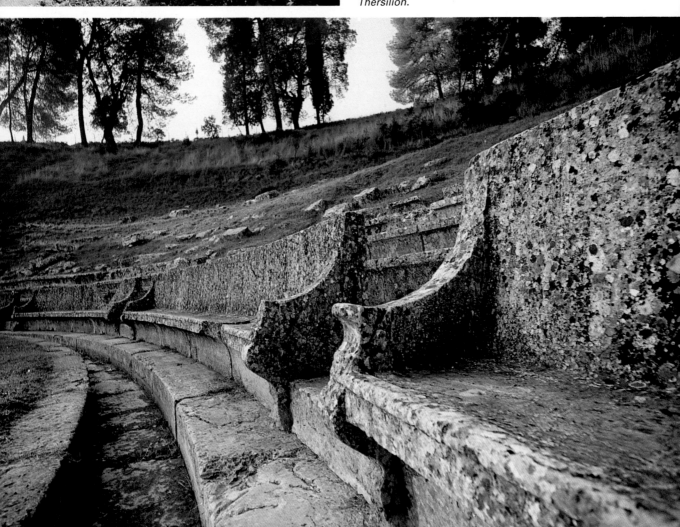

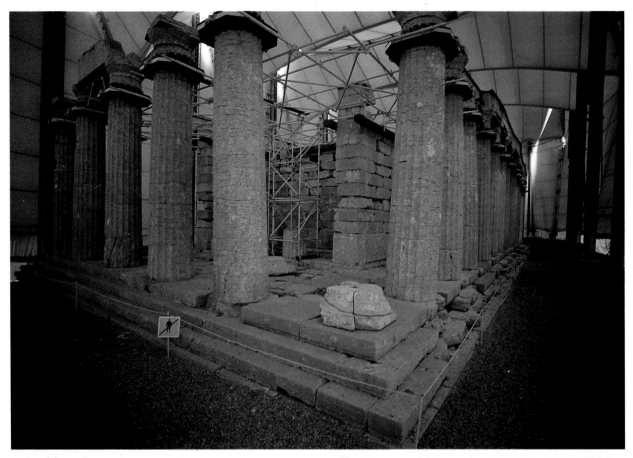

Temple of Apollo, exterior Doric colonnade from which can be seen the wall of the cella.

Pavilions covering the monumental Temple of Apollo in Bassae during restoration work.

BASSAE (ANDRÍTSENA)

In the 5th century BC, the inhabitants of *Phigaleia* decided to erect a temple in honor of *Apollo Epikouros* (Savior), who had saved them from an epidemic of plague; the chosen site was the inaccessible rise (about 100 meters) in the heart of that spur of Arkadia that insinuates its way in between Elis and Messinia. The **temple** is a perfect example of the manner in which the ancient Greeks succeeded in enhancing the dwelling-places of the gods by selecting adequate sites and adapting the design of the buildings to the surrounding landscape. Perched on the hillside rise the ruins of the Doric temple built in 420-417 BC by Iktinos, the architect of the

Athens Parthenon. The structure of the temple reflects the Peloponnesian concept of creating a contrast between the external Doric order and the Ionic order of the interior: the Doric columns in fact surround the *vestibule* and the *naós* (the space including the cella and the immediately adjacent corridors), while within the *naós* an Ionic colonnade is set in the perimeter walls of the cella, at the end of which stands a Corinthian column, perhaps the symbol of the god himself. Of great importance the marble frieze (almost completely preserved) which ran around the interior of the cella, sculpted with scenes of battle between the Greeks and the Amazons and between the Centaurs and the Lapiths, today in the British Museum.

OLYMPIA

This famous center of antiquity is today the main attraction in the territorial district of Elis, at the extreme western tip of the Peloponnese looking out over the waters of the Ionian Sea. Along the road that from the capital of Elis, *Pirgos*, leads to the Arkadian interior, stands the modern Olympia near the ruins of the ancient city and of the majestic **Altis Sanctuary**. The ancient remains spread out on the fertile valley floor, irrigated by the Alpheios and Kládeos rivers at the foot of *Mount Krónion*. In remote times the territory was dominated by the Pisatans (inhabitants of the Peloponnesian city of Pisa) and their king Oinomaos. During this period, historically datable to about the middle of the Helladic period (1990-1600 BC), the inhabitants venerated a number of Ctonic divinities, among which predominated Ge or Gaia (Earth). Historical evidence confirms that the cult was supplanted by that of Zeus, perhaps with the Dorians, and was institutionalized through celebration of the Games held in the god's name. The myth relates how the Games were created by Pelops, who in order to win the hand of Hippodameia had defeated her father by trickery during a chariot race. The first Olympic Games were celebrated in honor of the dead king; after suffering a decline, the Games were reinstated by Herakles, to whom is attributed the institution of the sacred precinct in the *Altis* and the building of the sanctuary dedicated to Pelops, called the *Pelopion*. The official date of the first Olympic Games is 776 BC, the year in which the Elian king Iphitos, a contemporary of Lycurgus, followed the advice of the Delphic oracle and reorganized the Games as a means of bringing to an end the scourges and the political divisions which were devastating Greece. This grand festival of sport in honor of Zeus, in which all Greek men could take part, was held every four years - during the period

Model of the Sanctuary of Olympia.

Colonnade of the palestra (3rd century BC) where the athletes prepared for the contests.

The Philippeion: according to Pausanias, begun by Philip of Macedon and completed by Alexander the Great.

1. Gymnasium.
2. Palestra.
3. Heroon.
4. Theokoleon.
5. Paleo-Christian basilica and Pheidias' Ergasterion.
6/7/8. Baths complex from the Hellenistic and Roman eras.
9. Leonidaion.
10. Stoa.
11. Bouleuterion.
12. Propylon.
13. Prytaneion of the Eleis.
14. Heraion.
15. Nymphaeum of Herod Atticus.
16. Philippeion.
17. Metroon.
18. The Terrace of the Treasuries. The Nymphaeum, an anonymous treasury,followed by the Treasuries of Sikyon, Syracuse, Epidauros, Byzantium, Sybaris and Cyrene, an anonymous treasury, an altar, and the Treasures of Selinus, Metaponto, Mégara and Gela.
19. Stoa of Echo.
20. Temple of Zeus.
21. Pelopion.
22. Portico.

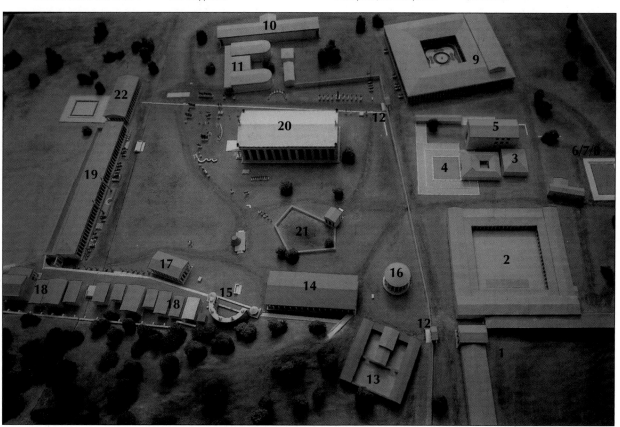

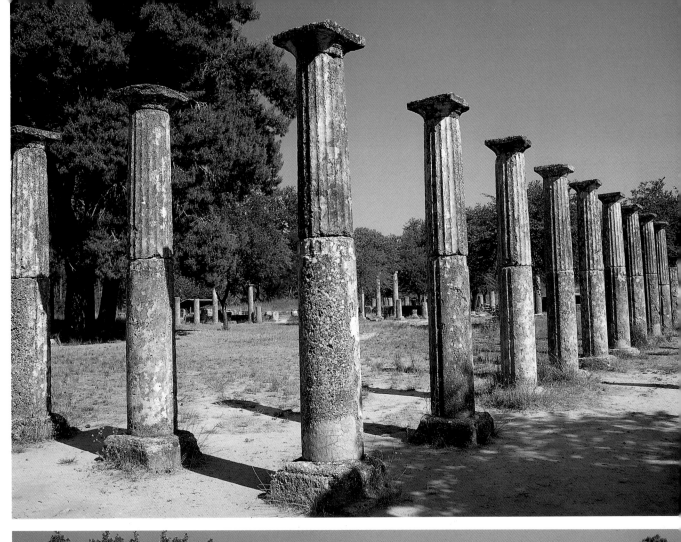

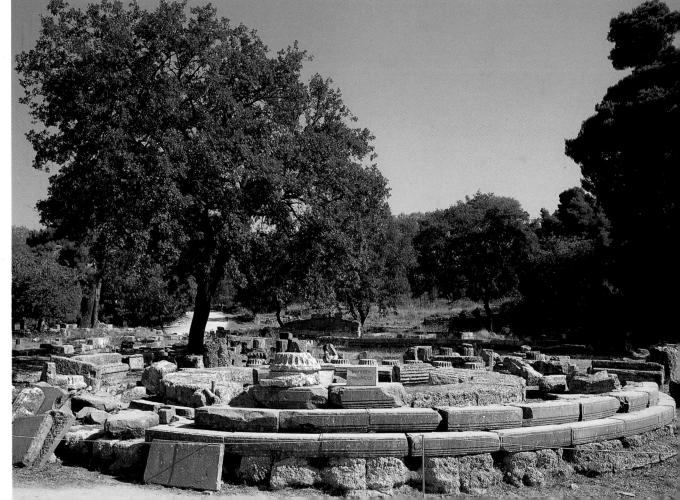

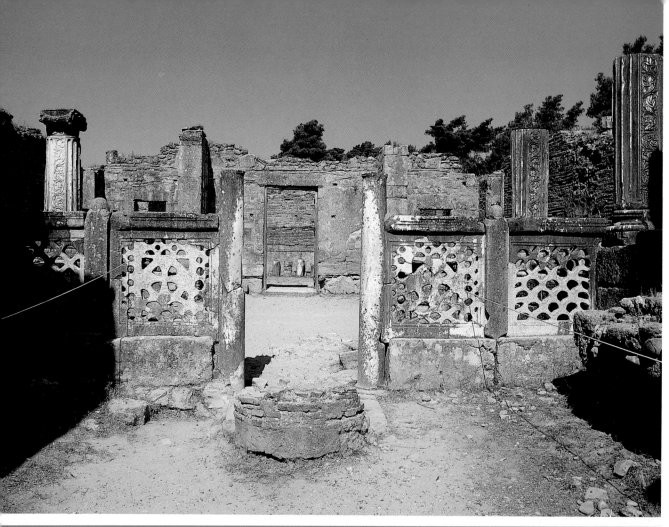

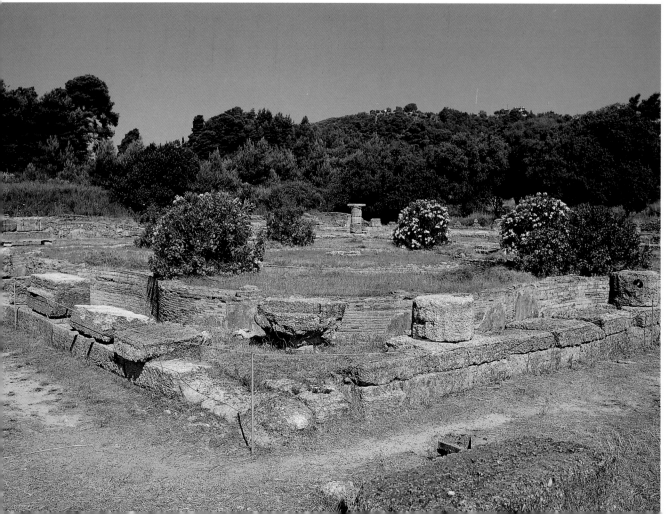

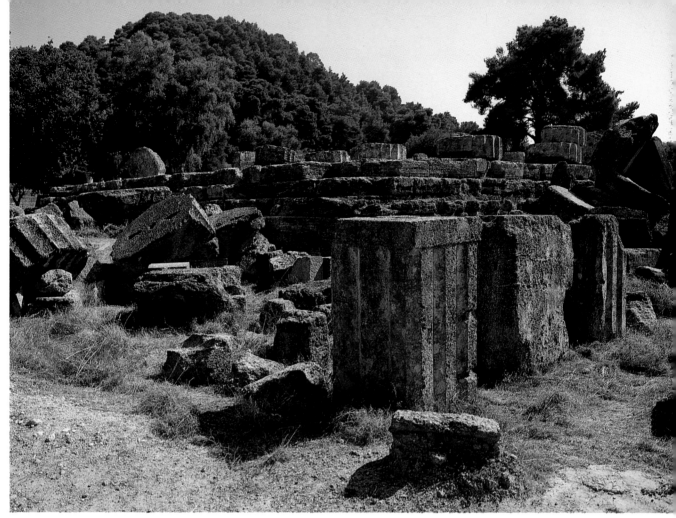

Left: The remains of Pheidias' Ergasterion and traces of the paleo-Christian church built above it.

The foundations of the Leonidaion, used as guest quarters for illustrious visitors.

The krepidos of the Temple of Zeus (64.12 by 27.68 meters) and fallen architectural elements.

of the Games, the cites were forced to suspend hostilities and accept the sacred armistice. The athletic contests, which included different specialties, among which horse racing, discus and javelin throwing, wrestling, jumping, chariot racing and boxing, lasted five days; at the end of the meeting, the winners named by the *hellanodikai* (finish-line judges) were each crowned with a wreath of wild olive. This panhellenic festival was also an opportunity for cultural exchange among the different Greek peoples, since theatrical pieces and recitations were permitted during the intervals between contests. The event enjoyed its moment of greatest splendor in the 5th century BC; later, the Games gradually lost their sacred valence, especially during the period of Roman occupation. Nero's participation in the Games has remained in history: he won the chariot race six times. Following the suppression of these illustrious contests by Theodosius I in 393 AD, the site was abandoned and devastated by later earthquakes, to re-emerge only after excavation by

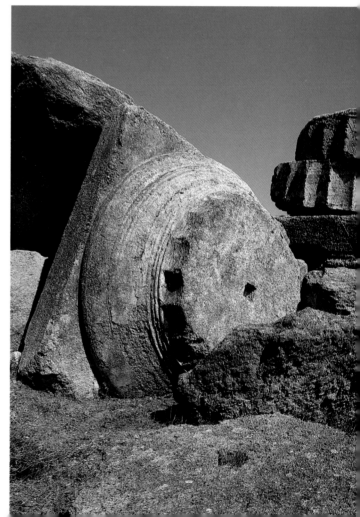

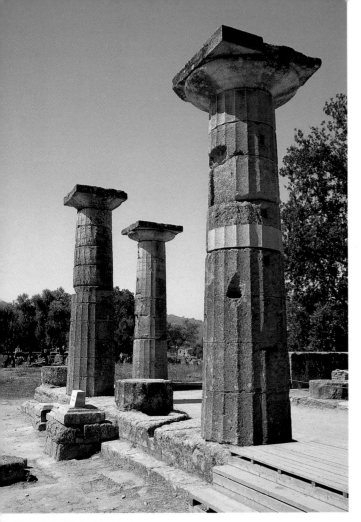

the 1829 *Expédition de Morée* and systematic investigation by the German Institute, begun in 1875. The sacred *Altis* precinct, of which the Eleis were administrators since the offerings and the sanctuary buildings belonged to Zeus, is marked off by two enclosures, one dating to the 4th century BC and the other to the Roman period. Outside the *Altis* are a **portico** and a **gymnasium** of the Hellenistic period, linked by a Doric **propylon**. Along the southern flank of the gymnasium gallery there remains the square foundation of the **palestra** (3rd century BC), with its double Doric colonnade, where the athletes prepared for the contests. In front of it, again to the south, is another four-sided structure, the ***Theokoleon*** (4th century BC), built as quarters for the clergy and other authorities; facing are the vestiges of a ***heroon***, a circular building used as a chapel to a dead hero, dating to Roman times. The archaeologists have also recognized in this area the foundations of the studio (***ergasterion***) in which Pheidias and his collaborators worked. Confirming this fact are finds including tools and pieces of ivory and of gold-work. Still further south are the ruins of the ***Leonidaion***, the imposing building with a 138-column Ionic peribolos (4th century BC), which was erected by Leonidas of Náxos and became guest-quarters for important visitors. Other structures outside of the sacred precinct include the ***Bouleuterion***, composed of two parallel apsidal buildings and a central square building (6th-5th centuries BC) in

The Heraion, built in 600 BC. In one of the niches inside the cella was found the statue of Hermes with the infant Dionysos, attributed to Praxiteles.

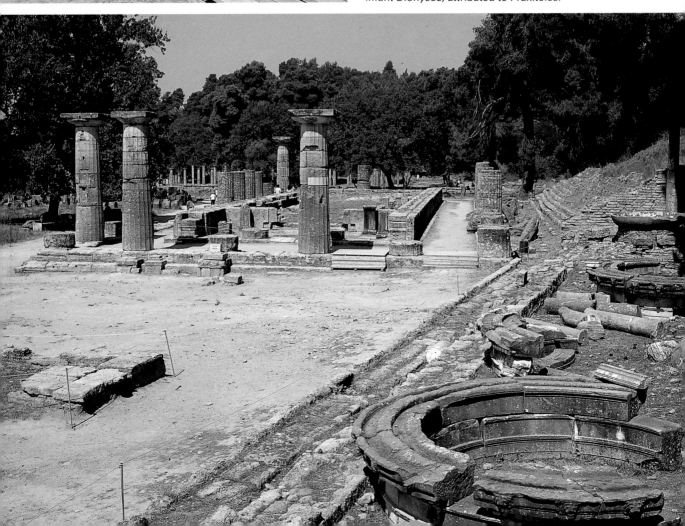

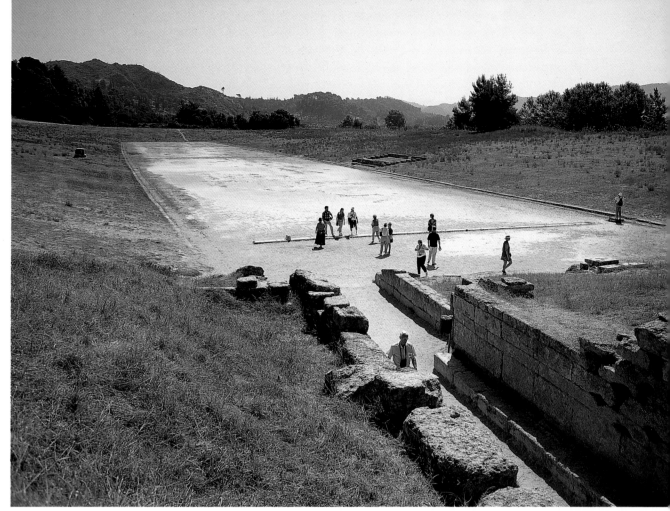

The stadium, the plan of which dates to the 6th century BC. The dimensions (212.17 meters in length by 192.27 in width) are equal to those of today's so-called "Olympic" stadiums.

West entrance to the stadium.

which the meetings of the Olympic Senate and of the *hellanodikai* were held, and the *stoa*, added in the 4th century BC. Within the sacred Altis precinct, reached through the *propylon* of the gymnasium, are gathered the monuments most representative of the sacred character of the event. Of primary importance is the **Temple of Zeus**, built by the architect Libon in 471/456 BC: the building represents the full maturity of the Doric style, with its columns (6x13) and the high steps of the access ramp. The greater portion of the interior was probably occupied by the chryselephantine statue of Zeus, by Pheidias, while the metope and the pediments are the work of the unknown master author of the **Heraion**, the best-preserved building on the *Altis*, built in about 600 BC in Doric style on pre-existing foundations. Between the two temples is the famous ***Pelopion***. Finishing off the precinct are the **nymphaeum** erected by Herod Atticus, the ***Philippeion***, which contained the statues of the family of Philip II of Macedon, and the **Prytaneion** where the Eleis held their assemblies around the sacred hearth. There also remain, as testimony to the magnificence of the sports event, the ruins of **twelve treasuries** on the slopes of the *Mount Krónion*: these are small temples with two columns, donated by the cities to Zeus.

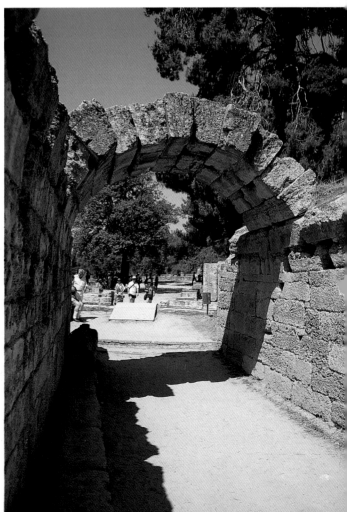

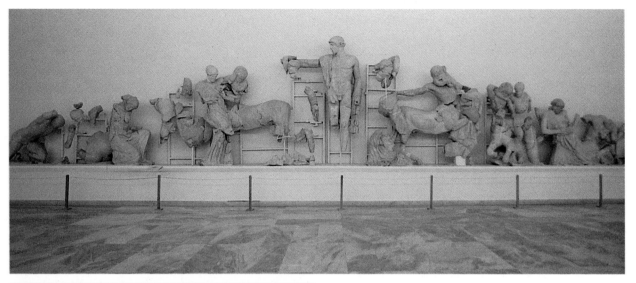

West pediment of the Temple of Zeus. The Centauromachy, with at the two ends Theseus and Peirithoös and the male and female Lapiths. At the center, Apollo.

Detail of Apollo, who with Zeus on the east pediment, represented the spiritual axis of the event.

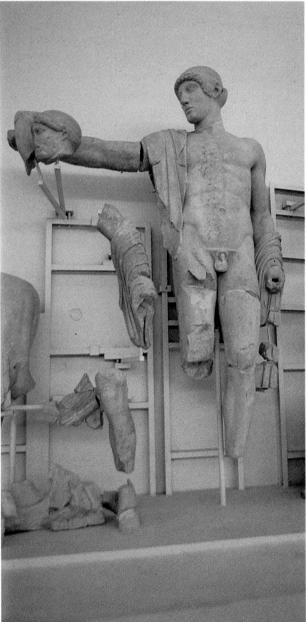

MUSEUM OF OLYMPIA

The Olympia Museum, near the ancient remains of the sanctuary, houses finds of exceptional importance. A large part of the museum is dedicated to the refined local production of weapons and military equipment, ample testimony to a culture in which the cult of heroism had always dominated. For this people, the very person of the warrior was a work of art, and for this reason he had to wear armor of superb workmanship: the *cuirasses* found in the inexhaustible soil of Olympia and conserved by the museum are the most elegant products of the military arts ever found in the Greek territory. Among the armor there stands out the suit with the delicate engravings of the *liberation of Helen* by the Dioscuri, and that bearing the images of the meeting between *Apollo* and the Delphic divinities and *Zeus*, only recently recovered. Together with these finds

The bride of Peirithoös, Deidamia, attacked by a Centaur.

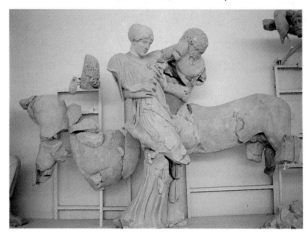

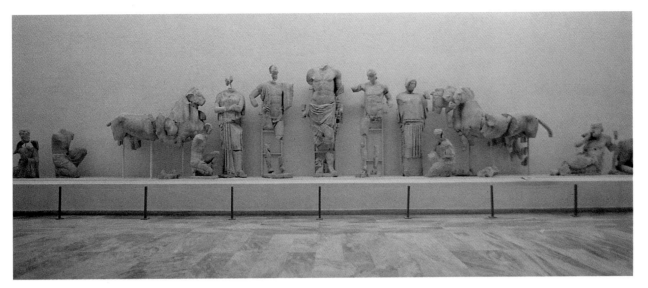

East pediment of the temple, portraying the preparation for the tragic contest between Pelops and Oinomaos: lying on the sides, allegorical figures representing the Rivers Alpheios and Kládeos, while the center is dominated by the image of Zeus.

The head of Apollo, miraculously preserved; that of Zeus has been lost.

The face of the old seer who received the premonition of impending disaster for king Oinomaos, on the east pediment.

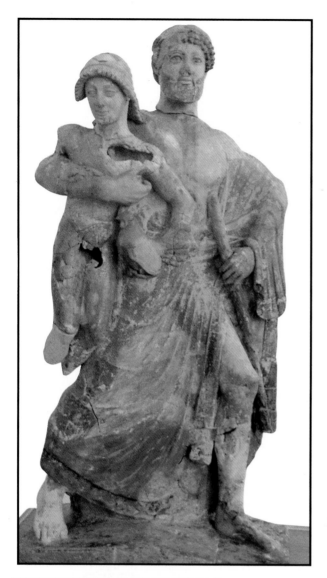

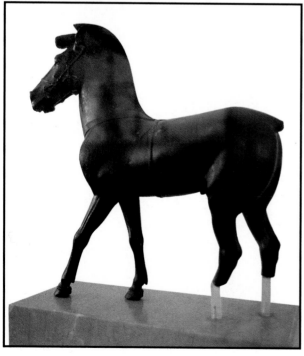

The group with Zeus abducting Ganymede, found in the soil of Olympia, probably the work of Corinthian terracotta workers (490-480 BC).

Marvelously austere bronze horse from 470-480 BC.

Bronze finds from the Olympia excavations: lamina with griffin, and clapper.

146

are displayed numerous bronze *votive offerings* from the sanctuary, including small plaques, laminas, reliefs and statuettes; the latter represent mainly warriors or Zeus himself, often portrayed as a hoplite. These small bronzes are formidable examples of what is surely Peloponnesian, but probably not local, workmanship, which even in very ancient times achieved a solemn and complex plasticity of language. Also of great importance are the clay fragments of a *head of Athena* and of a number of warriors, found at Olympia and created with such height of expression that they could only be of Corinthian make. Probably of like provenance is the group of *Zeus abducting Ganymede*: the delicacy of Zeus' bearing and the sweetness of the face of the youth are hallmarks of the technique of the Corinthian school, which evidently dominated in Olympia as well as in other parts of Greece. The principal attraction of the museum, however, is the **Hall of the sculptural decoration of the Temple of Zeus** containing twelve *metopes* and two colossal pediments, all the work of the same artist, who due to his capacity to use marble in a country populated mainly by bronze-workers, was held to be somewhat "foreign" and whose identity has remained shrouded in mystery. Pausanias attributed the pediments to Alkamenes and Paionios, two sculptors who worked on the sculptural decoration of the temple: Paionios is the author of a *Nike* found south-east of the Temple of Zeus, surely originally set on a Parian marble pillar facing the entrance and dating to about 420 BC; Alkamenes was probably the sculptor of the *corner statues* of the west pediment. Although the identity of the decorator master of Olympus is still today a mystery, it is generally thought that he was a

The famous Hermes with the infant Dionysos, from the Heraion of Olympia, where according to Pausanias a statue of the same subject by Praxiteles stood. Controversy among archaeologists continues; the statue is considered the fruit of a refined, persuasive technique dating to after Praxiteles' time. Note the admirable structure created by the plays of light.

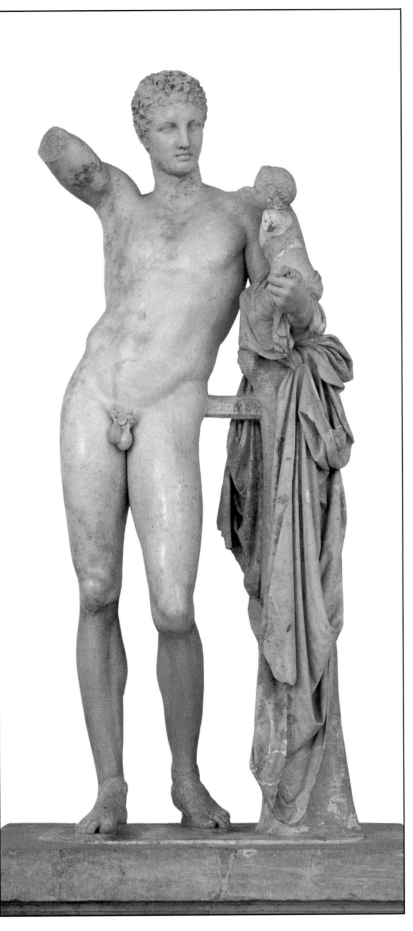

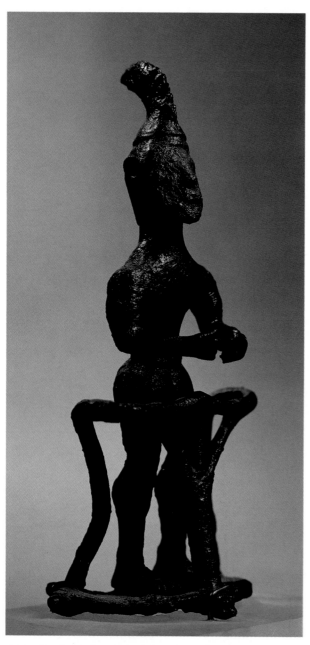

Statuette of a god on a chariot, perhaps Zeus with a crested helmet (8th century BC).

Zeus portrayed as a hoplite (7th century BC).

Archaic head of Athena from a Gigantomachy (490 BC).

sculptor of Eastern origin, probably Ionian. The metopes depict a cycle of the exploits of Herakles, who is at once the great Dorian hero and the founder of the Olympic Games. We can follow his labors from the first adventure involving his struggle with the Nemean lion through those on the cosmic scale; for example, fetching the golden apples from the Garden of the Hesperides. The *west pediment* represents the battle between the Centaurs and the Lapiths and the wedding of Peirithoös, while the main metope (that is, the *east pediment*) represents the tragic contest between Pelops and Oinomaos. The representations of Oinomaos and of the queen

and of Pelops and Hippodameia standing side by side are one of the highest dramatic expressions of the sculpture left to us by ancient Greece; the imposing figures of Apollo and Zeus dominate the two pediments, respectively. The museum tour concludes with a statue described by Pausanias as an original by Praxiteles, in the second left-hand chapel of the *Heraion*: the *Hermes with the Infant Dionysos* (dated to the mid-4th century BC). Despite the continuing disputes over its attribution, the work is nevertheless expressive of a language which is so subtle and at the same time so vital that it could only have been that of a great master.

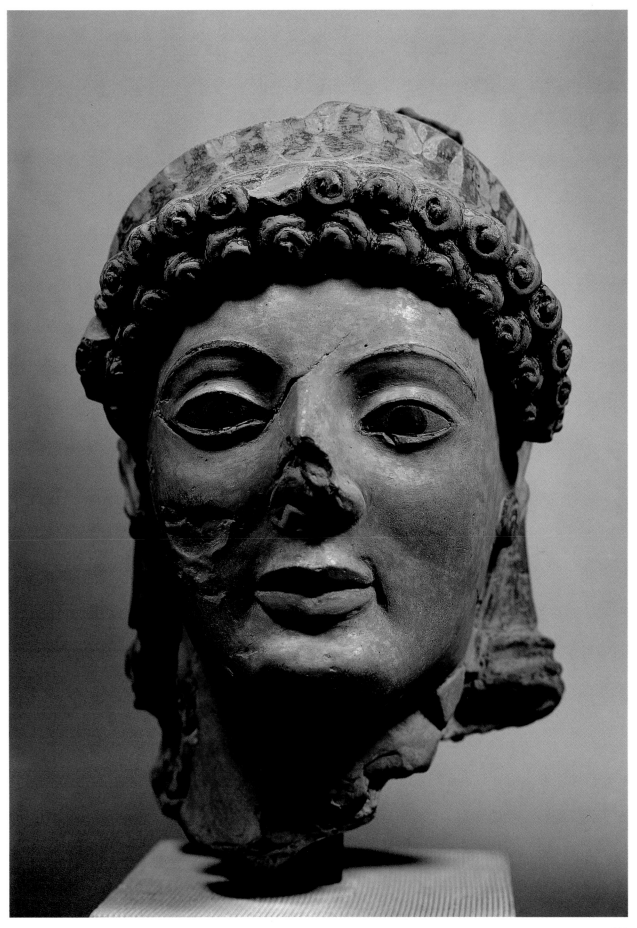

EPIROS - THESSALY - MACEDONIA

DODONA - IOANINA - METSOVO - METEORA - VOLOS
MAKRINITSA - PLATAMONAS - DION - VERGINA - PELLA
KASTORIA - THESSALONIKA - CHALCIDICE PENINSULA
MOUNT ATHOS - KAVALA - PHILIPPI - XANTHI - THASSOS

*T*he territories of these three regions of north-central Greece are less well-known to the traditional tourist, but their history and their traditions, like their natural resources, are no less rich than those of the rest of continental Greece. Thessaly, lying along the Aegean coast, was once submerged by the waters of the sea; when they receded they left behind one of the most suggestve landscapes in the territory: the rock pinnacles of Metéora. The Metéora monasteries are without doubt one of the major attractions of Thessaly; and to these we must add

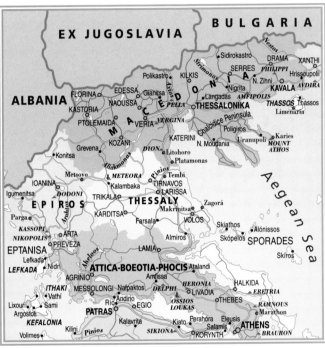

both the magnificent landscapes of the Vale of Tempe, lying between the majestic peaks of Mounts Ossa and Olympus (the home of the gods) and cut through by the green, well-watered Peneios plain; as well as the wooded and verdant Pelion peninsula, dominated by the city of Vólos. This region suffered systematic invasions, beginning with the Pelasgians in 2000 BC and ending with the Turks: the only period of tranquillity was the Classical era (5th-4th centuries BC), during which time the Thessalians formed a league that had a determinant influence on the history of the country. Epiros was the cradle of an ancient civilization that centered on the Dodona oracle (2000 BC). The history of the region and its tribes, closed and foreign to external events, remained obscure for many centuries, until a local princess married the great Philip II of Macedon and gave birth to Alexander the Great. It was Pyrrhus, however, whose expedition against the Romans raised Epiros to the height of its fame. This territory lies in the north-western corner of the country, its access to the sea is represented by the port of Igoumenítsa, and it is delimited to the east by the bulk of the Pindos mountains: its extremely isolated geographical position has always contributed to its aloofness from the different dominions in continental Greece. The population of the region, with the typical proud spirit of the peoples

who inhabit the harsh, poor lands, has always rebelled against foreign interference: it is enough to remember the insurrections of the mountain partisan groups against the Turkish oppressors and the fronts of the Resistance along the Epirot slopes during the Second World War. The region's capital, Ioánina, was also the seat of the personal kingdom of the Albanian adventurer Ali Pasha of Tepelene, who at the end of the eighteenth century rebelled against the Sultan and attempted to create a sort of independent state comprising Epiros and certain Albanese territories. During this period as well as after the wars of liberation, the city of Ioánina became an important center of Greek culture and developed many handcrafts resources, still one of the city's principal spheres of activity. Macedonia, finally, is the largest province in Greece and stretches across the north of the country: to the north it is delimited by the Serbian and Bulgarian territories, while its coasts are bathed by the waters of the Thermaic Gulf. The territorial structure of Macedonia, the capital of which is Thessalonika (the second largest city in Greece after Athens), is highly variegated. The River Axiós cuts through the region, dividing it in half: to the west a mountainous territory, with forests, lakes and rivers, where there arise the characteristic mountain villages such as Florina, Edessa and Kastoriá; to the east the fertile plains along the gulf, irrigated by the Strymon River. The Chalcidice peninsula, in form similar to a hand with three fingers outstretched, gives the Macedonian coast its unmistakable profile. On the peninsula, the Republic of Mount Athos is an interesting place of pilgrimage, but for men only. Thessalonika itself, in which the ruins of a turbulent past overlap, exhibits the marks left by the agitated course taken by events in this territory, which achieved great splendor under the dynasty of Philip and Alexander the Great (4th-3rd centuries BC). Macedonia has always exerted a strong attraction for the peoples of the territories north of it thanks to its access to the sea.

A suggestive view of the majestic rock pinnacles of Metéora in Thessaly.

151

DODONA

Dodona was the site of continental Greece's most ancient oracle. In a fertile valley in the heart of Epiros there arose, in about 2000 BC, an oracular cult linked to a female divinity; the cult was replaced in the 13th century BC by that of Zeus. The divinity made known its pronouncements to the faithful of the sanctuary through the quivering of the leaves of the sacred oak tree that shaded the site or through the sound made by a strip of metal, moved by the wind, striking against a bronze cauldron. The Greeks venerated this **sanctuary** for centuries: except for a slight decline during the 5th century, it flourished until its destruction during the wars between the Etolians and the Achaians, in 219 BC. Although rebuilt, it was later burned by the Romans in 168/167 BC. Of the structures of the sanctuary itself there remains little, except for the scarce ruins of the temples and the small treasuries inside the sacred precinct. The most important constructions on the archaeological site are, instead, the immense **theatre** built by Pyrrhus, King of Epiros (3rd century BC) where summer festivals are still held, and the ***bouleuterion***, a vast hypostyle hall with three rows of columns. Some remains of the *walls* of the acropolis also still stand.

The scarce remains of the sanctuary of Dodona.

The monumental theatre built by Pyrrhus in the 3rd century BC.

Remains of the walls of the acropolis.

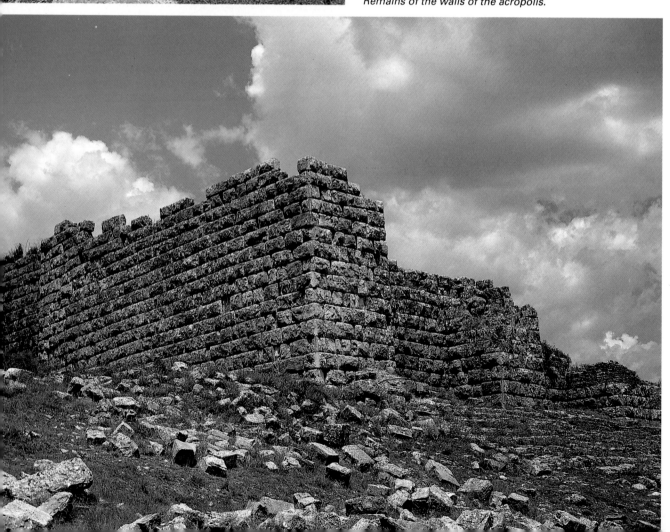

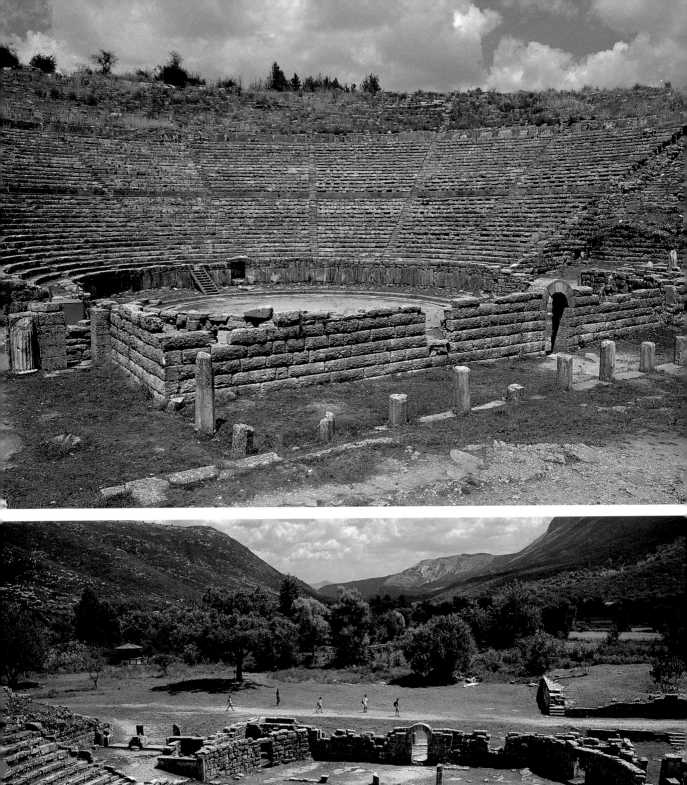

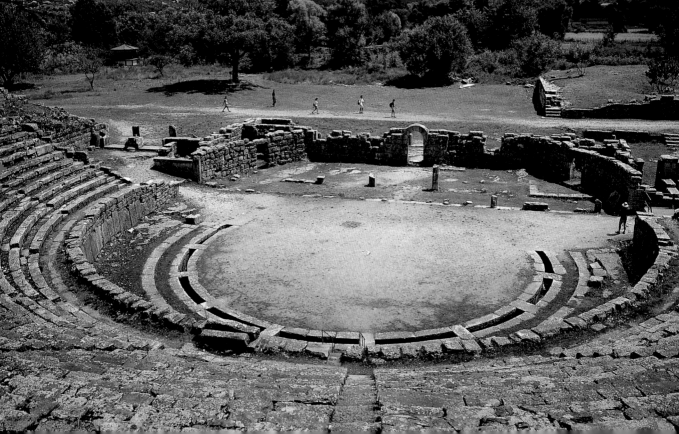

IOÁNINA

Ioánina, a good-sized urban center and the capital of Epiros, arises on the left bank of Lake *Pamvótis*, overshadowed by the Pindos mountain chain. Although its origins are uncertain, the site gained fame in the 11th century BC when the Norman Boemond fortified the acropolis, which still today dominates from the heights of a promontory the waters of the lake. The most evident foreign mark on the city is that left by Turkish dominion, during which time Ioánina attained great celebrity, becoming the site of the personal kingdom of Ali of Tepelene, named by the Turks Pasha of the city in 1788. Under his rule the city became an active center of business and culture, so much so as to push Ali, its mad, bizarre sovereign, to declare his independence from the Sultan. The repercussions of this action were to say the least violent: Ali sought refuge in the *Agios Panteleimon* Monastery, but was captured and beheaded in 1822, after a siege lasting two years. The **citadel**, reduced to ruins by the Ottomans, is today very Oriental in aspect, with narrow streets, buildings and shops in Turkish style; among these there stands out the mosque, erected by Ali and in a state of perfect preservation, now home to the **Museum of Popular Art**. The pearl of the city is, however, the **small island** at the center of the lake, which merits a visit thanks to its monasteries, among which that of *Panteleimon*.

The clock tower at the entrance to the old city.

View of Lake Pamvótis: at the center, the island on which the Panteleimon monastery rises.

MÉTSOVO

This Epirot village, once inhabited only by shepherds, is today one of the most characteristic villages in the region. The town lies on one of the slopes of the mighty bulwark represented by the Pindos mountain chain which separates Epiros from Thessaly and from Macedonia. Twisting paths lead through the forest to Métsovo, which is still immersed in an uncontaminated landscape and preserves its popular traditions. It is told how this charming village, near the only road pass that crosses the Pindos mountains, was held in high esteem by the Turks after a Grand Visir, fallen into the Sultan's bad graces, sought refuge here and was lovingly sheltered; when the Visir returned to his sovereign's favor, he granted the population of Métsovo many privileges which permitted the town a high degree of independence and freedom. The town continued to be economically favored by a series of benefactors whose names are known to all. Those of Tositsa and Averoff are kept alive in the townspeople's memories by the Tositsa Mansion, one of the most luxurious constructions in the village, and by the Averoff Gallery, where the works of modern and contemporary Greek artists are exhibited. Of note as well are the *Agios Nikólaos* (Saint Nicholas') Monastery, built in a gorge in the Pindos slopes below the town.

View of the beautiful Tositsa residence (late 19th century).

The village of Métsovo, overshadowed by the peaks of the Pindos mountain range.

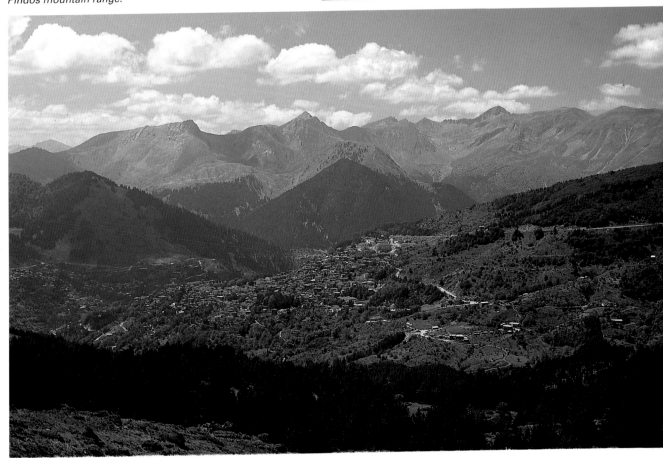

METÉORA

The Greek adjective *meteoros* means "in the air", and it is an appropriate attribute for this extraordinary group of rocks that rise precipitously like high towers soaring toward the sky, seemingly without contact with the ground underneath. These conglomerate rocks underwent a strange geological phenomenon, probably due to erosion by the sea, which has given them their unique aspect. The view of the Metéora themselves is almost surreal; the **monasteries** that have been built on their tops complete one of the most unmistakable landscapes in all of Greece.

During the 15th century, when the Serbian Emperors of *Trikala* were fighting the Byzantines for possession of the land, small monasteries were created by hermit monks on the most inaccessible of the peaks. Between 1356 and 1372, the cenobite Saint Athanasios founded the *Monastery of the Transfiguration* on the **Great Meteoron** and set strict regulations which first of all excluded women completely; Athanasios was followed by other hermits, founders of other centers. That of the Great Meteoron nevertheless continued to predominate, and in the 16th century it was enlarged by

Athanasios' disciple Ioasaph, son of the Emperor [...] Serbia. The monastery rose to even greater impo[...] tance under the guidance of the former Emper[...] John Kantakouzenos. Of the 24 monasteries th[...] once dotted the formation, there today remain on[...] five due to the numerous disputes over possessio[...] of the lands which culminated in massive expropr[...] ations during the century.

Despite their glorious past, these famous centers [...] retreat have suffered immense degradation an[...] today are not only greatly damaged but also almo[...] completely uninhabited. The monastic complex[...] are all rather similar (a courtyard with the church [...] its center, the cells and the refectory), althoug[...] those of *Saint Nicholas*, *Saint Stephen*, *Varlaá* [...] and the *Great Meteoron* merit special visit[...] Absolutely inaccessible in the past, if not b[...] removable ladders and later by means of a winc[...] driven system of ropes and nets (today used on[...] for hoisting supplies), the monasteries are tod[...] served by blacktop roads which link the separa[...] bastions; much more suggestive, instead, is th[...] route which follows the ancient trails, signs [...] which are still visible.

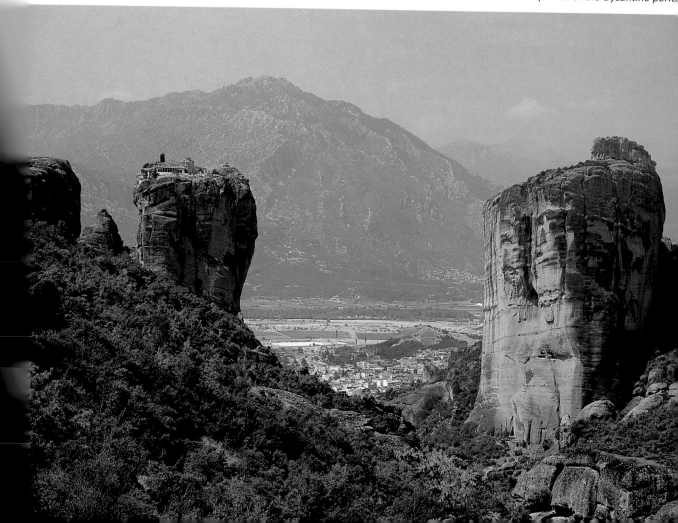

The lunar landscape of Metéora: the rocks rise l[...] soaring towers toward the sky, topped by the beauti[...] monastic complexes of the Byzantine peri[...]

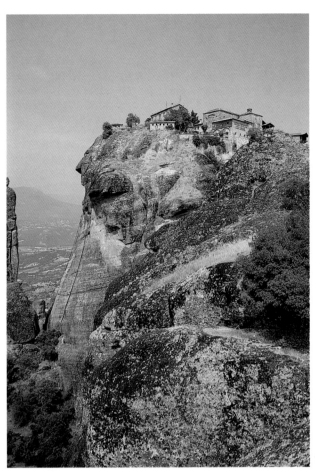

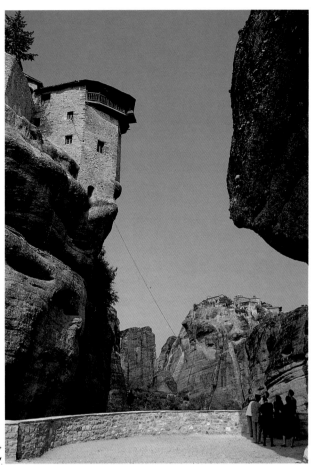

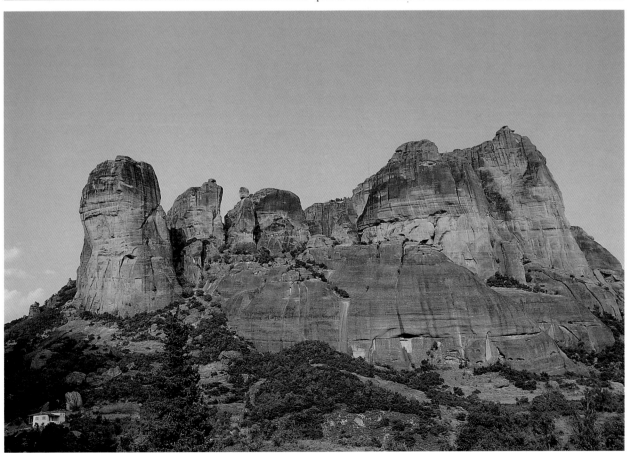

GREAT METEORON

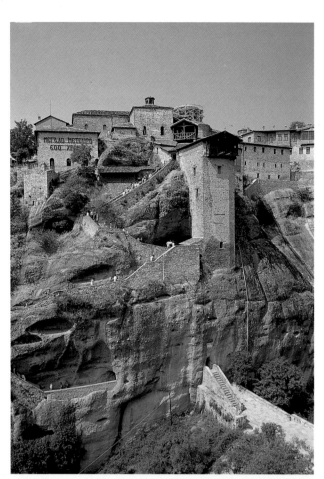

The architecture of the Metéora monasteries is obviously subjected to the dictates of the particular positions they occupy: they are all perched on small spaces on the peaks of the rocks, and often extend down through different levels; taken as a whole, the outstanding elements are the facades, white or in dark stone, the cupolas of the churches and the spacious courtyards surrounded by the austere monks' cells which often look out over extremely high sheer cliffs. The Great Meteoron Monastery, also called the *Meteoron* or the Monastery of the *Transfiguration*, is situated on one of the highest and most precipitous peaks (613 meters above sea level); it is reachable only by a steep and uneven path. Along the way are visible the remains of another monastery, the so-called *Monastery of the Manuscripts*, famous for its illuminated codices: it is today completely abandoned and in ruins. The majestic *Great Meteoron*, founded by Athanasios, is without doubt the richest and the most famous of the

The Great Meteoron Monastery, rising on one of the highest peaks (613 meters).

Interior of the Church of the Transfiguration (14th century).

monasteries, in part because it benefited from the donations of the Serbian Emperor Symeon Ourosh, father of one of Athanasios' successors, Ioasaph Ourosh. Especially fascinating is the tour of the monks' prison, dug in dark, damp caverns on the precipice of the crag. *Tunnels* cut into the thick rock lead to the great gate that gives access to the irregularly-shaped *courtyard* in which the *cloister*, the *refectory*, the *chapels* and the *main church* (called, as are all monastery churches, the *katholikon*) of the Transfiguration are located. Inside the church, despite the signs of progressive deterioration, we can still admire the resplendent art of the Middle Ages, in particular in the representation of the Martyrdom of the Saints. Of note also the frescoes from the late 15th century depicting the Nativity, the Transfiguration and the Resurrection. In the apse of the chapel built in 1387-1388, the portrait of Saint Athanasios. The refectory and the chapel of the *prodromos* date instead to about the 17th century. Evidence of the church's riches is offered by a series of precious icons and cult objects from the 14th century.

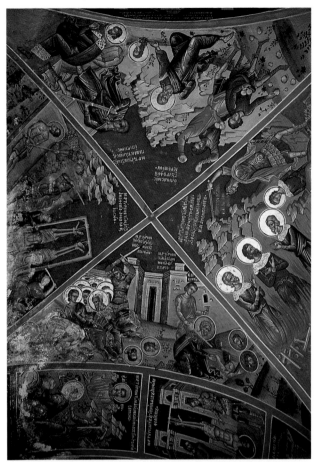

Central cupola of the Church of the Transfiguration: frescoes of the Martyrdom of the Saints.

Iconostasis with precious 14th-century icons and cult objects.

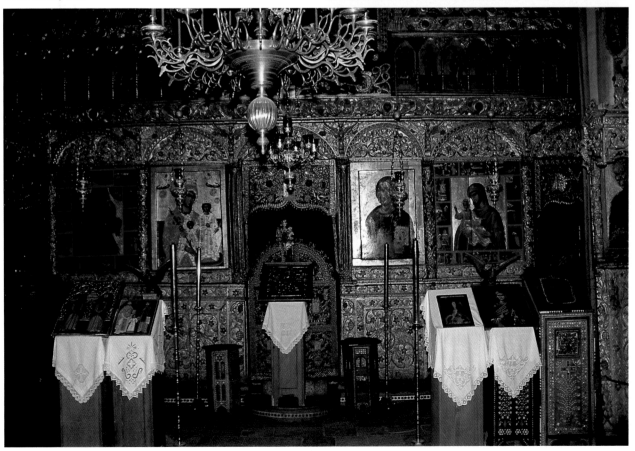

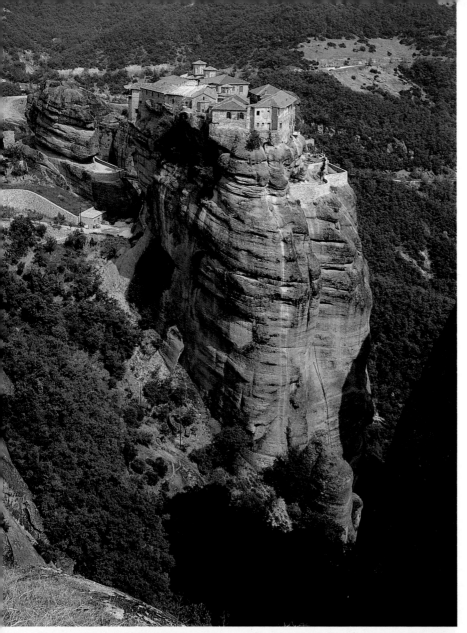

VARLAÁM

This monastery was founded in the early 16th century on the site of the hermitage of the anchorite Varlaam. Its structure, differently from those of the other monasteries, more resembles a true fortress, perched as it is on the summit of one of the highest rock columns. The very inaccessibility of this site engenders immediate reflection on the religious fervor of the hermits who meditated in these retreats and on this singular form of orientalizing asceticism that here, with the help and the support of nature, reached its perfect expression. The *Varlaám* Monastery, like the others, exhibits the typical structure made up of a central courtyard, the refectory, the cells and the *katholikon* (monastery church). In **All Saints' Church** we find the beautiful frescoes from the Byzantine period, signed by the painter Frangos Kastellanos and by Georgis of Thebes in 1565. Today, following the excellent restoration work conducted in 1870, the frescoes have regained their original freshness. The refectory is used as a small museum for exhibiting the church ornaments and vestments, while in the **library** are preserved rare antique *manuscripts*. The monastery guest room and the garden outside, protected by a fortified wall, are also beautiful.

The Varlaám monastery, founded on the site of the hermitage of the anchorite Varlaam (14th century).

Example of a winch used to raise the nets in which the monks travelled up to the monastery.

View of the Varlaám monastery, which resembles a true fortress.

Iconostasis in the interior of All Saints' Church.

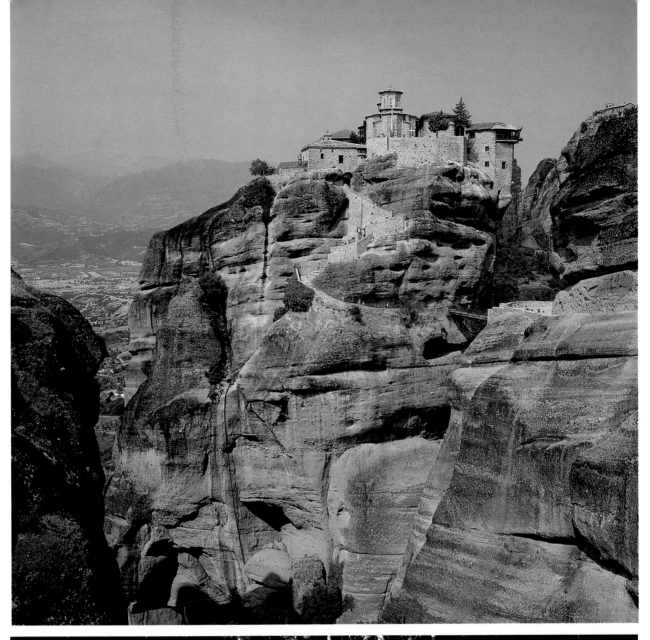

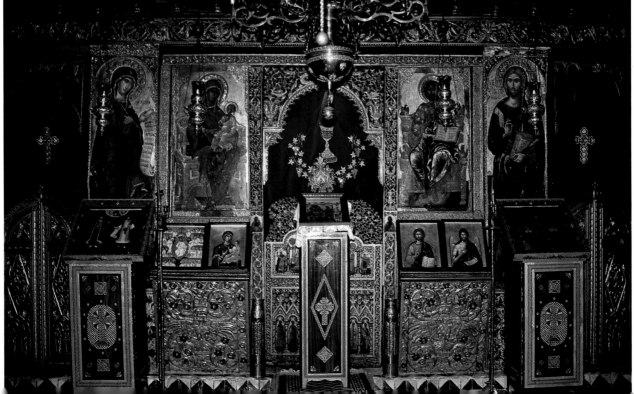

HOLY TRINITY MONASTERY

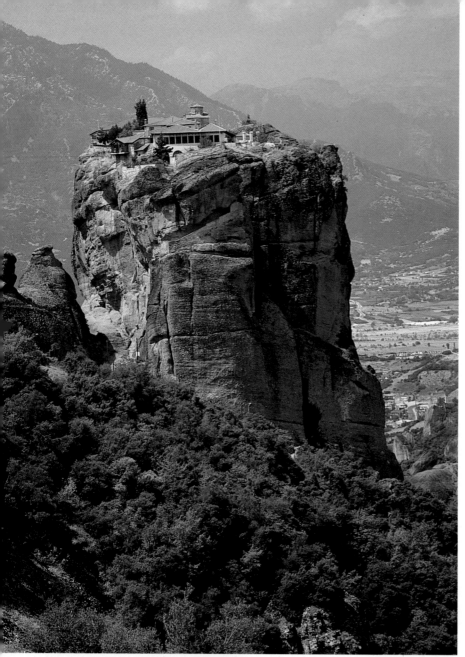

The interior of this monastery is accessible only up a steep flight of steps cut into the rock face and roofed by a vault, similar to a tunnel. The climb is, however, amply rewarded at the end by the sight of one of the most beautiful panoramas that can be viewed from these high peaks: from its the excellent position, this monastery offers a view unequalled by any of the others.

The architectural plan dates to 1438, the year of the monastery's foundation: the church was built only some decades later (in about 1476) and the narthex dates to a much later period.

The pictorial decoration in the interior of the church is of no great importance; the best part of Holy Trinity Monastery is the *exterior*, where among other things are found a delightful garden looking out over the chasm. A road different from that by which we arrived descends from the monastery to the nearby village of Kalambáka.

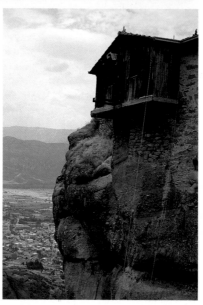

The pinnacle on which the Holy Trinity Monastery arises, along the road from Saint Stephen's to Roussánou.

The stairway cut into the rock leading to the Holy Trinity Monastery.

A detail of the monastic complex overlooking the void.

ROUSSÁNOU

Following the route that from *Saint Stephen's* Monastery leads back toward the *Great Meteoron*, we encounter the last of the monastic complexes perched on the summits of the famous Metéora rock pillars worth special visits. This solitary site, once frequented exclusively by hermits, was transformed into a convent late in 1639, at a time when the iron-clad regulations set down by Athanasios prohibiting the presence of women in these places of the prayer had slackened. The architectural characteristics of the buildings, housing what is today a lively community still directed by the nuns, are the same as those of the other monasteries. We enter Roussánou (Saint Roxanne) through a passage cut into the rock, hanging over the void, although the position of the monastery is not one of the most inaccessible: it rises at the foot of one of the highest rock towers and is completely surrounded by lush vegetation. The structures of the courtyard, the refectory and the church offer no particular attractions; the interior of the church is frescoed with a cycle of bloody scenes of the Persecution of the Martyrs.

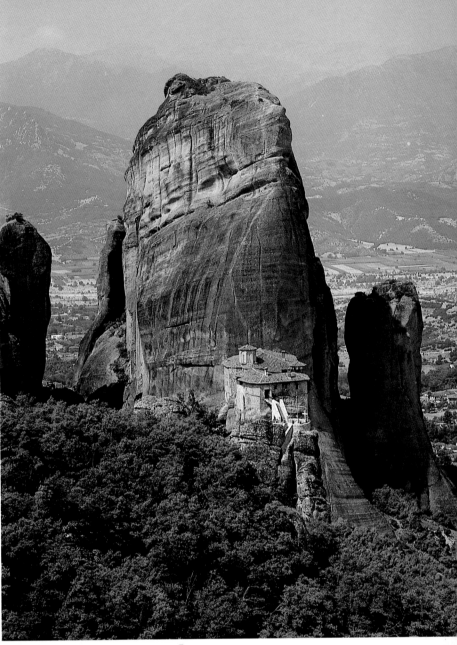

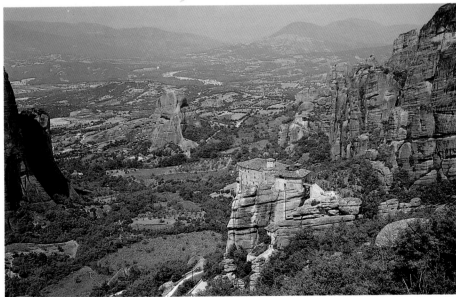

Roussánou: the only convent of nuns, at the foot of one of the highest rock pillars.

The convent, surrounded by lush vegetation.

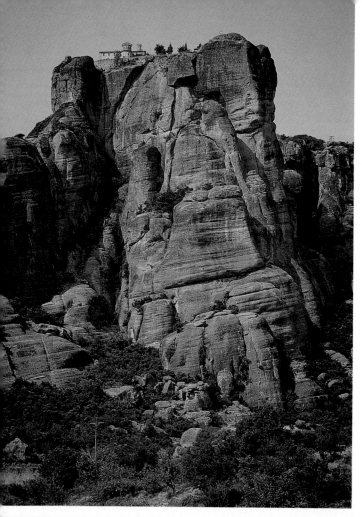

SAINT STEPHEN'S MONASTERY

Saint Stephen's Monastery (*Agios Stéfanos*) is located on one of the peaks of an enormous rock pillar and linked to the mountain mass by a *drawbridge*. Like the others, this religious site was first a hermitage and was transformed a short time later into a monastery by the Emperor Andronikos III Palaiologos in 1328-1344; today it is occupied by nuns. The older church does not have outstanding frescoes to offer, but making up for this shortcoming is a sculpted iconostasis of great value and the likewise valuable icons along the sides. **Saint Stephen's Chapel**, instead, was built and painted some centuries later (toward the end of the 18th century). The refectory dates to the same period. In the **library** are many valuable *manuscripts*, unfortunately completely destroyed by time and neglect; in the **museum**, besides the usual cult objects, there is a splendid *gold embroidery* of Christ.

The cliff on which rises the Saint Stephen's Monastery and view of the monastic complex.

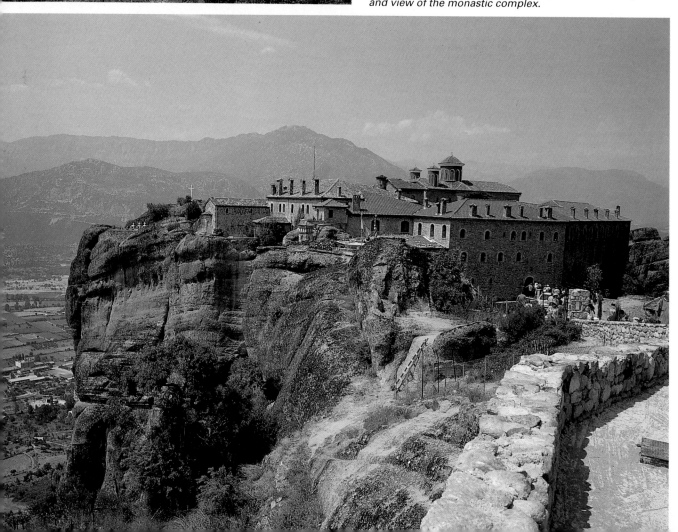

SAINT NICHOLAS

From the village of *Kastráki*, a steep path leads to the Saint Nicholas Monastery (*Agios Nikólaos*), founded in the 15th century and enlarged in a later period. The frescoes in the church, dating to the first half of the 16th century, are the work of the Cretan monk Theophanes Strelizas. The cycle depicts the *Last Judgement* and *Paradise*; the most striking image is that of *Adam* naming the animals.

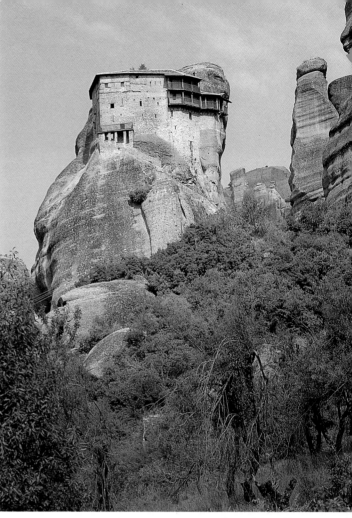

The Saint Nicholas Monastery, a few kilometers from the village of Kastráki.

The village of Kastráki from the Saint Nicholas Monastery.

VÓLOS-MAKRINÍTSA

Vólos and Makrinítsa are two of the most significant centers on Thessaly's Pelion Peninsula, which is formed of massive mountain ranges soaring even to very high altitudes, heavily mantled in lush vegetation and in places wild; the uniformity of the green cover is broken here and there by small villages or small Byzantine churches scaling the sides of the mountains. Mythology tells us that these localities were the homeland of the wild *Centaurs*, but also of the wise Cheiron, the mythical preceptor of Achilles and one of antiquity's greatest heroes. Vólos is a modern center, despite its descendence from the extremely ancient *Pagassaés*, once the ancient port of *Iolkos* and name-giver to the Pagasitic Gulf on which it arose; it is told that it was from Iolkos that the great Jason set sail with his ship Argo in search of the Golden Fleece. Attractions in Vólos, besides its beautiful seafront promenade (the *Argonafton*), include a pleasant visit to the oldest and most characteristic quarters of the city. Makrinítsa is one of the many villages that dot the sides of the Pelion massif. The traditional houses, with their slate roofs, are dominated from above by the main square, which looks out like a giant terrace over the Pagasitic Gulf. At the center of the square is the Byzantine church of the *Panagía* and a charming fountain.

The mountainside village of Makrinítsa, also aptly known as the "Balcony of Pelion".

The city of Vólos lying along an inlet on the Pagasitic Gulf.

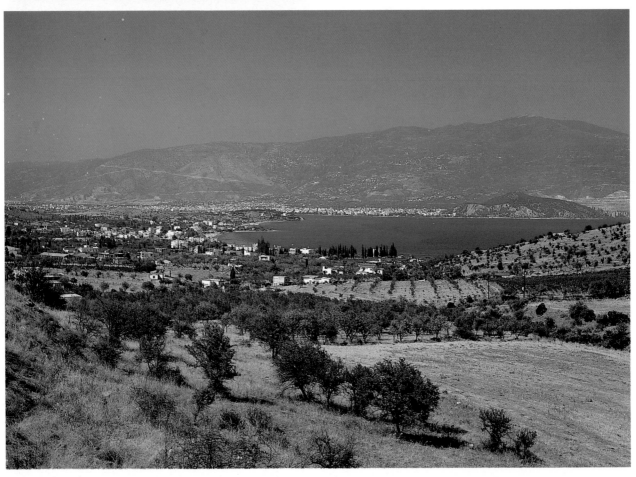

VOLOS MUSEUM

Although quite small, the museum of Volos displays archaeological finds which are highly representative of Greek culture. One section is dedicated to the objects from the sites at *Sésklo and Dimíni*, from whence come the most noteworthy artistic finds of the Neolithic: terracotta *statuettes* linked to the cult of the Earth Mother and many *ceramics* with white and black decoration on red backgrounds or black decoration and white "framing". From Iolkós come *bronze objects* from the Mycenaean period, and from *Pherai* bronzes and vases from the Geometric and Archaic periods. The *collection of steles* of later date (Hellenistic-Roman) recovered from the soil of *Phalannas* and of *Pherai* is also worth seeing.

Funerary steles of the Hellenistic and Roman periods.

Ceramics and small idols of Thessalian production, from the Neolithic age.

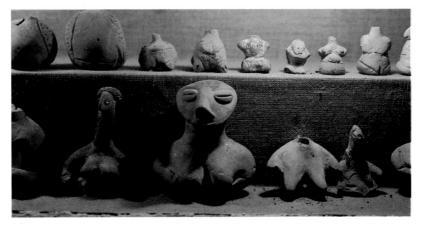

PLATAMÓNAS

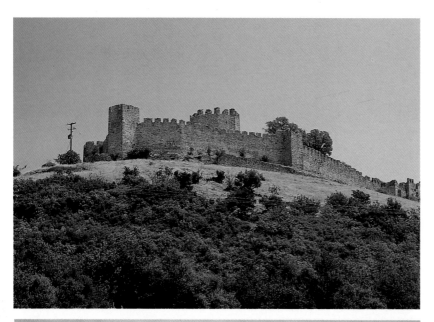

Along the road from Lárissa to Thessalonika, after the *Vale of Tempe*, are a series of pleasant coastal resorts.

One of these, at the foot of majestic *Mount Olympus*, is overlooked by the mighty Platamónas castle built in the 13th century by the Crusaders. Still today, the **fortress** dominates the Thermaic Gulf; its function in the past was in fact that of controlling access to the waters. In a suggestive, commanding position, the castle is an unmistakable landmark in the profile of the highlands that delimit the coast.

DION

Dion arises in a well-chosen position at the foot of Mount Olympus, a short distance from Katerini; surrounded by lush vegetation and bathed by a small stream, it is the image of an uncontaminated and sacred locality. It was here, in fact, that Alexander the Great, before set-

View of the fortified castle of Platamónas, built by the Crusaders in the 13th century.

Some mosaics in situ at the Dion archaeological site.

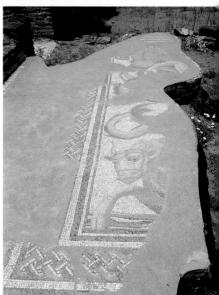

ting out for Asia, made his sacrifices to the gods of Olympus for the success of his expedition. The University of Thessalonika Mission, led by Prof. Pandermalis, recently discovered the ancient site and is continuing the excavations, which never cease to reveal new and sensational finds. A **circle of walls** encloses the city center, occupied by ruins from the Roman era even though its origins date much further back. At certain points in the walls are visible the limestone blocks of the Classical fortifications. Before entering the city, we may visit some typical **Macedonian tombs** (4th and 3rd centuries BC). The city itself is divided by *streets* which run perpendicularly to form true *blocks*; together with the warehouses and the shops are public buildings such as the baths from the 2nd century BC, in which the foundations of the bathing rooms are perfectly preserved, and the *odeion* for assemblies; there are also private buildings. The remains of a **paleo-Christian basilica** have also been uncovered within the city. Outside the urban perimeter have been found the ruins of a number of **sanctuaries** dedicated to Asklepios, to Demeter, to Dionysos and finally to the Egyptian Isis. Looking down from a small road-bridge we see the *Sanctuary of Isis*, immersed in a suggestive atmosphere created by the luxuriant vegetation and the waters of the nearby stream; it is reached through a central corridor which ends in a stairway, at the top of which are three *small temples* dedicated to *Artemis*, *Isis Lochia* and *Isis Tyche*. Inside the temples are the statues of the divinities: that of *Isis Tyche* was found intact on its base and is now displayed in the small Dion **Museum**. Two **theatres**, one Roman and the other Hellenistic, are the last of the monuments outside the walls.

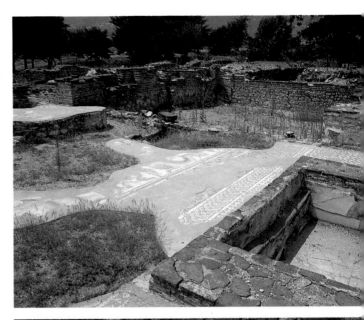

View of the interior of the city: the baths; in the background the ruins of the paleo-Christian basilica.

Mosaics inside the city walls: floral motif and a representation of Dionysos Enthroned.

Walls from the Hellenistic period along the main street, with cuirasses and shields in relief.

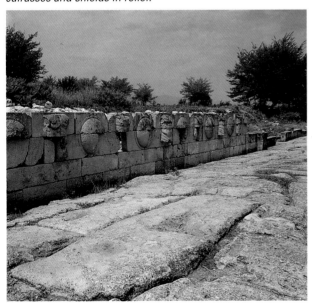

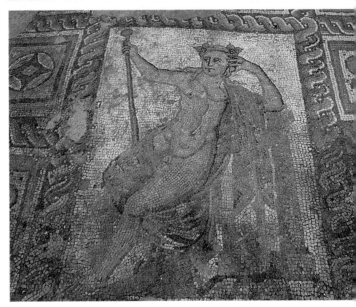

VERGÍNA

The excavations conducted by Manolis Andrónikos at the sites where it was believed the first Macedonian capital (*Aigai*) arose have finally brought to light the great sepulchral monuments of one of the most significant Greek kingdoms. The **two tombs** uncovered in 1977-1978, as well as many others discovered in following years, were sensational discoveries. These are monumental tombs consisting of a *vestibule* and a *burial room* preceded by an imposing marble gate: the facades of these buildings were frescoed and the doors flanked by two columns. Inside the larger of the tombs were found artifacts of enormous value: two silver vases, two bronze vases, two gold *larnakes*, two splendid diadems, portraits in ivory and the deceased's weapons. These objects, preserved in the Thessalonika museum, have led archaeologists to believe this was the **tomb of Philip II**. The preciosity and the quality of the decoration bear witness to the high cultural level of the Macedon kingdom during the reigns of Philip and Alexander. On the same street are traces of the **palace** built by King Antigonos Gonatas between 278 and 240 BC, of which there remain the central courtyard with its peristyle and the surrounding mosaic-floored halls: one of these features a center motif and female figures in the corners. Between the necropolis and the palace is a **theatre**, in which, it is told, Philip II was stabbed.

PELLA

Known as early as the Classical period, the city of Pella gained renown when in the late 5th century BC King Archelaos, abandoning Aigai, made Pella the capital of the Macedon kingdom and built a sumptuous **palace**. It was here that Alexander the Great was born. Although the city was destroyed by the Romans in 168-167 BC, the many ruins still attest to its past splendor. The **palace** was built on an extremely regular and harmonious plan, with at its center a large courtyard with a peristyle, the black and white *mosaic* floor of which, with its geometric design, is still *in situ*. Still more admirable are the floors of the rooms of the palace

Street flanked by column drums, leading to the Hellenistic palace.

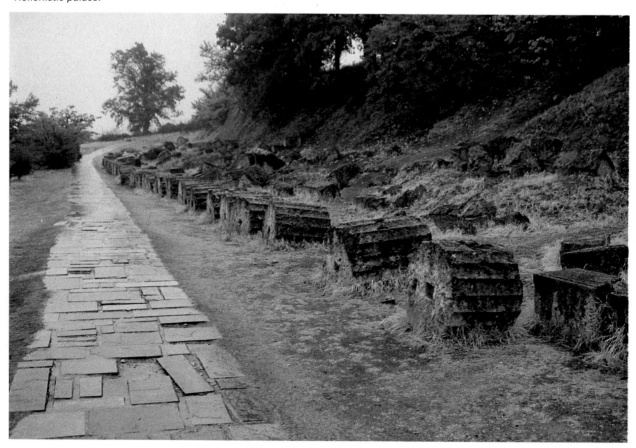

to the west of the courtyard, in which the restored mosaics have recently been replaced. These date to the 4th century BC, and although they are composed of river pebbles according to Archaic technique they illustrate the sumptuousness of the culture of northern Greece during the period of Macedonian hegemony: the mosaics depict the Abduction of Helen by Theseus, an Amazonamachy and an episode from a deer hunt, by Gnosis. Other examples are displayed in the small local **museum** together with many *sculptures* and *small bronzes* from the Hellenistic age. Among the mosaics we must remember that showing Dionysos seated on a panther and another hunting scene (evidently the favorite sport of the dynasts): a lion hunt. All of outstanding figurative quality.

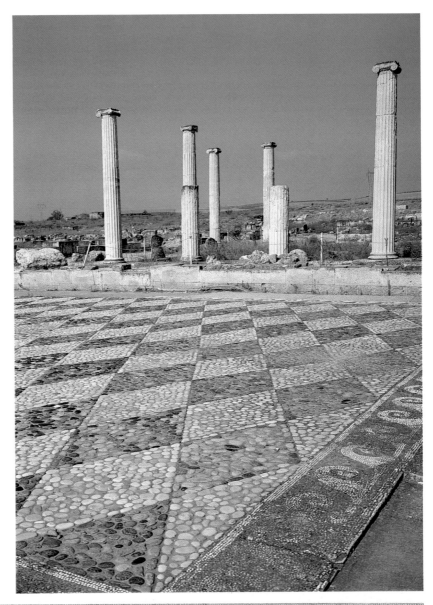

Mosaic with geometric motifs, in black and white, in the central courtyard of the palace.

The beautiful mosaic representing the lion hunt, in the Museum.

KASTORIÁ

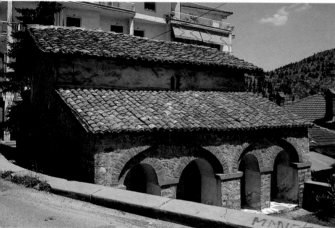

Once one of the most suggestive towns on the entire Balkan peninsula, above all thanks to its old wooden houses and its many churches, but also to its enviable position on the shores of the lake of the same name, Kastoriá, in antiquity the Greek *Kelethron* and renamed *Diocletianopolis* during the Roman era, is today an important center of fur production. The city has nonetheless paid a high price for its recent prosperity: since the beginning of the century it has been gradually changing its aspect, and is no longer an ancient and characteristic village; in fact, the last of the by now extremely rare wooden homes are to be found only along the shores of the lake. Kastoriá is famous for its many *churches* and *chapels* (there are over 72), all exhibiting the typical architectural forms of the Byzantine style, articulated and rounded-off, with low umbrella-shaped domes (in Oriental style). Among the most significant buildings are the **Chapel of the Taxiarchs**, erected between the 11th and the 13th centuries; the **Church of the Panagía Koubelídiki**, dating to the 11th century and unique thanks to its cylindrical bell-towers and its frescoes decorating both the interior and the facade; the **Churches of Agios Athanasios** and of the **Taxiarchs of the Metropolis**, both from the 14th century; the 11th-century **Church of Agios Stéfanos**, containing a fresco of the Crucifixion and a precious wooden iconostasis dating to the 13th and 14th centuries; the **Church of the Agii Anárgiri**, built in the 10th century and restored in the 11th, decorated with frescoes.

Two of the numerous small Byzantine churches and a view of the city from the lake.

View of the old city with the Byzantine walls; in the background, the bay.

THESSALONIKA

Thessalonika, or *Salonica*, is today the second city and the second most important port in Greece. Capital of Macedonia, it lies on a plain between the sea and a line of low hills at the head of the gulf of the same name.

The city prospered thanks to its geographical position, which made it an important crossroads between East and West; it was chosen by Galerius as the capital of the Eastern Empire in 298-299 AD. During the persecution of the Christians, many martyrs died there, among whom Saint Demetrios, the "guardian and patron of Thessalonika" and of the East. The city fell to the Turks in 1430. A simple Islamic inscription on a column in the Church of the *Panagía Ahiropíitos* recalls the day of the conquest.

Today, Thessalonika, partially reconstructed following the fire of 1917, is the seat of a prestigious University and an important industrial and business center.

The built-up area is divided into a lower city, nearly all modern, and an upper walled city with uneven small streets that lend it a faint Oriental flavor.

The ***circuit walls*** were rebuilt in the 6th century, and a four-kilometer stretch including towers and gates is still standing. Few traces remain instead of the fortifications of the port, in the southern part of which there rises the ***White Tower*** (in Greek, *Lefkós Pírgos*), built in the 1400s and sadly famous for the massacre carried on there by the Turks in the 18th century. The famous ***Arch of Galerius***, dating to the late Imperial period, is supported by four pillars decorated with reliefs sandwiched between large architectural elements decorated in turn with vines and oak leaves. The arch was part of a complex that also included the so-called **Rotunda**: originally intended as the Emperor's mausoleum, it was a grandiose circular hall surmounted by a hemispherical cupola which at the end of the 4th century was transformed into the Palatine Chapel under Theodosius I. A century later were built **Saint**

Demetrios' Church and the **Church of the Virgin** (the previously-mentioned *Ahiropíitos*), with three naves divided by a double row of archways in Oriental style. Even later, instead, are the **Panagía Halkéon** (1028), built on the Greek cross plan, with noteworthy frescoes in the interior, and the Church of **Dódeka Apóstoli**, the smallest of all, built in 1311-1315; its interior is decorated with *mosaics* and *frescoes* depicting scenes from the life of Christ.

The Venetian White Tower (15th century), near the port.

Right side of the triumphal arch of the Emperor Galerius (3rd century AD). The reliefs commemorate the Emperor's Persian victories.

View of the interior of the ancient ramparts with the powerful defensive keeps.

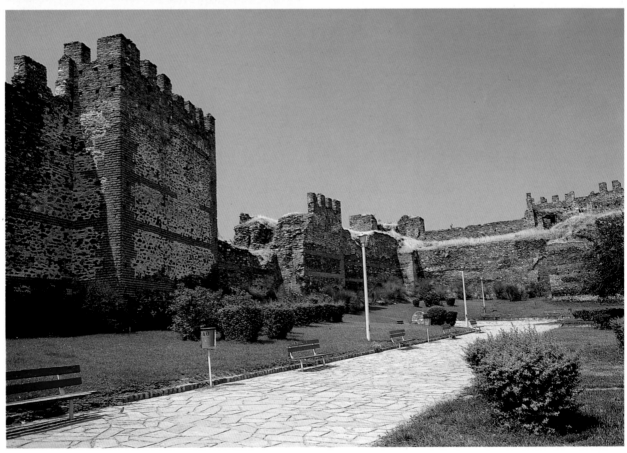

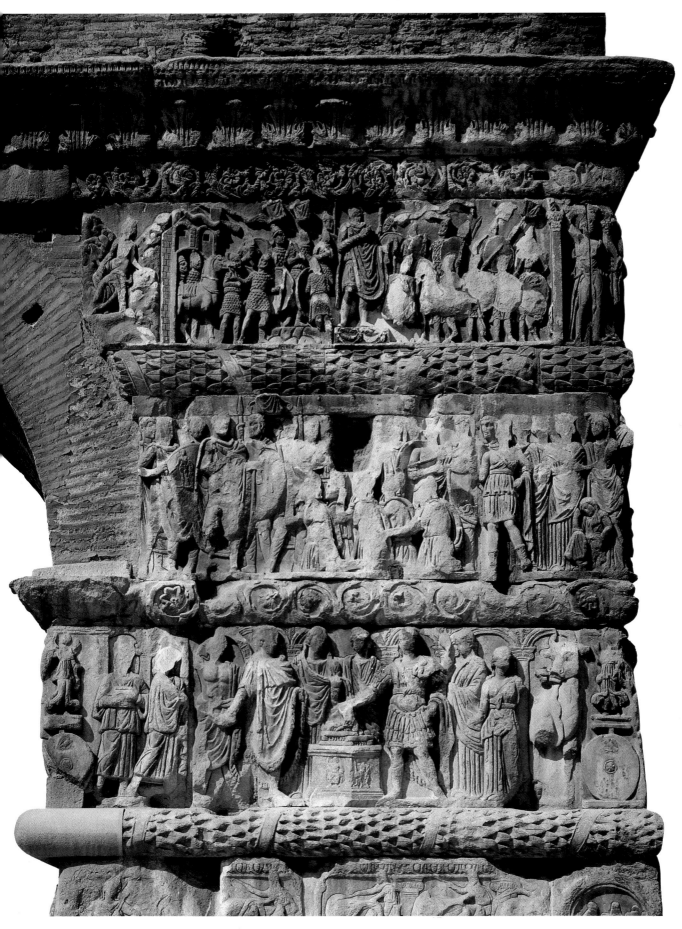

SAINT SOPHIA

The great church of Saint Sophia (*Agía Sophia*) was built in the mid-8th century in honor of Divine Wisdom (in Greek: *sophía*). Rows of pillars and columns divide the space inside the building into three parts. The side aisles are strictly related to the narthex, while at the center four great pillars define a square space that is ideally prolonged into the apse, flanked on the right and the left by two small chapels. The scenography of the interior is greatly enriched by a series of mosaic cycles, true masterworks of mature Byzantine art. Of particular note: the mosaic adorning the cupola, depicting the *Ascension* (late 8th to early 9th century), that in the arch preceding the apse, of a *Golden Cross* on a silver background (8th century) and that of the apsidal vault, with the moving *Nativity* scene (9th century).

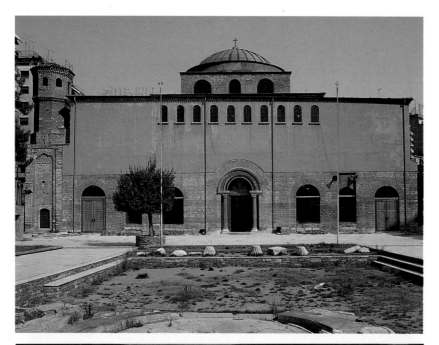

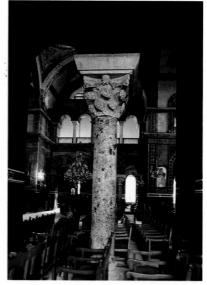

The facade of the basilica with the atrium.

The splendid mosaic of the central cupola, glorifying Christ.

The wall dividing the central nave and the apse, with Byzantine paintings from the "Palaiologos Renaissance".

A column in the north colonnade. Note the original decoration with rows of delicate acanthus leaves.

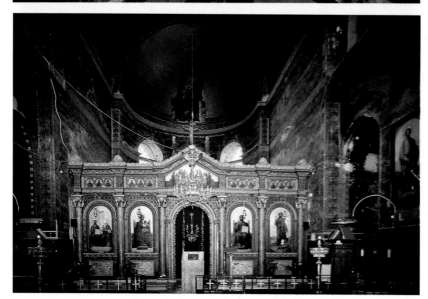

SAINT DEMETRIOS

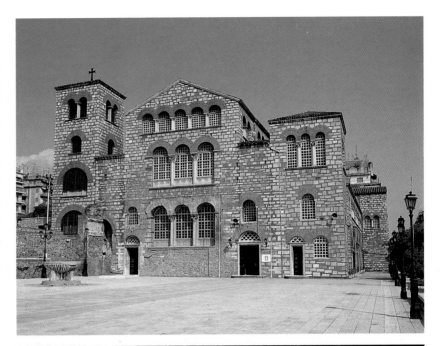

Agios Demétrios is today the most important paleo-Christian church in Thessalonika. The first foundations, with three naves, date to the 5th century. In 1493 the church was transformed into a mosque, while today's church, again a Christian place of worship, has 5 naves with a narthex and transept. The aisles are divided by four rows of columns, and the transept is slightly raised with respect to the naves. At the center of the transept is the altar, under which, in a cross-shaped cavity, was found a phial containing the dried blood of the Saint.

Of note the *marble facings* of the narthex and of the center nave, and the capitals of the porticoes between the naves. Beautiful *mosaics* (7th-11th centuries) decorate the pillars on either side of the apse with scenes from the life of Saint Demetrios and Saint Sergius on the right, and of the Virgin with Saint Demetrios on the left. Also worthy of note are the *pictorial cycles* in the narthex and on the west side of the basilica. The foundations of a *marble ciborium* dating to the 11th century, which probably replaced another, in silver, destroyed in the 10th century by the Saracens, have been brought to light at the left of the central nave. The *Crypt*, on the site of the martyrdom of the Saint and in which his body was at one time preserved, opens under the north wing of the transept. Nearby, the relatively recent Chapel of *Saint Euthymius* in which are preserved beautiful frescoes, the precise date of which (1303) is given by the dedicatory inscription.

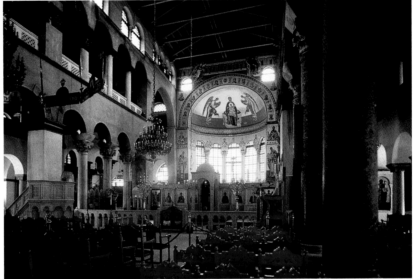

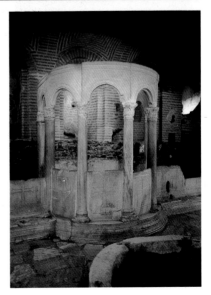

View of the facade with the bell-tower.

The nave with the mosaics of the apsidal vault and the imposing women's galleries.

The crypt on the site of the martyrdom of the Saint.

The 10th-century marble ciborium in the form of an aedicula.

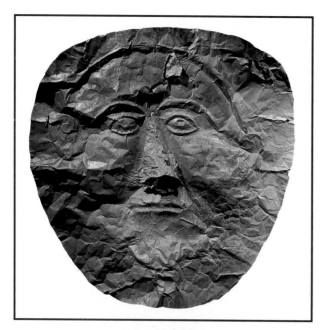

THESSALONIKA MUSEUM

The new archaeological museum of Thessalonika arises in the modern area of the city near the municipal park, site of the International Fair. The collection, which includes finds excavated in Macedonia and Thrace and from historical periods stretching from the Neolithic (4000 BC) to approximately the 4th century AD, was greatly enlarged following the discovery of the royal necropolis of Vergína in 1977 by Manolis Andrónikos, member of the Greek Archaeological Service.

Among the pieces that merit special mention are the *grave goods of Philip II* of Macedon (336 BC), including a large bronze shield, two pairs of bronze shin-guards, an iron helmet, a silver strainer, a silver wine pitcher (*oinochoë*) with a head of Silenus, a true masterwork of Greek handcraft, and the splendid gold funeral casket (which was found inside a marble sarcophagus) with the 8-pointed Macedonian

Gold funeral mask, from a royal Macedon tomb.

Bronze helmet from Lefkádia-Náoussa, 5th century BC.

The golden diadem found in the tomb of Philip II. Note the marvelous detail of the floral decoration.

The ivory miniatures found in the tomb of Philip II. Note the small head of a bearded man, perhaps Philip himself.

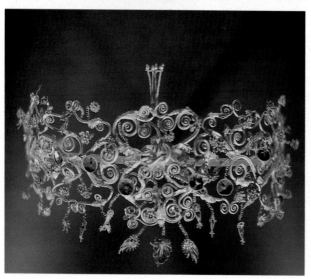

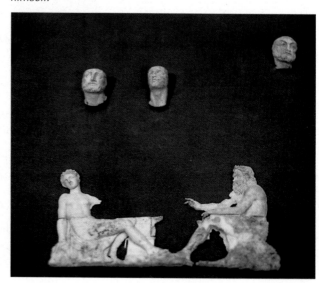

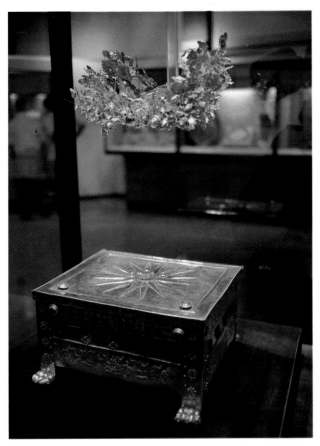

The gold burial casket of Philip II, with the Macedonian star on the cover. Above it, the golden crown of oak leaves.

Gold-plated iron cuirass from Vergína. Of note the covering plates.

Gold quiver-cover with a embossed decoration. From the larger Vergína tomb.

star on the cover. The outstanding treasure of the collection is nevertheless the marvelous gold *diadem*, surely one of the most exclusive jewels to have come down to us from Classical antiquity.

Alongside a rich series of small bronzes and terracotta and glass objects that date from the Classical period (5th century BC) through the mature Hellenistic period (2nd-1st centuries BC) are many weapons and pieces of armor, among which the splendid gold-plated iron *cuirass* found in the Vergína necropolis, completed by parts in leather which are also decorated with delightful gold plaques.

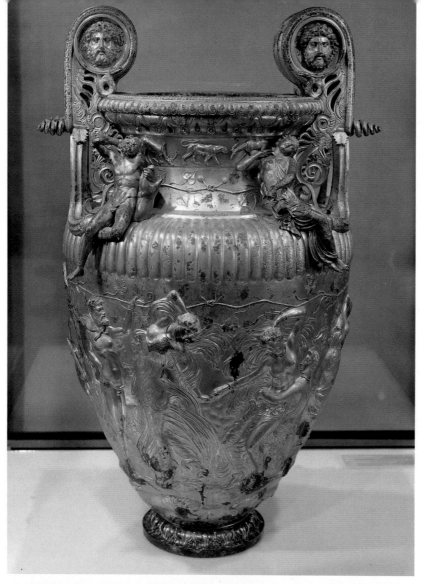

Recent research indicates that the cuirass belonged to Philip II himself; it is certainly of the type normally used by Macedonian nobility, since it very closely resembles that worn by the young Alexander the Great in the representations of his Asian campaign. Again in the metalwork section, of special note a capacious silver container (*situla*), with a cover, that contained the ashes of a sovereign, with on its shoulders a crown of golden oak leaves attesting to the rank of the deceased; and the celebrated **Dervéni krater** (so-called after the site at which it was discovered in 1962), an enormous gilded bronze container with silver appliqués. On the front side the embossing technique was used to portray the divine couple, Dionysos and Ariadne. The latter figure is very lively as she gracefully lifts her veil amidst a crowd of Satyrs and Maenads (330 BC). In the sculpture section, of note a number of bases from an Ionian temple near the ancient *Therma*, various inscribed funerary steles, votive reliefs, several low reliefs attributed to the sculptor Evandros (1st century BC), busts of emperors such as Augustus and Settimius Severus, and a beautiful floor mosaic dating to the mid-3rd century BC, showing three pairs of divinities: Dionysos and Ariadne, Zeus and Ganymede, Apollo and Daphne.

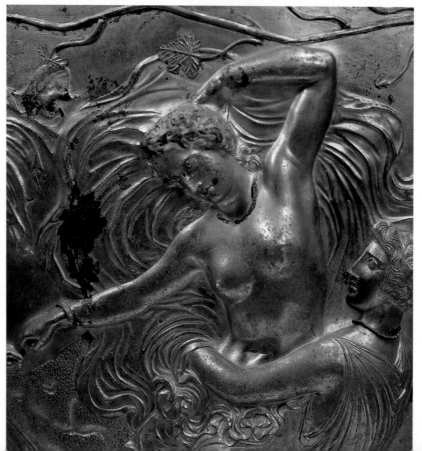

The celebrated Dervéni krater. In the photograph below, a detail of Dionysios and Ariadne.

CHALCIDICE PENINSULA

The largest peninsula in Greece is a prevalently hilly country, sloping now brusquely, now gently down to the sea, reaching out its three arms into the waters. The grey limestone formations, at first glance bleak and barren, are covered by oaks and conifers at higher altitudes. Together with the natural beauty of the area, of note the **Olintos** excavations, the remains of **Potidaeia** and the stupendous monasteries of **Mount Athos**, a republic in its own right.

Olintos, which flowered in the 5th and 4th centuries BC, was destroyed in 348 BC by Philip II of Macedon. The *orthogonal city plan* is still evident today; its focal point was the main square, the foundations of the principal building of which are still visible. Slightly outside of the center, instead, is the *House of Good Fortune*, a luxurious villa with a peristyle erected in the 4th century BC, which has given us a group of mythological *mosaics* representing Achilles, Thetis and the Nereids, Dionysos and the Bacchantes, and Pan.

Not far from Olintos are traces of **Potidaeia**, an ancient Corinthian colony of which today there remain only long lengths of the *walls*, a beautiful example of Hellenistic defensive architecture.

View of the Kavourotrypes Bay on the Sithonian peninsula. In the foreground, a cliff.

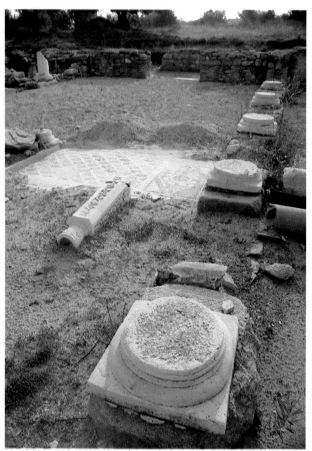

MOUNT ATHOS

The greatest attraction of the region, however, is **Mount Athos**, on the easternmost of the three peninsulas, about 45 kilometers in length. The two slopes of the rocky promontory are dotted with about *20 Byzantine monasteries* which are largely independent of Greek government. Access to these marvels of architecture is subjected to rigid regulations which strictly prohibit women from entering the sacred sites.

The earliest of the monastic communities to be founded on the heels of the ascetic experience of Saint Athanasios of Trebizond date to the 10th century, and that experience survives even today: the lifestyles of the about 1500 monks has changed little in 1000 years. On the western slope are the Monastery of **Saint Dionysius**, founded in 1375,

Remains of the paleo-Christian basilica of Nikitas, on the Sithonian peninsula. In the foreground the bases of the columns of the nave.

View of the Ouranopolis tower with the adjacent beach, by night.

Panorama of the sea with the Stavronikita Monastery and in the background the Pantokratoros Monastery.

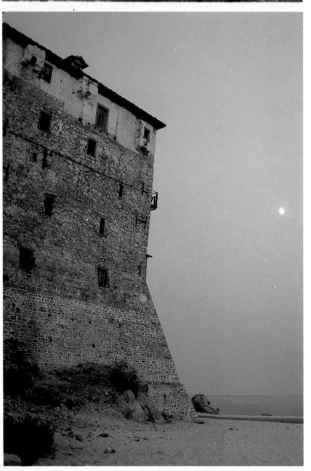

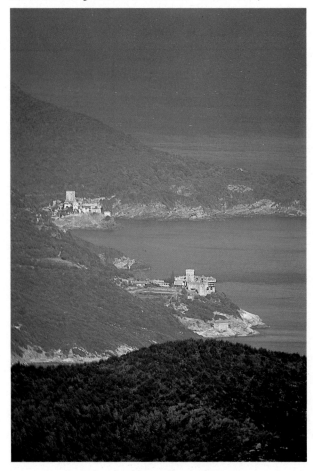

with frescoes from the 16th and 17th centuries in the refectory and the church, besides a library containing a number of illuminated Bibles dating to the 12th century; and the Monastery of **Saint Simonas Petras**, from the 14th century, known for the incredible dimensions of the central building and the rows and rows of balconies surrounding the outside walls overlooking a sheer drop to the sea. On the eastern slope the most important centers are the **Hiliandariou** and **Vatopediou Monasteries**, founded in 1197 and 980, respectively. The latter is famous for its *library* and for the rare objects preserved in the *church treasury*. Suggestive is the visit to the monastery of the **Megistis Lavra**, the oldest of them all, founded in 963 AD by Saint Athanasios. The monastery is at the foot of the highest peak (about 2040 meters above sea level) of the *Athos* massif, with its unforgettable panorama of the surrounding gulf.

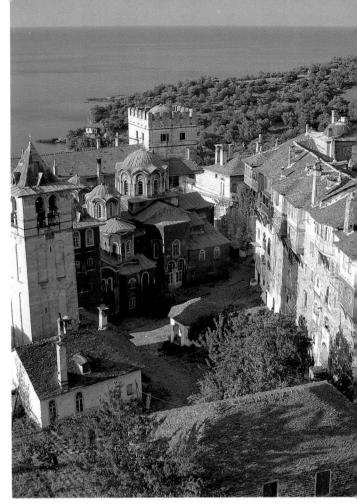

The Iviron Monastery with the soaring peak of Mount Athos in the background.

The main courtyard of the Megistis Lavra Monastery. In the background the intense blue of the sea.

The main buildings facing the courtyard of the Megistis Lavra Monastery.

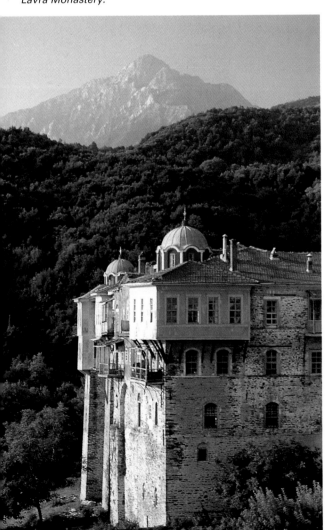

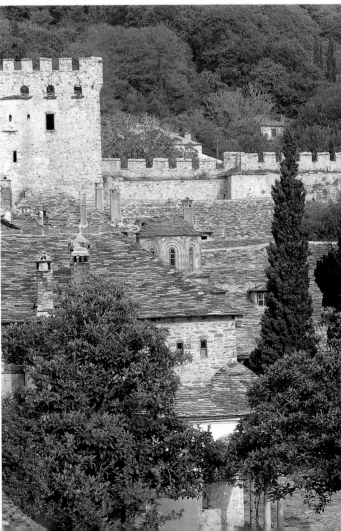

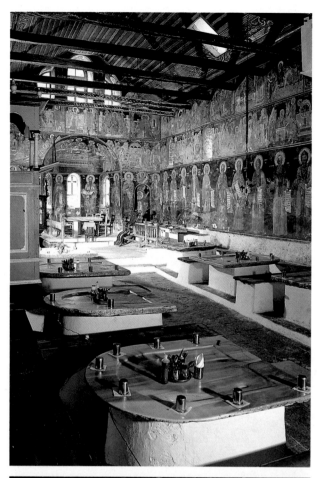

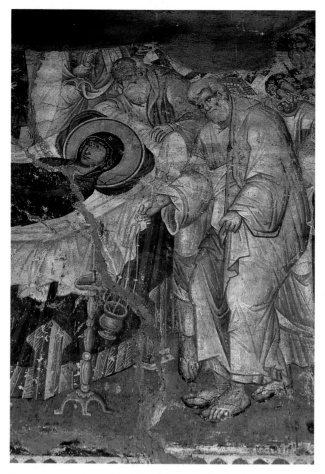

The great refectory of the Megistis Lavra Monastery.

Detail of the fresco "The Dormition of the Madonna", by Panselinos of Kariés.

The "Axion Esti" icon in the cathedral church in Kariés, the administrative center of the region.

Monks distilling eau-de-vie at Keli Ravdouchos.

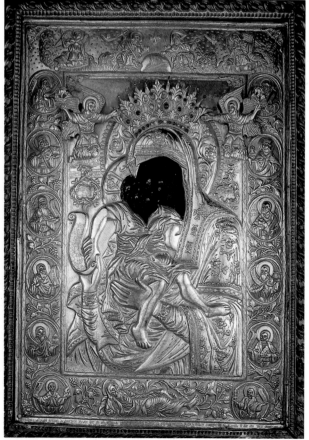

KAVÁLA

Modern city and port of eastern Macedonia, Kavála arises on the site of the ancient *Neapolis*, almost directly facing the island of Thássos. The historical nucleus, with its middle-eastern flavor, lies on the promontory that dominates the city.

The remains of the ancient settlement are today very few: of a certain interest is the *Roman aqueduct* from the 2nd century AD. The local **Archaeological Museum** includes material from the entire surrounding area, covering a timespan from the Bronze Age (2000 BC) through the late Byzantine period; of note a beautiful red-figured krater from the 4th century BC, a red-figured water pitcher showing Aphrodite on horseback (4th century BC) and a superlative painted funerary stele dating to the mid-3rd century AD.

Panorama of the city of Kavála and the gulf of the same name.

The port with a view of the old city, still surrounded by its walls, in the background.

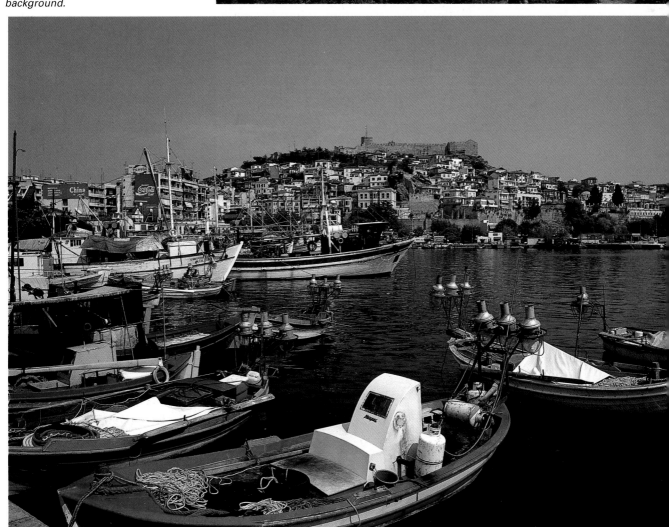

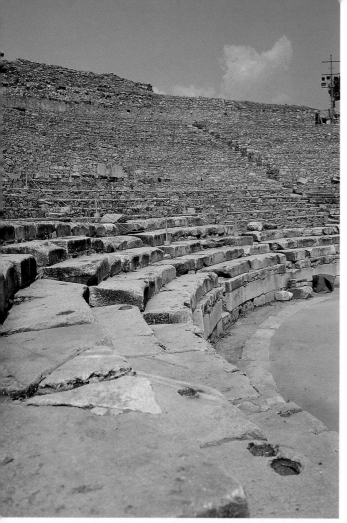

PHILIPPI

Known for the memorable battle of 42 BC between Brutus and Cassius, Caesar's assassins, and Octavian and Anthony, the city took its present name from Philip II of Macedon, who occupied it in 356 BC. A flourishing colony of the Roman Empire, the city was visited by Saint Paul, who established the first Christian community in Europe there in 49 AD. In Byzantine times it was a metropolitan see hosting as many as five bishops. In 473 AD Philippi was occupied by the Goths. The most important monuments are found at the foot of the **acropolis**. A **theatre**, built by Philip II, is incorporated into the slope, and nearby, hollowed out of the rock, is the **Sanctuary of Pan**. At the center of the built-up area is the paved expanse of the great rectangular **Forum**, which was flanked by raised **porticoes** on the east, west and south sides and by a library to the east. The remains of early Christian Philippi bear witness to the importance of the city during the Byzantine era. Of interest are the remains of **Basilica A** and the large **Basilica B**, also known as the *Direkler* or Pillared Basilica, which arises on the ruins of a 2nd-century AD *Roman gymnasium*, a large part of the perimeter of which is still intact.

The well-preserved tiers of seats in the enormous theatre-amphitheatre and the Forum, surrounded on three sides by porticoes and all the buildings of public importance for the Roman colony.

View of the interior of Basilica B, or Direkler. The ambitious plan of the original building is still clearly apparent from the remains.

The remaining structures of the palestra buildings from the west. Behind, the columned street leading to the Forum.

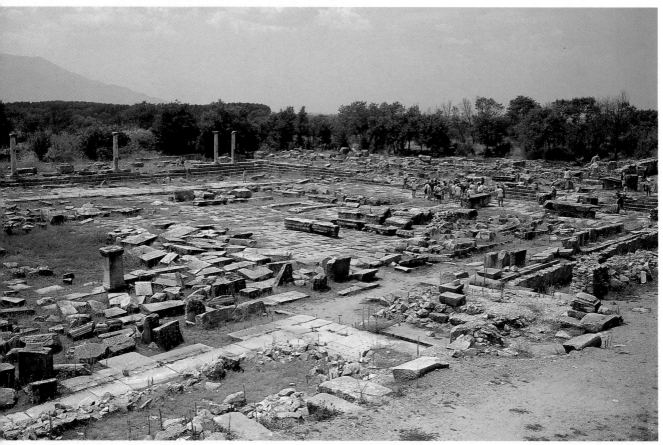

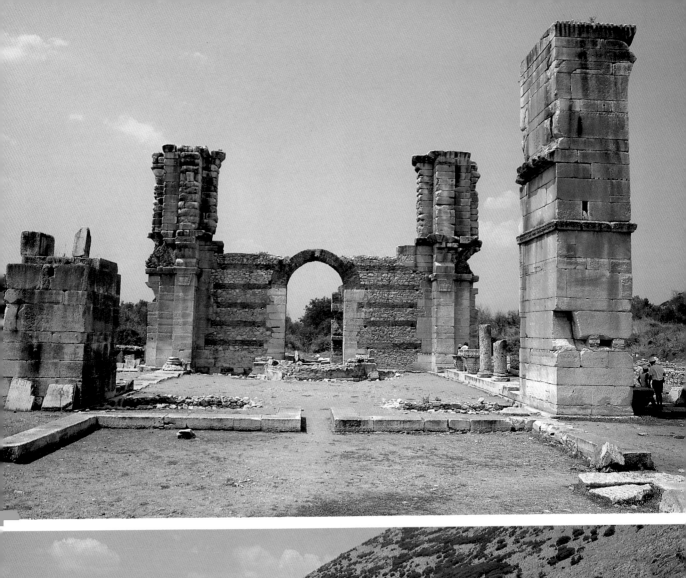
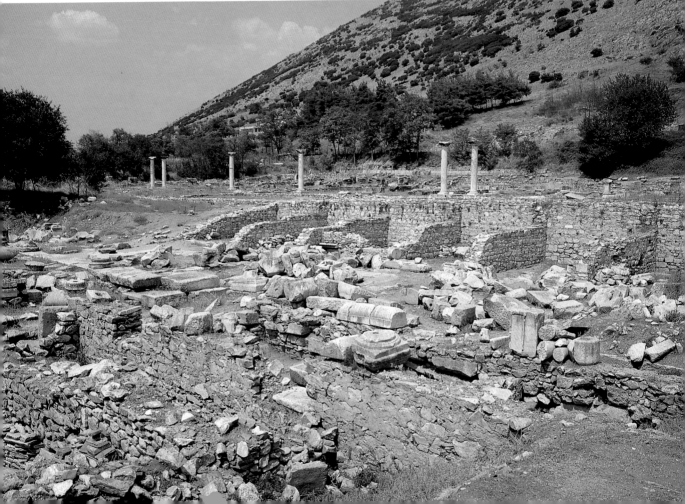

Strolling through the old city. Examples of homes in the "Turkish" style on the narrow winding streets.

A beautiful example of a rich Turkish residence with a closed-in balcony.

XANTHI

A large agricultural and tobacco-marketing center, Xanthi occupies the site of the ancient *Xantheia*, a town mentioned as early as the Middle Ages. The historical center is even today very picturesque, and the city also preserves important 12th- and 13th-century Byzantine remains such as the **fortifications** with the *towers*, *sentry walks* and defensive works. The powerful **Monastery of the Taxiarchs** dominates the entire area from a rise overlooking the old center.

The truly characteristic features of Xanthi are instead its **minarets**, the spires of which still rise high into the sky, and the narrow streets of the historical center, which cross and re-cross to form a true labyrinth. Located along these streets are what are perhaps the most characteristic examples of the surviving Ottoman influence on architecture. Two of these buildings, restored during the neo-Classical period, are today home to the rich **Museum of Popular Tradition and Folklore**, which presents an extensive panorama of Thracian and Macedonian handcrafts from the late 1800s. Of note the Thracian costumes, the examples of the Macedonian goldsmiths' art, and the characteristic wooden furniture with copper finishings.

THÁSSOS

Off the coast of Thrace, the island of Thássos is a compact mass of marbles and schists thickly covered by Mediterranean vegetation including firs, plane-trees, pines and chestnuts. Corn and olives prosper in the limited plains areas, and the island is famous for its honey. In the early 7th century BC, perhaps attracted by the nearby Mount Pangaion gold mines, colonists from *Páros*, among whom the father of the lyrical poet Archilocos, took possession of the island. It soon prospered, and after having sided with the Persians became an Athenian satellite during the 5th century BC. The island retained a degree of independence from Macedonia and formed an extremely advantageous alliance with Rome. In 1429, the Emperor of Byzantium enfeoffed the island to the Genoese; it fell under Turkish dominion in 1496, returning to Greece only in 1912. Today, Thássos is known for its extraordinarily temperate climate and for the beaches on the eastern shore; historical and archaeological interest is also aroused by localities such as *ancient Thassos*, *Aliki*, *Panaghia* and *Theologos*.

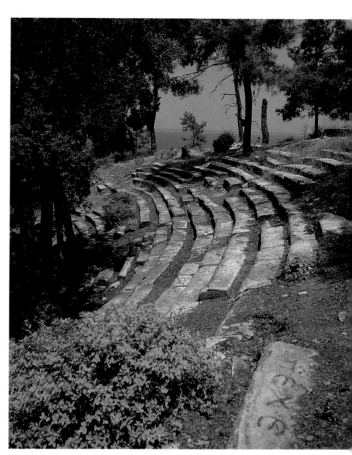

Among lush vegetation, the remains of the tiers of the Hellenistic theatre which fanned out at the foot of the acropolis.

Panorama of the modern-day Thássos Town and of the bay, from the acropolis of the ancient city of Thássos.

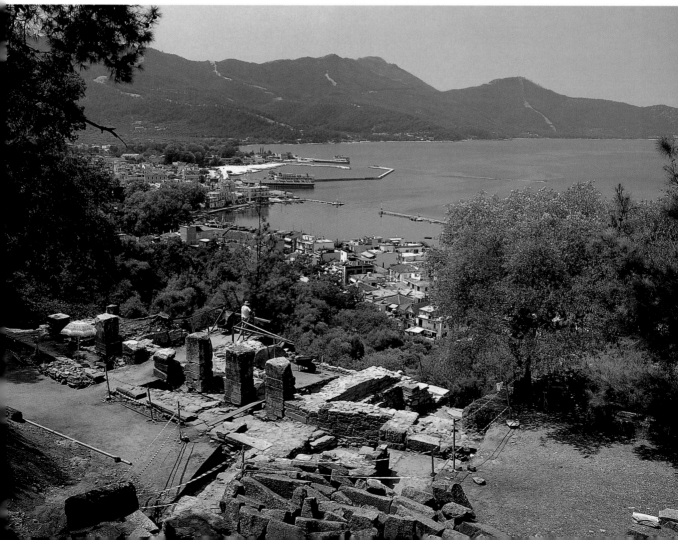

MUSEUM OF THÁSSOS

Near the *agora*, the museum houses the most recent finds of the French archaeological excavations; the earlier finds are all exhibited at the Louvre. Among the pieces of greatest artistic importance is doubtless the colossal statue of a young man (*kouros*) carrying a ram, 3.50 meters in height and dated to about 600 BC. The unfinished statue is partially deteriorated due to its having been used in construction of the medieval walls of the city. Of note a late-Archaic (6th century BC) protoma of *Pegasus*, four heads of *Zeus Agoraios* and a sculptural group, from a *donarium* erected after a victory in a theatrical contest, representing Dionysos, Comedy, Tragedy and the Dithyramb. The many heads, including one of Lucius Caesar, are from the Roman period, as is a copy of the celebrated *Cnidian Aphrodite by Praxiteles*.

The colossal kouros called the "Cryophorous", or ram-bearer, a masterwork from about 600 BC.

The eagle of Zeus (?), perhaps from an Archaic building within the precinct of Zeus Agoraios.

Goddess on a dolphin, acroterial decoration from a Hellenistic donarium in the agora area.

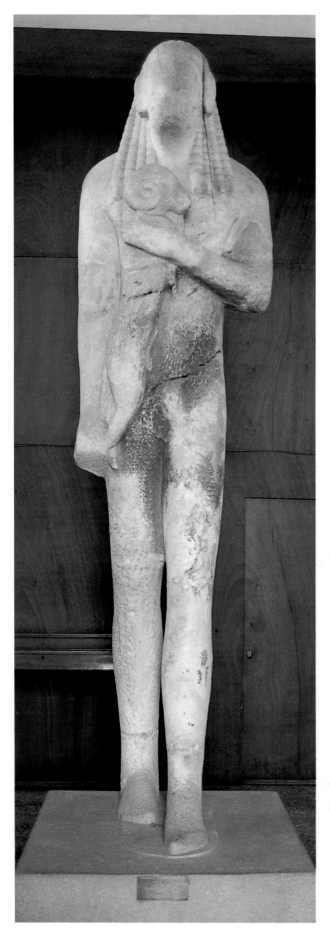

THÁSSOS ARCHAEOLOGICAL SITE

The *Thássos* excavations are delineating a precise picture of the economic and strategic importance of the island in ancient times. The **site**, on the northern coast of the island, had two *ports* and was encircled by *defensive walls with gates and towers*. The scarce remains of the acropolis, on which can still be seen a portion of a *Sanctuary of Athena*, contrast with the important ruins of the lower city, in which many *sanctuaries* and places of worship, such as those dedicated to Dionysos, Artemis and Herakles, are to be found. Alongside the latter are the remains of a 5th-century AD basilica and the triumphal arch perhaps erected in honor of Caracalla. The richest area by far, however, is that of the **agora**, center of the city's business life. Lined by *porticoes* and semicircular *exedras*, it encloses the remains of the city's *tribunal* and the *precinct of Zeus Agoraios*, dating to the late 5th to early 4th century BC, within which is found a *small circular temple*, a rectangular temple and various other constructions linked to the cult. To the south are the *altar of the hero Theagenes* and the base of the *monument to Lucius Caesar*, Augustus' adopted son.

Detail of the external facade of the city gate called the "Silenus Gate". The decoration, in relief, shows Silenus bearing a cup and entering the city dancing.

Entrance to the sanctuary of Athena on the acropolis (?).

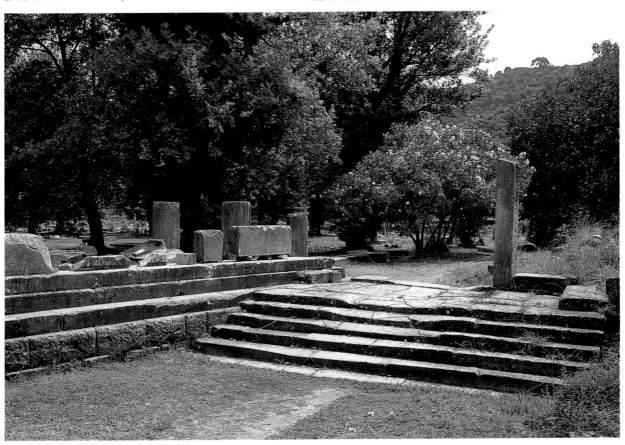

INDEX